ALESSANDRO ANGELINI

BAROQUE SCULPTURE IN ROME

5/GALLERY OF THE ARTS

I wish to express my gratitude to my friends
Barbara Agosti, Andrea Bacchi, Luca Baranelli
and Tommaso Montanari for their attention
and advice. Special thanks to Lia Bellingeri
for her care in revising this text.

EDITORIAL COORDINATOR
Paola Gallerani

TRANSLATION
Susan Wise

EDITING
Timothy Stroud

ICONOGRAPHIC RESEARCH
Alessandra Montini

CONSULTANT ART DIRECTOR
Orna Frommer-Dawson

GRAPHIC DESIGN
John and Orna Designs, London

LAYOUT
Virginia Maccagno

COLOUR SEPARATION
Eurofotolit, Cernusco sul Naviglio (Milan)

PRINTED APRIL 2005
by Conti Tipocolor, Calenzano (Florence)

CONTENTS

PRIMACY OF THE LOMBARDS IN ROME

"A great many French and Netherlanders coming and going and there is nothing we can do about them". That is how, around 1620, Giulio Mancini, the Sienese doctor and art connoisseur, summed up the situation of painting in Rome where the colony of transalpine painters was continuing to grow. Had sculpture chanced upon a historian as knowledgeable, attentive and subtle as Mancini was for painting, he probably would not have expressed himself otherwise. Confirmation of the massive presence of northern sculptors, stone-cutters and carvers in Rome, who were living in the same districts and even the same quarters as the painters, according to Mancini, is provided by the well-known examples of Nicolas Cordier from Lorraine and François Duquesnoy from the Low Countries, who shall be discussed later. They were naturalised Romans surrounded by a group of their less famous countrymen who may have emigrated at the time of the St Bartholomew's Day Massacre or Philip II's disastrous war against Flanders.

Art in early seventeenth-century Rome was mostly produced by men belonging to this mosaic of different, even remote "nations" of Italy and Europe, drawn by the extraordinary magnet, the papal court. This was the most cultured, cosmopolitan court of the time, and the most universal and fascinating due to the antique and modern treasures it kept ("the most universal city in the world, where the fact of being a foreigner and national differences count for nothing: everyone feels at home here", as Montaigne described it). The largest and most talented of all these foreign communities was undoubtedly that of the Lombards, which counted the two leading painters of the day: Caravaggio and, taking the term Lombard in its oldest, broadest acceptation, Annibale Carracci. People like Michelangelo Merisi (Caravaggio's real name), Tanzio, Manfredi, Buteri—Lombard painters active in Rome—were joined by an even greater number of sculptors and stone-cutters. They came from the area of Milan, Ticino and the lake region, and provided Rome with a crucial workforce that cut marble and travertine on the great pontifical building sites of the first modern age. Detailed studies have yet to be made on the intense exchange that took place in the

field of sculpture between the Milan of the Borromeo and Rome in the period from Sixtus V to Paul V. Obviously the coming and going between these cities of major individuals interested in the figurative arts, like Carlo and Federico Borromeo, if each in his own way, largely explains this flow of Lombard sculptors to Rome, a fact that became truly striking around the year 1600. Once the full picture of statuary in late sixteenth-century Milan has been drawn up we shall have a better idea of the developments of the plastic arts in Rome, at least during Paul V's pontificate (1605–21). The building sites of Santa Maria presso San Celso and the furnishing of the Duomo in Milan were the training grounds for the sculptors who went south, either to Rome or, like Cosimo Fanzago, to Naples, where they met with amazing good fortune. The contribution of masters such as Francesco Brambilla the Younger (documented 1572–99), and Andrea Biffi (documented 1593–1631) in forming this colony of Lombards in Rome was essential. Sculpture in the Pauline age cannot be properly understood without first looking at the reliefs on the choir and pulpit of Milan's Duomo, with its vigorous *Doctors of the Church* (1591–94) cast in bronze from Brambilla's model, which both Stefano Maderno and Cosimo Fanzago carefully studied.

The presence of Lombard sculptors in early seventeenth-century Rome is inseparable from the great architectural building sites, especially churches, dominated by master builders like Martino (who died in Rome in 1591), Onorio Longhi (1569–1619), Domenico (1543–1607) and Giovanni Fontana (1540–1614), Flaminio Ponzio (1560–1613) and Carlo Maderno (1556–1629). These pragmatic Lombard stonemasons were often bound by family ties as well as being fellow-countrymen. They dominated Roman architecture until the middle of the Barberini pontificate and Bernini's rise to supremacy (1629), and usually worked with groups of stone-cutters and plasterers assigned to carve the facades and interiors of the churches. The decorative exuberance and plasticity of the facades of Carlo Maderno's churches (for example Santa Susanna completed in 1603) undoubtedly stem from the decoration of the facades of Borromeo's churches of San Fedele and Santa Maria presso San Celso in Milan. In particular, the custom of including niches on the facade for full-relief statues was a specifically Lombard practice that spread almost systematically to Rome during those years, and gradually became a trait of seventeenth-century Rome. They appeared to seek to extend the carved decoration, hitherto reserved to the interiors, onto the facade. The portal, set in a porch with its projecting tympanum, almost recalled the form of the Eucharistic tabernacle on the altar, while the lateral niches with statues replicated the exuberant decoration of the chapels.

The finding of St Cecilia's remains in the foundations of the Trastevere church consecrated to her was undoubtedly one of the major events in Roman religious life

right after the jubilee year 1600. The discovery of the maiden's "holy body", miraculously intact as though it had just been buried, was celebrated by Cardinal Paolo Emilio Sfondrato. The high prelate commissioned a lavish altar to be built immediately beneath Arnolfo di Cambio's ciborium inside the apse of the church of which he was the titular. Like Cesare Baronio, Federico Borromeo, Antonio Bosio and others, Sfrondato recognised in the early Church of the Catacombs and the first basilicas the vigour of the Catholic faith, which, with the antiquity of its early structures, could be used to counter the recent arguments and controversies the Lutherans advanced against Rome. The restoration of Santa Cecilia in Trastevere, including the renovation of Pietro Cavallini's famous frescoes, should be seen in the context of this rediscovery of underground Rome, with its deep religious and cultural implications. The flamboyant altar inlaid with polychrome marbles and decorated with gilt-bronze low reliefs houses a rectangular space, a dark loculus, inside which the Carrara marble statue representing the maiden martyr, carved by Stefano pl. 1 Maderno (ca. 1576–1636) was placed.

The sculpture was supposed to represent Cecilia's limbs in the same position as they had been found. The deliberate contrast between the dazzling, triumphant polychromy of the altar and the austere simplicity of the fragile, recumbent, entirely white body, looming as though out of the dark shadow of death, is a powerful motif. The very fact that the face is veiled and turned aside and the arms recline naturally in the surround-ing space makes Maderno's "natural" handling recall certain effects of Caravaggio's painting of the same period. The realism of those delicate hands resting next to one another on the ground and the smooth folds that gently crease the garment surpasses any form of abstraction and ornamental complacency, inspiring awe by its intense formal concentration. But *St Cecilia*'s naturalism is far from being an exception in Maderno's production or the overall scene of Roman statuary in the early seventeenth century. The six gilt-bronze figures—the popes *Lucius* and *Urban*, and the martyrs *Maximus, Valerian, Caecilia* and *Tiburtius*—on each side of the altar as though in a medieval marble transenna carved by the Cosmati, reflect an aspiration to rigour and simplicity already entirely distinct from late-Mannerist taste. It is no coincidence if this Cecilia holding an organ, directly derived from Raphael, was repeated in similar forms by Guido Reni at the same time as Maderno. But compared to the Bologna painter's formal, idealised figures, the bronze saint expresses a mildness and simplicity in keeping with a *sermo humilis* probably perfectly suited to Sfrondato's exigencies.

As we know, the Tridentine church deemed essential for religious edifices a form of art that could communicate religious messages with a simple text, pleasing style and clear iconography based essentially on tradition. In that sense, attention was focused

mainly on painting, as this had always been the *Biblia pauperum*, and in Florence, Milan and Bologna artists for some time had sought a pictorial "reform" that presented the "devotional" content in a direct manner tending to naturalism. Critics have indeed pointed out this reformation in painting which, before influencing other fields, had arisen in Florence from the simplicity of Santi di Tito's style. But this evolution toward a "way to naturalism" directly concerned sculpture as well, and was especially represented in early seventeenth-century Rome by the sculptors from Lombardy, of whom Stefano Maderno was the spokesman, who had trained with Annibale Fontana close to the building site of Santa Maria presso San Celso. In the Santa Cecilia altar, his first and most important work, Maderno used two different registers, one quiet and natural as already described, and the other tending more to a hedonistic preciousness noticeable in the two extremely graceful bronze angels holding the crown. These two ephebic creatures standing on the tympani still possess the elegant, elongated tension present in several figures modelled by Prospero Bresciano. Maderno later attenuated this manner in public and ecclesiastical commissions, reserving it for antique-style terracotta groups where this robust buoyancy is expressed in dramatic compositions without the slightest academic smugness.

Immediately after Carlo Borromeo's canonisation in 1610, Maderno carved the full-length effigy of the Milanese bishop in the church of San Lorenzo in Damaso. Here too the sculptor effected a certain realism in fashioning the statue of the saint swathed in his vestments, who is shown firmly and solemnly blessing as he strides forward as though in a procession. The pluvial, creased in deep, soft folds, and the mitre are intricately trimmed, both of which are noble attributes of the episcopal dignity that Borromeo's pastoral zeal had glorified. On the strength of these distinguished commissions, Maderno was invited to join the most prestigious Roman building site of the first years of Paul V's pontificate: the Pauline Chapel in Santa Maria Maggiore where the most outstanding sculptors worked, most of them members of the Lombard colony. One of the sculptors who had a fundamental role in the Pauline Chapel was actually from Lorraine, Nicolas Cordier (ca. 1567–1612), to whom the biographer Giovanni Baglione gave due recognition. Cordier, in Rome since 1593, had been apprenticed in his native country as a skilled craftsman, mainly devoted to intaglio and openwork decoration in keeping with French tradition. To him the discovery of sixteenth-century Italian sculpture essentially meant boundless admiration for Michelangelo to whose greatness he paid tribute by explicitly imitating several of the "divine" master's figures. The most obvious example of Cordier's veneration for Buonarroti can be seen in the large statue of *St Gregory the Great* at the Caelius, carved in 1602 on a commission by Cesare Baronio for the oratory of the *Triclinum pauperum*. According to Baglione, the marble in which Cordier carved the sanctified pope had already been "roughed out by Michelangelo" and certainly the face appears

to be modelled on the one of the same saint the Florentine artist had sculpted a century earlier for the Piccolomini altar in the Siena Duomo. Actually Cordier admired Michelangelo's youthful works—the *Pietà* in St Peter's, the *Moses* in San Pietro in Vincoli, the *Risen Christ* in Santa Maria sopra Minerva—where the polish of the marble surfaces was perfectly finished. He adopted this finish, even carrying it to extremes in a feverish concern for detail, a consequence of his matchless craftsman's skill. This monumentality, reminiscent of Michelangelo, combined with a meticulous intaglio that was soon to be directed toward realism, led Cordier to become an extremely sought-after sculptor in Rome as well as a brilliant restorer of antique sculpture. Before he began work on the Pauline Chapel, he was involved in the Aldobrandini Chapel in Santa Maria sopra Minerva (1604) for Clement VIII, which, due to the collective effort of an experienced group of sculptors, can be considered a sort of rehearsal for the great Santa Maria Maggiore building site.

Designed by Carlo Maderno, the most outstanding architect of the day, the Aldobrandini Chapel was planned to accommodate in a relatively small space the two tombs of the pope's parents, Silvestro Aldobrandini and Lesa Deti, adorned with the relative *Virtues*. They were to flank the altar with the *Institution of the Eucharist*, one of Federico Barocci's last masterpieces. Owing to the Urbino painter's delay in following Clement VIII's strict, scrupulous directions, the chapel was not inaugurated until March 1611, by which time the tombs had been ready for some time and the illustrious patron had passed away five years earlier. As with the St Cecilia altar, the use of polychrome marble and stone in the Aldobrandini Chapel is profuse. In keeping with the sixteenth-century sepulchral typology codified by Andrea Sansovino, the two deceased figures carved by Cordier lie recumbent on the tombs. But the bust has an unnatural appearance in order to render the attitude more decorous and devotional, especially in the case of Deti, who is veiled and holding her breviary. We see how in the course of the century the recumbent position of the deceased figure was gradually abandoned and replaced by a half-length bust or by the figure raised and seated. Deti's portrait, as glacial as one of the ladies by the mature Pulzone, expresses Cordier's virtuosity to perfection in the folds of the veil, the silk of the garment gathered over her breast, and her fingers slipped between the pages of the breviary. The sculptor's Michelangeloesque style is manifest in the *St Sebastian* placed in the recess to the right of the altar. The position of the limbs and typology of the face were inspired by Buonarotti's *Risen Christ* in the Dominican church of the same name in Rome. The military garb Cordier placed at the saint's feet, the helmet with its mascaron and the abandoned armour, would be profitably recalled by Bernini when the great artist introduced similar details in his Borghese *David* and his *St Longinus* pls. 18, 20
in St Peter's. *Charity* flanking the Deti tomb, with its three lively little children, is one pl. 6
of the finest sculptures carved in Rome at the time, being Cordier's work that best

displays his training in the Richiers' workshop in Lorraine. But in the Aldobrandini Chapel the dialogue between Lombard and French sculptors like Cordier is extremely harmonious, as seen in the lovely intaglio carvings by Ippolito Buzio (1562–1634), pl. 4 who was born at Viggiù in Valceresio. *Prudence*, preening in the mirror like a vain young girl, offers treatments analogous to the *Charity* by Franciosino (as Cordier was known), yet in the wealth of serpentine hair, the bared breast and the girl's languid attitude, a more penetrating and sensual realism can be perceived. In close affinity with Cordier, Buzio also reveals his talent in the statue of *Pope St Clement* where the meticulous handling that traces a tight web of creases in the surplice or the fine curls of the beard does not in the least reduce the vigour of this mighty, austere elderly figure. The Lombard sculptor had already demonstrated a similar manner in rendering the face and drapery of the large marble statue of *St James* for the church of San Giacomo degli Incurabili, completed in 1601. For the marble of the Pilgrim Apostle, Buzio clearly sought his inspiration in Jacopo Sansovino's famous model, at the time in San Giacomo degli Spagnoli, yet giving it a Lombard "skin", that is to say a meticulous, sensitive surface smoothness. The full, mighty forms of his statues soon made this Lombard one of the most fascinating masters among the sculptors in Rome, certainly one of the most innovatory among those who worked on the Pauline Chapel. We should also mention Buzio's series of portraits, several examples pl. 5 of which are still in the Aldobrandini Chapel and bear the likenesses of Clement VIII's relatives. For the same chapel he also carved the bust of *Lesa Deti*, which has recently been rediscovered and belongs to the Metropolitan Museum in New York. This sculpture is truly impressive for the surface realism that became an important precedent for the youthful Gian Lorenzo Bernini.

Cordier's strong personality, seen to a certain degree in the Aldobrandini Chapel, seems even to have influenced the career of the Vicentine artist Camillo Mariani (1567–1611), to whom we owe the sculpture of *Religion* for the Leti tomb, almost a lamer, more rustic *Faith*, and the two massive figures of *St Peter* and *St Paul*. Mariani had already begun working in Rome in the 1590s in the San Giovanni in Laterano yard, but his personality only fully blossomed in the eight large stucco statues of saints modelled soon after 1600 in San Bernardo alle Terme. This jubilee commission promoted by Caterina Sforza, countess of Santa Fiora, revealed the degree to which Alessandro Vittoria's great Venetian legacy had influenced the Vicentine sculptor's pl. 3 training. The warm Venetian feeling for colour is reflected in the *St Catherine of Alexandria* for instance, as solemn and matronly as a Veronese lady, or in the *St Jerome* that, in the typology of the elderly face with a curly beard, is an explicit tribute to Vittoria. But all of the "*figuroni*" (Baglione) in the niches of San Bernardo alle Terme—Mariano's true masterpiece—were to fascinate generations of Roman sculptors way beyond the early eighteenth century. Indeed, the artist's talent achieves

admirable effects in the solid composition of his saints, modelled in a malleable material resembling plaster that offered suffused effects.

As mentioned, the most prestigious building site for sculpture in Rome at the beginning of the seventeenth century was the chapel of Santa Maria Maggiore that Paul V Borghese wished to dedicate to the venerated image of the Madonna, held by tradition to have been painted by the Evangelist Luke. Placed opposite the left transept of the *basilica liberiana* (the basilica of Pope Liberius), the large chapel was a pendant to the one Sixtus V had already opened (the Sixtine Chapel) opposite the right transept, which was dedicated to the relic of the Holy Manger from Bethlehem. Although just a few years had passed since the completion of the Sixtine Chapel in Santa Maria Maggiore, significant stylistic changes already marked the decoration of the Borghese Chapel even if several designs were repeated. The presence of artists who were slightly younger than those who worked on the Sixtine (who also belonged to the Lombard school whose leading members have been referred to) explains the evolution in style and taste. Flaminio Ponzio da Viggiù (1560–1613) was the architect who designed the two lateral walls with the tombs of Clement VIII and Paul V framed in low reliefs depicting outstanding episodes from the two popes' lives. Just like Domenico Fontana, who had designed the matching parts of the Sixtine Chapel, Ponzio's work seems to evoke several important Lombard antecedents even more than Bandinelli's tombs of the Medici popes in Santa Maria sopra Minerva. The memory of the facade of Santa Maria presso San Celso in Milan appears to be combined here with motifs inspired by the choir of the Milan Duomo with its Marian reliefs and caryatid-angels on which Andrea Biffi and Francesco Brambilla had worked years earlier. In the two lateral walls of the Pauline Chapel, the carved figures in the low-relief stories achieve a greater dimension than the ones in the Sixtine Chapel, and the compositions are by and large simpler and more rigorous, even monumental. However the greatest difference is found in the caryatids that were placed on the pediment above, thereby acquiring new strength and life, whereas in the Sixtine Chapel they appeared simply as hermae. The bright polychromy of the stone materials and metals contributes to the severe splendour of the Borghese Chapel, the use of colour being so sophisticated that they seem to imitate the frescoes on the vaults and dome. These effects could be observed in Sixtus V's chapel as well, but this new decorative rigour and desire for simpler effects owe more to the famous precedents of the altar of Santa Cecilia and the Aldobrandini Chapel.

The newest, most striking aspect of the chapel is the lavish high altar inlaid with dazzling coloured marbles and gilt bronze inside which a cast frame designed by Mariani and supported in flight by five angels contains the image of the Madonna. The dazzling gold of the frame stands out against the lapis lazuli ground: a stroke of

genius that impressed Bernini who would borrow it many years later in an entirely different context. Inside the frontispiece a low relief by Maderno represents *Pope Liberius Tracing the Perimeter of Santa Maria ad Nives*. Here the preciousness of the polychrome sculpture achieves effects of sheer virtuosity with the two groups of gold bystanders attending the foundation of the basilica, their feet deep in the white Carrara marble snow-drift. The ten reliefs are arranged five on each side between the two walls of the tombs of Clement VIII and Paul V and celebrate the increasingly international dimension of early seventeenth-century pontifical policies. The strictly religious episodes, like the canonisations of the saints championed by the two popes, play a minor role in the carved cycle compared to subjects of high European diplomacy favoured by Rome or even military undertakings aimed at strengthening the Papal State. Iconographically these reliefs possess an emblematic value in the final phase of the wars of religion, the difficult relationship with the Turkish East and successful hegemonic endeavours of a Church grown firmer within its borders and international credibility. The reliefs by older sculptors like Ambrogio Buonvicino (ca. 1552–1622) or Giovanni Antonio Paracca, known as "Il Valsodino" (documented 1598–1646), were still close to the late-sixteenth-century manner. In their stories the spatial planes overlap rather mechanically, reducing the size of the background figures as stiff as little lead soldiers in a papier-mâché architectural decor. The carved reliefs by Ippolito Buzio, Mariani or Pietro Bernini are very different and more modern. Among the most interesting are the ones placed at the upper centre of the two walls respectively depicting the *Coronation of Clement VIII* and that of Paul V. The style of the first, by Pietro Bernini, is clearly rooted in international Mannerism, with the bystanders in the foreground facing the viewer like in a fresco by Federico Zuccari or in the tight composition of a Netherlandish Mannerist artist. The decorative scheme seen in the quilted garments, curly hair, plumes, and draperies with papery folds achieves effects of fascinating abstraction. One can appreciate the same formal intent in the mobile, slender and stunningly elegant caryatids placed on the pediment.

pl. 11

The quieter composition by Buzio, the author of the *Coronation of Paul V* and the caryatids crowning the pediment of the Borghese tomb, gives the impression of contrasting Bernini senior's high-strung abstractions. The *Coronation* aims at realistic, natural narration which, as pointed out, was the Lombard sculptors' greatest invention. Unlike the Bernini relief there is not a single decorative detail to distract from the simplicity of the action. The cardinals swathed in their smooth copes are admirably positioned in the well-defined space created under the baldachin by the steps to the throne, in serried rhythms that recall the sober image of a "reformed" painter like Bartolomeo Cesi. And even the caryatids, so tender and youthful, present a naturalism inconceivable in Pietro Bernini's artificial figures. Alongside these two principal masters the presence of Maderno and Mariani in the reliefs is less extensive but no less

significant. Maderno's *Rudolf II of Hungary Attacking the Turks* in particular reflects pl. 2
a liveliness in arraying the figures in space and a clever faithfulness to antique models
that Algardi himself would make us of many years later. The *Siege of Strigonia* was
Mariani's last work; it was left unfinished and completed by his collaborator Francesco
Mochi. Here as well the dash of the action, the fast pace, almost like in Tasso, usher in
a decidedly new mood for sculpture. The skill Cordier had shown hitherto as a creator
of sculptures in the round afforded the Lorrainer the opportunity of carving four
statues in the Pauline building site: the prophets *Aaron* and *David* and the saints *Bernard
de Clairvaux* and *Dionysius the Areopagite*. The features of a mighty, inspired humanity
stem clearly from Michelangelo's *terribilità*—heroic, awe-inspiring grandeur—and the
model of the *Moses* in San Pietro in Vincoli is accurately borrowed for the patriarchal
Aaron with his flowing, serpentine beard. The vigour of these massive figures is
enhanced by an admirable concern for detail rendered with the great bronze sculptor's
sensibility in the *David*'s ornamented chasubles and finely chiselled cuirass.

The protection the Borghese family extended to Cordier during that period explains
the quantity of antique sculptures in Cardinal Scipione's collections that Cordier
restored. An expert in working marbles of different kinds and colours, he exper-
imented with fragments of statues that he largely integrated, creating uncanny
works essentially modern in style. The two *Gypsy girls* or *Fortune-tellers* now held
respectively at the Galleria Borghese and Versailles are obviously inspired by a taste for
the vernacular and the exotic that Caravaggio had introduced in his genre paintings,
especially the two versions of the *Fortune-teller*. Cordier translated the example of
naturalistic painting into those gleaming, sensitive surfaces of coloured marbles that
gave the great Giambattista Marino the impression of "fragile glass". The two *Gypsy
girls* were in the rooms of Villa Borghese not far from the very fine *Moor* Cordier had pl. 7
carved out of a slab of alabaster, steeped in the same naturalism, achieving effects of
great virtuosity in the curly locks of hair and intact surfaces of flesh against which
the luminous white of the eyes stands out. The *Dying Seneca* resembles Cordier's
restorations and is perhaps his work: today in the Louvre but once belonging
to Scipione Borghese, it became the most famous effigy of the ancient philoso-
pher who was venerated by Europe's seventeenth-century intelligentsia as a sort of
pagan saint.

TUSCAN PRESENCES

Camillo Mariano's experience in colour exerted a strong influence on the debut
of a major figure of seventeenth-century sculpture in Rome, Francesco Mochi
(1580–1654), a native of the Valdarno. Historical documentation attests that the Tuscan

sculptor assisted Mariani in the plastic decoration of San Bernardo alle Terme when he was barely twenty years of age. Furthermore, in the years following Mariano's sudden death, Mochi completed a series of important commissions that had been assigned to Mariani like the *Siege of Strigonia* and the *Apostles* in the Pauline Chapel: evidence that the two had worked together. Indeed, some of Mochi's brilliant colour solutions probably could not be explained without the decisive collaboration of the Vicentino sculptor who had taken him in when he arrived in Rome. In spite of this significant Venetian component, it seems clear that Mochi had already received training in Tuscany on his arrival in Rome soon after 1600, in Florence to be accurate. There, at a very early age, he had been impressed by the greatest sculptor of the day, Giambologna, and may have been acquainted with one of his more established pupils like Francavilla. Several aspects of Giambologna's statuary, beginning with the skill in working bronze low reliefs, remained so typical of Mochi's style even in the years of his maturity that art historians are inclined to believe his apprenticeship took place in the 1590s in the renowned Borgo Pinti *bottega*. Works produced in this very active breeding-ground, like the sculptures for the Salviati Chapel in San Marco and the subtle low reliefs with the *Stories of Cosimo de' Medici* for the equestrian monument of Piazza Signoria, were to be truly decisive for Mochi's development in Rome and later in Piacenza.

pl. 14 In 1603 the artist's first patron, Mario Farnese, duke of Latera, sent him to Orvieto to be employed by the overseers of the Opera del Duomo for the execution of two marble statues with the figures of the Annunciation. In 1605 the *Angel of the Annunciation* was already completed, undoubtedly representing at that time the most radically innovative sculpture ever seen in Rome, and perhaps Italy. The conception of this figure hovering in mid-air and resting on an eddying cloud was strongly influenced by the bronze *Angel* Giambologna had placed on the architrave of the Salviati Chapel in San Marco in Florence. That model may have suggested to Mochi the motif of the figure's rotation, the eloquent gesture of the arms flung open and even the bare shoulder and tilted wings. The smooth rectangular folds of the drapery that appear crushed in several places are also derived from Giambologna. As is possible with a sculpture by the great Netherlandish artist, the observer can circle the Orvieto angel—unlike Bernini's statuary—and view the work from all angles. In Mochi's statue all the features he could have learned from his masters in Florence were carried to such extremes that he even touched on solutions that had never been tested before. Perhaps the study of contemporary painting by Caravaggio and Rubens inspired the sculptor to create a thrilling sense of drama in the statue, enhanced by an extraordinary way of making the marble soar in the air that subsequently only Bernini would achieve. Even the pathetic tilt given to his figures so they appear off-balance in space is drawn from Giambologna's Florentine models. But Mochi adds a new, stirring emotion to gestures and expressions, as in the Orvieto *Our Lady of the Annunciation*

(1609), or enhances with warm languor the grief in certain faces like in the *St Martha* for the Barberini Chapel in Sant'Andrea della Valle where he obtained entirely novel effects. In this very successful first decade of the seventeenth century, Mochi pursued his career with the *St Philip* carved in 1610 for the series of apostles that were backed up to the pillars of the main nave in Orvieto cathedral. It should not be underestimated that Mochi's statue was produced just a few years after the *St Matthew* carved by Francavilla from a model by Giambologna for the same setting. And yet despite its obvious Florentine origin, nothing in preceding statuary matches the *St Philip* for the psychological intensity in the saint's pugnacious elderly face and his energetic arm emphasising the sharp incisiveness of his sermon.

Pietro Bernini (1562–1629), who has already been mentioned, was also of Tuscan birth and training. When he arrived in Rome in 1606 he was already a mature artist with a long career behind him in Naples and other centres of the Vice-Kingdom. Bernini senior, a personality with a complex culture, had also been deeply influenced by his youth spent in the Florence of Giambologna and his pupils. In the Tuscan city in the late 1570s Pietro must have frequented the cultured society formed around Bernardo Vecchietti and Ridolfo Sirigatti, his first master. Above all he must have been close friends with painters possessing a cosmopolitan culture like Federico Zuccari, who was working at the time on the frescoes of the dome of Santa Maria del Fiore, and Antonio Tempesta who, according to the well-informed historian Baglione, had taken young Bernini to work with him at the Villa Farnese at Caprarola. The first documented sculptures, *St Lucy* and *St Catherine* in the church of Santi Pietro e Paolo at Morano Calabro (1591), reflect Giambologna's teaching although reinterpreted in an anti-heroic, subtle, and apparently archaicising vein by an artist who must also have diligently studied early renaissance Florentine sculpture (Bacchi). This vein of what we shall refer to as archaicising "purism" allowed him to satisfy the demands of the patrons of the Vice-Kingdom who often insisted that respect should be paid to a number of typologies passed down from Benedetto da Maiano and Antonello Gagini's proto-Renaissance tradition. Giambologna's models were translated in more and more tapering, elongated and slender forms swathed in vibrant papery draperies with sharp folds. The documented collaboration with Giovanni Caccini in Naples and Florence during the 1590s confirms a close stylistic affinity between the two sculptors and in Pietro's case confirms the unbroken bond with contemporary Florentine statuary.

Then, when Bernini arrived in Rome, stimulated by the atmosphere, he fully displayed his exceptional talent in the most elegant, sophisticated *maniera*, in perfect harmony with the painting of Cavalier d'Arpino, who opened the way for his employment in the Pauline Chapel. Pietro Bernini's Roman masterpiece is the "great marble story" figuring the *Assumption of the Virgin* intended for the Pauline Chapel pl. 10

facade and then placed in the wall of the baptistery of Liberius' basilica. Mindful of Cesari's and Zuccari's great painted altarpieces, Bernini made the marble as sensitive and malleable as stucco in the broken, angular folds of the apostles in the foreground or the small layered clouds amidst which the angels in Mary's retinue flit about. The elastic figures are bent in emphatic poses, and the expressiveness of their countenances is enhanced by abundant locks and flowing, drilled beards. The cherubs with their saucy expressions are equally an important precedent for the countless *putti* young Gian Lorenzo was soon to carve while still working in his father's *bottega*. Between circa 1614 and 1624, Pietro Bernini's career was increasingly bound to that of his son who, born in Naples in 1598, received in his father's studio a direct, decisive training. The two hermae of *Flora* and *Priapus* now kept in the Metropolitan Museum of New York were carved for the park in the Villa Borghese and were still entirely the work of Pietro Bernini. The extremely close analogies between these sculptures and the caryatids Pietro sculpted for Clement VIII's tomb induce us to exclude even Gian Lorenzo's partial execution. The instance of the four garden sculptures representing the *Seasons* for the park in the Villa Aldobrandini in Rome is entirely different. If typologically Bernini appears to have turned once more to Florentine statuary, and particularly the *Seasons* that Caccini had carved in 1608 for the Ponte Santa Trinità, from a stylistic standpoint it is essential to draw distinctions. Indeed the two statues of *Spring* and *Summer* display the typical features of Pietro's mature production: delicate, closely drilled forms, rather engrossed expressions, and papery draperies. On the other hand, *Autumn* and *Winter* offer two capricious and extraordinarily innovative inventions that seem to suggest Gian Lorenzo's more direct intervention. Then if the execution of *Winter* in the skilfully drilled surfaces still follows Pietro's manner, that of *Autumn*, more vigorous and naturalistic, may already reflect Gian Lorenzo's hand. Pietro Bernini's oeuvre continued with the half-length *Antonio Coppola*, the Florentine surgeon who contributed to the construction of the hospital of San Giovanni dei Fiorentini next to the homonymous church. The effigy, paid for in 1612, is carved from the surgeon's death mask. This explains the impression of raw naturalism seen in the hollow face which has led some to suggest that it was Gian Lorenzo's work rather than that of his father. In fact, each formal element, from the abstract way of marking the folds of the cloak to the thin fingers and handling of the hairs of the beard and moustache, is typical of Pietro's background and confirms attribution of the work to Bernini senior.

The first document that mentions Gian Lorenzo working in his father's *bottega* dates from February 1618 and concerns the decoration of the Barberini Chapel in Sant'Andrea della Valle dedicated to Our Lady of the Assumption. The task, coming right after that of the Pauline Chapel, involved at least some of the sculptors who had worked in Santa Maria Maggiore, especially those who belonged to the Tuscan

community. In addition, the brothers Maffeo and Carlo Barberini who supported the initiative to comply with the testamentary wishes of their uncle, the Prothonotary Apostolic monsignor Francesco, were from Florence even though they moved to Rome some time before to begin their brilliant respective ecclesiastical and military careers. The Florentine Domenico Passignano was assigned to paint the episodes of Mary's life, while the marble statues placed at the corners of the chapel were commissioned from four different masters, three of Tuscan birth or training—besides Bernini and Francesco Mochi there was Cristoforo Stati (1556–1619) from Bracciano, a pupil of Giambologna—and a Lombard, the Milanese Ambrogio Buonvicino. The comparison between *St John the Evangelist* carved by the latter and *St John the Baptist* pls. 9, 12 executed by Pietro Bernini casts new light on the profound cultural differences mentioned in the decoration of the Pauline Chapel. The emaciated face and minute features of the *Baptist* carved by Pietro, and the delicate twist of the bust and close drilling of the marble for the hair and lambskin, were still derived from Tuscan-Roman Mannerism. This acute rarified elegance seems to contrast with Buonvicino's solid, vigorous statue characterised by an entirely Lombard gentle naturalism and expressive mildness. *St John the Evangelist* seated in the act of writing, paid for in 1612, is certainly Buonvicino's most mature, elaborate work, perhaps influenced by Mochi's and Cordier's more modern production. At this time Buonvicino was a much sought-after sculptor in the early days of the Borghese pontificate. He did the low relief for the facade of St Peter's representing *Christ handing the keys to St Peter* and added his signature in a prominent position. This sculptor's cultural roots, which were founded deep in sixteenth-century Lombard classicism, and his training as a master plasterer explain his delicate touch and his propensity for compositional symmetries that give his sculpture an intensely nostalgic appearance.

The chapel of Our Lady of the Assumption also housed *St Mary Magdalene* in marble, pl. 8 the best work by Cristoforo Stati, another sculptor trained in Florence under Giambologna's influence. The stamp of that great master can be observed throughout the Bracciano artist's work. Mainly statuary groups with mythological or biblical subject-matter, the most famous was *Samson and the Lion* executed in 1607 for the duke of Lerma as a pendant to Giambologna's *Samson and the Philistine*. The Barberini *Magdalene* is depicted seated on a heap of stones meditating on the crucifix. Her bulky forms are softened by the slight torsion of the entire figure including the gently tilted head. The *St Martha* Mochi carved right after 1610 appears far more elaborate. He handled the statue "in a way that presently seems capricious and peculiar, and according to connoisseurs it is the best" (Pascoli). In the narrow space of the recess the Valdarno artist fitted the statue of the youthful saint leaning over and holding the holy water aspergill with which she tames the ferocious dragon perched with its long limbs on the prostrate body of a youth. In this sculptural group Mochi

told an *istoria* that implies (as though in a play) several acts, some of which have already taken place or are about to happen (the dragon killing the youth and then, after the blessing, becoming tame). This was the first time Mochi experimented with story-telling: it would not be long before Gian Lorenzo Bernini systematically adopted it in his famous statuary groups for Scipione Borghese. Inside the chapel Maffeo Barberini also had the idea of putting his parents' portraits next to his uncle's, a tribute to the iconographic ancestor worship that would become especially noticeable during his pontificate. The full-length seated figure of *Francesco Barberini* carved rather awkwardly by Stati was flanked by half-length portraits of *Cosimo Barberini*, lost, and *Camilla Barbadori*, now preserved in the Statens art museum in Copenhagen, for which Gian Lorenzo Bernini was paid in 1619. Still following his father's models, Gian Lorenzo depicted the drapery and veil worn by the noblewoman in widow's weeds with a cool linearity that he would soon surpass. Also following his father's model, he carved the two *putti* on the tympanum of the left door. Comparison of these two cherubs, which possess a nearly feline energy and are marked by a newly incisive line, with the one of the same type that Pietro carved for the door of the Sala Regia in the Quirinale, shows that Gian Lorenzo was gradually breaking away from his father's influence.

Owing to Mario Farnese's protection in Rome, in 1611 Mochi won a prestigious commission that called him to Piacenza for several years. On the city piazza in front of the Palazzo Comunale he was to erect two imposing equestrian monuments that represented respectively Ranuccio Farnese (1569–1622), at the time the reigning duke of Parma and Piacenza, and his father Alessandro (1545–92), the fabled *condottiere* who quelled the rebellion in Flanders. Of course the reference for these colossal bronzes was the equestrian statues Giambologna's pupils executed at the time for the French and Spanish sovereigns: Henri IV's cast by Francavilla for the Pont Neuf in Paris (1604) and Philip III's by Pietro Tacca for Madrid (1611). It was certainly no coincidence that the Farnese commission was given to the sculptor who was the greatest and most up-to-date offshoot of Giambologna's legacy in Italy, not to mention his mastery in bronze casting. The first monument he completed in 1620 was *Ranuccio Farnese*, whom he depicted as a haughty but temperate sovereign attired as the commanding general reviewing his troops. The steed advances solemnly, its solid, massive forms reflecting its derivation from the famous examples Giambologna placed in the piazzas of Florence for the monuments of Cosimo I and Ferdinando I de' Medici. But, typically, a new vitality bows the horse's head and shakes its thick mane, giving the whole group a ceremonial emphasis. The cartouche and scroll decorations adorning the tall marble base recall the late-Mannerist Florentine tradition, whereas the robust *putti* holding the coat-of-arms, with their florid beauty and nonchalant posture, have been associated with a Rubens model.

The equestrian statue of *Alessandro Farnese* seems more idealised but also highly dynamic. Mochi wished to give it the severe frown and awesome energy of the legendary high-strung *condottiere* of the Flanders campaign in the midst of the fray. Each element of the carved group communicates an explosive vitality: the steed's impetuous gait, its wind-tossed flowing mane, the duke's imperious gesture as he tightly grips the reins and staff. This is one of the greatest achievements of seventeenth-century European equestrian portraiture, striving toward a new sublime style in which the ancient model of Marcus Aurelius and the modern one created by Giambologna seem to blend with Rubens' more mobile, emphatic painterly style. Among the most wonderfully innovative parts of the two monuments are the four low-relief stories respectively introduced in the long sides of the two bases. A culture belonging to the great Florentine renaissance tradition of *stiacciato* ("flattening", i.e. the lowest form of relief) from Donatello to Giambologna clearly appears in the *Allegories of Peace and Good Government* on the monument to Ranuccio Farnese. Here the vivid picturesqueness of the low reliefs is given a dramatic tone in the oblique style of the compositions and the impressive architectural forms in the background that frame the animated groups of figures. The greatest achievements were reached in the reliefs of the monument dedicated to Alessandro Farnese where the historical and military stories further illustrate the personality of the "Gran Capitano". In *Alexander Meeting the English Ambassadors* Mochi skilfully reduces the scale of the figures toward the atmospheric background, creating the powerful impression of two approaching hosts of armed men. This striving for a singular atmospheric effect and the grandiose expansion of a space that becomes truly boundless reach their apogee in the *Construction of the Bridge on the Schelde*, where Alessandro—a modern Trajan—is shown pl. 13 giving orders in the field. The accurately topographical reconstruction of the site is in perfect harmony with the epic tone conferred on this grandiose seascape, viewed from above as though through an eyeglass, and over which loom huge billowing clouds.

THE RISE OF GIAN LORENZO BERNINI

The years in which Mochi was away from Rome coincided with the rise of Gian Lorenzo Bernini; the son gradually became so emancipated from his father in his later years that the latter somehow became his son's collaborator, and in a definitely subordinate position. Bernini's first individual production, which can be dated to between 1614 and circa 1618, concentrates mainly on small-scale marble groups with mythological subjects. Working in his father's *bottega* at the time when Pietro was restoring antique statues for Cardinal Scipione Borghese obviously deeply influenced the young artist. The carving of groups in an openly Alexandrian vein began with the *Goat Amalthea with the Infant Jupiter and a Faun* in the Galleria Borghese, where for

a long time it was believed to be an example of Hellenistic-Roman statuary. In this small marble, or in the *Putto Bitten by the Sea Monster* in the Staatliche Museen in Berlin or the *Putto with a Dragon* in the Paul Getty Museum in Los Angeles, one is struck by the inventiveness displayed by Bernini as he blends his knowledge of Alexandrian statuary with inspirations borrowed from the great painting of the time. This inventive experimentalism is combined with a handling of marble that, while following his father's modes, is immediately characterised by a more incisive carving and greater sensibility to the surface texture of certain materials. Pietro Bernini's rather uniform and abstract modelling was transformed by Gian Lorenzo into constant, skilful variations in the surfaces rendered with a strikingly tactile feeling. In the *Faun Teased by Children* today in the Metropolitan Museum of Art in New York, the young Bernini, in the nude grotesque figure reeling backward, tackles a compositional difficulty with complete naturalism and nonchalance in an obvious emulation of some of the playful mythological scenes of Annibale Carracci or the young Rubens. No sculptor before him had been able to render the different quality of the various surfaces so effectively (the smooth firmness, the rough bark of the wood) and Bernini certainly owes this to contemporary painting. In this way the marble bodies that Giambologna, Mochi and Bernini senior designed as though they were contained within shining sheaths, in Gian Lorenzo become as palpitating and differentiated as variously hued bodies in an oil painting. In that sense we notice the reference to an immediate pictorial precedent in the *St Sebastian*, today in the Thyssen-Bornemisza Collection in Madrid, for which Maffeo Barberini paid the Bernini *bottega* in 1617 while it was still directed by Pietro. For the unusual rendering of the martyr with his entirely abandoned body resting against a curved tree trunk, Gian Lorenzo was inspired by Rubens' painting *St Sebastian Cared for by Angels* executed in Italy, which is now in the Galleria Nazionale in Palazzo Corsini in Rome. Even more than an iconographic tribute to Michelangelo, the statue is imbued by a sweet pathos that seems to derive directly from Correggio by way of Rubens.

Meanwhile, Gian Lorenzo was becoming well-known for his first half-length portraits, a genre for which his fame soon spread throughout Europe. The small bust of *Giovanni Battista Santoni* placed in the recess of the tomb in the church of Santa Prassede toward 1615 still recalls his father's training. Despite the legacy of Pietro's teaching in the treatment of the beard and simplified bust, a more ductile, sensitive modelling adds sharpness to the gaze and anxiety to the brow. These qualities are accentuated in the half-length of *Paul V* carved in marble toward 1617 commissioned privately by the pope. Already expressing an extremely naturalistic sensibility, the small bust is crafted with subtle incisions—for instance in the tonsure of the hair and in the beard—that seem to scratch the marble as though it were wax and render with a vibrant sense of colour the figured decorations of the chasuble. As Longhi observed, this small bust can

pl. 16

be compared to the most penetrating drawings in the style of Caravaggio produced in the same period by Ottavio Leoni, an "excellent painter of portraits" (Zuccari). And this affinity may explain the portraitist Bernini's next stage, noticeable after 1620, in his thorough and radical embrace of the characteristics of Caravaggesque painting, whose revolutionary results for the first time were expressed in the three-dimensionality of marble. In this almost scientific study of the human physiognomy, which increasingly interested young Bernini in its physical and psychological aspects, the execution of the two small half-lengths of the *Blessed Soul* and the *Damned Soul* commissioned in 1619 by Pedro Foix de Montoya, currently kept in the Spanish embassy in the Holy See, represents an important phase. The iconographic model for these two allegories of the condition of the soul was very probably the *Quattro novissimi*, the wax sculpture by the Neapolitan painter and sculptor Giovan Bernardino Azzolino, documented in Rome in 1618. Even on a formal level Bernini seems to have wanted to emulate the specific qualities of wax in marble, creating subtle, intense naturalistic effects that had never been attempted before.

In Scipione Borghese's villa on the Pincio, where Pietro Bernini had replaced Cordier as restorer of antique marbles following the latter's death in 1612, Gian Lorenzo created his famous antique-style statuary groups in just a short period. The first, inspired by Virgil's verses in the second book of the *Aeneid* on Aenea's flight from burning Ilion, figures the Trojan hero striding into exile carrying his father Anchises on his back with little Ascanius following in his footsteps. Iconographically the theme had already been treated in 1598 by Federico Barocci in a painting Cardinal Scipione had placed in the very room that was to contain Bernini's sculpture. This is another example of Gian Lorenzo's aspiration to compete with painting and develop the theme in increasingly experimental terms. The arrangement of the figures on top of one another is reminiscent of Giambologna's accomplished models (*Rape of the Sabines*). But unlike the great artist from the Low Countries, Bernini designed his statuary groups against a wall so as to be viewed from a particular angle. In this way he overcame the plurality of points of view envisaged by Mannerist sculpture and, sensitive to contemporary painting, including that of Caravaggio and Rubens, he sought an ideal lighting for his marble groups. From an early age Bernini had preferred free-standing works in his groups of statues, or else single figures, and he avoided low-relief compositions whenever he could. Even in his maturity when he had to carve them he more often than not delegated their execution to his collaborators. His way of crafting marble exalted sculpture's three-dimensional nature, its true prerogative, yet did not express the more specific effects of painting in the relief surface. Of course Bernini's vocation to work in full relief entailed greater difficulties, for instance when creating scenes with mythological or biblical stories composed of several figures, and even containing allegorical meanings in keeping

with the principle of *ut pictura poesis*. Gian Lorenzo overcame this apparently insurmountable obstacle by a few extraordinarily innovative devices that since then have made his mythological groups some of the main attractions of modern Rome.

pl. 19 *Pluto and Proserpina*, for instance, carved in 1622 for Scipione Borghese who then offered it to Cardinal Ludovico Ludovisi, expresses the verses drawn from Ovid's *Metamorphoses* in a monumental plastic group. In Pluto's dashing motion to lift Proserpina, Bernini experiments with the kinetic action of the statue, summing up various moments of the *istoria* as in a snapshot. This representation of the abduction in the midst of the act actually suggests the preceding instant in which the maiden was quietly picking flowers before being seen and desired by Ditis. This prodigious and novel sense of movement is expressed as though the marble were engulfed by a whirlwind, in the spasmodically tensed limbs, the flaming locks that in the swift motion seem to melt into the air, the whirling drapery and even the maiden's tears about to fall from her cheeks. In this work the precedents set by Rubens' painting were decisive, in particular the canvas with *Susanna and the Elders* (ca. 1605) which Bernini could easily have studied in the Borghese collection.

Classical or biblical texts became a challenge for the artist to prove the superiority of sculpture over painting, in particular its ability to illustrate poetic or literary content pl. 18 (*ut sculptura poesis*). Such is the case of *David*, also in the Galleria Borghese, carved in 1623–24. Breaking with the tradition of renaissance sculpture which, from Donatello to Michelangelo, had represented the young biblical hero in an attitude of suspended action before or after the deed, Gian Lorenzo imagines David at the height of his daring feat in the act of flinging the stone at Goliath. In this masterpiece Bernini pulls together the essential lessons he learned during his youth: narrative expressed in a three-dimensional group, the comparison with Hellenistic statuary, the emulation of the great painting of the time, and the physiognomic study of a face reflecting the tremors of the soul. Before confronting his adversary, David has cast aside his cuirass, which now lies at his feet: by creating a sense of time Bernini suggests the action just before the actual flinging of the stone. Observing the hero's face frontally—the preferred position—the observer is led to enter into a mute dialogue with David and even, in an ideal "composite" situation, to take Goliath's place. The youth's pose, entirely off-balance, recalls Annibale Carracci's *Polyphemus* in the Farnese gallery. Examination of the tense face reminds us of Caravaggio's physiognomic experiments, while the typology of the nude, dishevelled youth suggests precedents closer to Guercino and Lanfranco.

At this time of feverish activity Bernini was also working on the last, most elaborate of the Borghese groups, the *Apollo and Daphne*. Inspired iconographically by the

verses of Ovid's *Metamorphoses*, the composition is admirably complex. Following the process initiated with *Pluto and Proserpina*, Bernini conceived the two figures in a sweeping motion that seems to suck everything up as though in a whirlwind: the off-balance bodies of the god and nymph, wind-swept hair, vibrant drapery and tender leaves sprouting from Daphne's fingers. The ancient model evident in the figure of Apollo, inspired by the Belvedere *Apollo*, is given a new detailed treatment in the airily kinetic effect applied to marble for the first time. From this time on, Bernini accentuated his attempt to better antiquity through his use of technical devices never attempted either in the Graeco-Roman or renaissance periods. The superiority of modern sculpture, based partially on this new sense of movement, vitality and a sort of animism of the marble, was the true revolution Bernini brought to statuary. This position was haughtily opposed throughout the artist's life by the custodians of classicist theories for whom sculpture always had to be modelled on the antique, assume composed, balanced postures and be static by definition. Only the most receptive "virtuosi" and more intelligent, broadminded patrons like Maffeo Barberini greeted these attempts with enthusiasm. And it was Gian Lorenzo's good fortune that they were the ones who played a decisive role in the Rome of the 1620s—through Barberini's election to the pontificate—and by their preferences soon raised Bernini above the figurative culture of the day.

The first sculpture on a religious subject that the artist carved for Urban VIII was the *St Bibiana* (1624) in the church of the same name which was then frescoed by two other "Florentine" artists, Pietro da Cortona and Agostino Ciampelli. The heroine of an intrepid, optimistic faith, the youthful saint, of whom precedents are only found in Rubens' painting, is penetrated by the "divine" light falling from the apse window, accurately calculated by Bernini to fall on the niche containing the statue. According to the sources, Giuliano Finelli (ca. 1602–53), a talented young sculptor from Massa who had come to Rome in 1622 after training in Naples in Michelangelo Naccherino's workshop, collaborated on this extraordinary work. It is difficult to estimate Finelli's probably very limited contribution, yet it can be said that he acquired his own unmistakable style from Bernini's masterpieces and always subsequently displayed subtle expert carving of the marble and tight drilling for the hair and draperies. Certainly Finelli, with others including François Duquesnoy, collaborated with Gian Lorenzo in his greatest sculptural and architectural under-taking of the late 1620s, the huge *Baldacchino* for St Peter's. Paul V had formerly thought of erecting a processional canopy supported by four angels over the papal altar in the transept of the basilica and assigned the work to Ambrogio Buonvicino and Camillo Mariani. But Urban VIII's design was far more ambitious. As early as 1623 the plan entailed a gigantic bronze baldachin resembling a ciborium whose mass was to be positioned in the huge space under the vault of Michelangelo's dome.

The colossal commission was the first major building project for which the artist was responsible, meaning he had to coordinate and instruct the many assistants and specialists working on the various techniques involved in his design. The ciborium was conceived as an entirely novel work: despite its colossal structure and huge weight, it was inspired by the light ephemeral form of a processional canopy. To build this ambitious structure, Bernini did not call upon classical or renaissance architectural models, but was inspired by the ornamental motif of the spiral columns that had been in the basilica since Constantine's day and were said to come from Solomon's Temple. The story of the construction is far more complex than this synthesis since the baldachin is an architectural work erected inside the larger architectural work of the basilica. The most radical change Bernini made in the *Baldacchino* project, which mainly concerned the carved part of the monument, occurred in 1633 when for reasons of safety and the structure's static nature the notion of placing the bronze statue of the Saviour over an arched canopy was abandoned. The excessive weight of such an effigy placed right over the papal altar led to the adoption of the present design, which features four large volutes, probably designed by Francesco Borromini, arranged in a tilted position to support the orb surmounted by the Cross. In the upper order the use of materials lighter than bronze—such as brass, wood and papier-mâché—allowed the structure to be lightened substantially. Bernini's first collaborators for the carved decorations were, as of 1624, Stefano Maderno, Giuliano Finelli, Jacopo Antonio Fancelli, François Duquesnoy, and Pietro and Luigi Bernini, respectively the master's father and brother.

It is worthwhile pointing out that for the first time Bernini sought assistants not merely among young pupils—like Finelli—but also recruited them among old, confirmed masters with their own careers, like Maderno. This formula was seen on other occasions, underscoring the unchallenged primacy of Bernini, who was also appointed Architect of the Fabbrica di San Pietro in 1629. The surface of the four bronze columns is entirely faced with delicate laurel branches surrounded by the buzzing bees of the Barberini family, while *putti* clamber about, their faces revealing in turn Maderno's or Finelli's style. Matching the massive columns, in the corners above, Bernini had four larger than life-size angels mounted, holding up brass garlands executed by Andrea Bolgi (1605–56). This sculptor from Carrara had come to Rome in 1627 after first training with Pietro Tacca, with whom he had worked on the *Monument of Ferdinand* in Livorno. His experience in bronze-working, which he owed to his Tuscan apprenticeship, immediately caught Bernini's eye and he was also employed by Gian Lorenzo on subsequent major works. The almost outgoing appearance of these garland-bearing angels—their dynamic pose, the draperies billowing in the breeze that seems to waft at this height—is characteristic of Bolgi's interpretation of Bernini's teachings. The chiselling on the *Baldacchino* proceeded

until 1636 when Bernini had already begun another project for St Peter's, the large piers that support Michelangelo's dome. The fronts of the gigantic piers in the central octagon of the basilica were to be appropriately ornamented by the creation of two niches, one above the other, adorned with statues. By means of this grandiose decoration, Urban VIII was attempting to commemorate the most precious relics conserved in the basilica: the Veronica and the holy lance, the wood from the True Cross and the head of St Andrew the Apostle. The project was begun in 1628 and continued until about 1639, and, aside from the strictly architectural tasks that later brought down so much criticism on Bernini's head, it involved some of the most competent sculptors in the city. The design in the four niches of the lower register of the piers centred on greater than life-size Carrara marble statues representing individuals connected with the stories of the relics, while in the upper register loggias were opened to display the relics, crowned by niches supported by the medieval basilica's spiralled columns. The loggia displaying the holy lance matches the statue of *St Longinus*, the Roman soldier who struck Christ's breast on the Cross and was pl. 20 suddenly converted. The niche of the True Cross is paired with *St Helen*, emperor Constantine's mother who found and unearthed in Jerusalem the fragments of Christ's Cross. Under the loggia containing Christ's sudary is *St Veronica*, the pious pl. 15 woman who wiped Christ's face damp with sweat with the veil upon which His effigy was imprinted. And the statue of *St Andrew* stands in the niche under the loggia of the cross on which the Apostle was martyred.

Bernini kept the execution of *St Longinus* for himself. The lengthy, elaborate evolution of this statue marks a turning point in his production, even influencing the careers of the other sculptors who worked on statues related to the story of the Cross and whose manner until then had been very different to Bernini's. Countless pen and pencil preparatory studies for the statue exist and we know that Gian Lorenzo made at least twenty-two terracotta models for the execution of the giant. Longinus is imagined in the highly dramatic moment of the revelation of the Christian truth: the emphatic gesture of his arms outspread in wonder and the excited, inspired expression on his face emphasise the trance-like state by which the Roman soldier has been seized. The reference to the group of the *Laocoön* is obvious in the head with the beard and tousled locks, while Bernini focuses most of his attention on the large cloak gathered on the hip in a huge tangle of folds. The sculpture is placed on a tall base, which explains the rendering of the entirely gradine surface to make the figure more dynamic and vibrant from a distance. The statue of *St Helen* appears far quieter and more composed, as she raises the Cross and shows the faithful the nails, symbols of the Passion. Bernini designed this figure while also planning the *Monument to Matilda of Canossa* for which Urban VIII had engaged him for St Peter's right aisle. The statue of Countess Matilda, the dauntless champion of the medieval church whom Maffeo

Barberini especially venerated, displays evident similarities with *St Helen*, with the solemnity of the Rubenesque figure, her full, rounded forms swathed in sumptuous draperies. Although Bernini's model, *St Helen* was carved in marble by Bolgi whom the master even allowed to place his own signature on the base next to the date of execution (1639). The compact surfaces of the marble and the "translucid, convex and mellow modelling" (Nava Cellini) reflect Bolgi's manner at the time when Bernini ensured him his greatest esteem and protection.

THE PARALLEL CAREER OF ALESSANDRO ALGARDI

In 1625 the Bolognese sculptor Alessandro Algardi arrived in Rome. After training in his native city he benefited from a short period in Mantua at the court of Ferdinand VI Gonzaga. Algardi, born the same year as Bernini (1598), had received his training in Bologna at a time when the leading artists had moved to Rome drawn by the attraction of the papal patronage. The most regularly active painter in the city was naturally Ludovico Carracci at the head of his academy, while Guido Reni alternated stays in Rome with increasingly extended returns to his home town. Algardi looked at these admirable pictorial works, but also worked with the stucco artist Giulio Conventi who taught him the first rudiments of the craft. His move to Mantua then led him to study, it is believed, in particular the famous white stuccoes in the Palazzo Te modelled by Giulio Romano and Primaticcio a century before and which he would vividly recollect at a later date.

In Rome he was recommended to the powerful Cardinal Ludovico Ludovisi, in whose famous collection of antique statues he undertook to restore several marbles. This was a widespread custom among novice sculptors who in this way could offer a sample of their talents. The Ludovisi *Dice Player* and *Athena* display Algardi's extensive integrations marked by an evident faithfulness to classical models and a subtle vein of melancholy in the heads. This thoughtful respect for antiquity later led Algardi to sculpt *ex novo* antique-style statuary groups, like *Sleep*, conserved in the Galleria Borghese, for which he imagined a black marble *putto* deep in slumber with a symbolic squirrel curled up beside him. Alessandro's first important work was the two stucco statues of *St Mary Magdalene* and *St John the Evangelist* inside niches in the Bandini Chapel in San Silvestro at the Quirinale. His Bologna recollections are still very obvious, not only in the handling of stucco he had learned from Conventi, but above all in his determination to translate into three dimensions several pictorial models by Domenichino who had warmly welcomed him on his arrival in Rome. Domenichino was still the best representative of Annibale Carracci's legacy in Rome under the Ludovisi. His strong charisma attracted sculptors who then became his

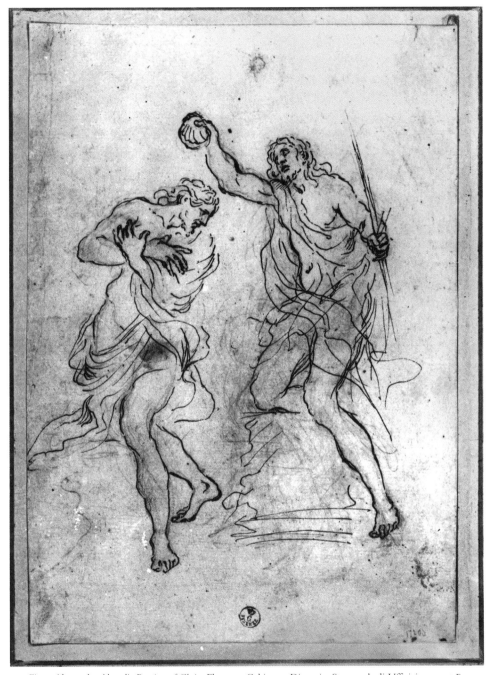

Fig. 1. Alessandro Algardi, *Baptism of Christ*. Florence, Gabinetto Disegni e Stampe degli Uffizi, inv. 17203 F.

chosen collaborators. Among them, the Frenchman Jacques Sarrazin (1588–1660), who was in Rome from 1610, worked regularly as a stuccoer in the building yards where Domenichino painted the frescoes: Villa Aldobrandini near Frascati, San Lorenzo in Miranda and Sant'Andrea della Valle. Sarrazin was a close follower of Zampieri—see the idyllic Alexandrian statues placed in the grottoes in the Teatro delle Acque at Villa Aldobrandini—and when he returned to France with Simon Vouet in 1627 he became the true founder of the classicism that would contribute to making statuary the dominant art form under Louis XIV.

In the Rome of the Barberini where Bernini's primacy in the field of sculpture was always greater, by virtue of his genius Alessandro Algardi was able to find another path that cannot be explained merely by the opposition between baroque and classical. Algardi also successfully displayed his technical abilities in fields where Bernini was not engaged, for instance in the production of bronze sculpture. The Bolognese artist soon established himself in metal carving which, since it could be reproduced, warranted the sculptor a sound, well-deserved fame. His imaginative harmonious inventions were not only displayed in grandiose compositions for churches but shined above all in precious reliquaries and small antique-style bronzes, small silver low reliefs and gorgeous chimney andirons [figs. 1, 2]. One of the first works of this kind to be shown in an important public place was the bronze relief representing *St Ignatius and the Early Saints of the Jesuit Order* for the front of an urn containing the ashes of St Ignatius in the church of Il Gesù in Rome. Algardi's clay model dates from 1629: it presents the procession of Jesuit saints solemnly arrayed, as in a frieze, to form a crown around the founder of the order. It is an airy, rhythmic composition that seems to anticipate one of the most famous reliefs Algardi was soon (1634–35) to undertake

pl. 23 and which adorns Leo XI's marble tomb in St Peter's. This monumental sepulchre was commissioned from the artist by the Florentine Cardinal Roberto Ubaldini, a former legate of Bologna and great-nephew of Alessandro de' Medici who had been Pope Leo XI for a few days in 1605. Algardi was almost obliged to adopt the compositional model of Urban VIII's tomb that Bernini was in the process of erecting in the basilica presbytery. To the polychromy and variety of stone materials and bronze flaunted by Bernini, Algardi opposed the more austere uniformity of white Luni marble, closer to the classicising ideal. The gestures of the three figures are steeped in a solemn, majestic calm unthinkable in Bernini. The impressiveness of the statues of *Leo XI* and *Magnanimity*, derived from the Ludovisi *Athena*, is enhanced by the quiet, serene vitality of *Generosity* holding a cornucopia that was to remain an example for statuary in Rome way past the early eighteenth century. Algardi completed his condensed vision with his customary care for minute details and the chiseller's delicacy concentrated on the low-relief flowering branches on the plinths and spiralling cartouches. One of the most fascinating parts, already mentioned, is the low relief of

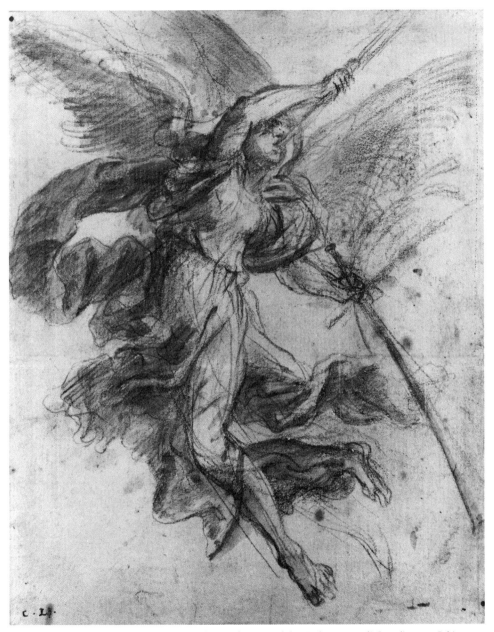

Fig. 2. Alessandro Algardi, *Study for the Personification of Fame in Flight*. Naples, Museo di Capodimonte, Gabinetto Disegni e Stampe, inv. 0200.8.

Alessandro de' Medici's exploits on the front of the great urn as on an antique sarcophagus. The narrative episodes, similar to the low reliefs in the Pauline Chapel in Santa Maria Maggiore, represent two of the most auspicious political events in the history of the Church in the modern age: *Henri IV Abjuring Protestantism* (1593) and

The Peace of Vervins with Spain (1598) that was signed during Leo XI's legation in France. In this way the episodes of the prelate's life become a glorification of the Roman Church at the end of the religious wars that had afflicted France for decades. Algardi's ability to introduce two such complicated stories with so many figures in a single relief is admirable. By a stunning device the two events are separated in the middle by a soldier in rear view opening a curtain onto the great stage of European politics and pontifical diplomacy. At this time Algardi's ability to work in low relief was unmatched in Rome; and as is known, Bernini was not particularly fond of this kind of execution. A vivid sense of atmosphere envelops the two scenes, and inside St Denis, where Henri IV solemnly performs the historical gesture of abjuration, we can nearly see the fumes and smell the perfume of incense.

In 1630 Algardi's renowned skill in competing with the antique ensured him an exceptional Barberini commission, the statue of *Charles Barberini*, Urban VIII's brother who had died that year, in the guise of a Roman *condottiere*, to be placed in the Conservatori Palace. For the statue a Roman bust was reutilised: Algardi integrated it with the legs and arms in the gesture of the *adlocutio* while Bernini carved the head, which he gave an acute sense of portraiture. During the first decade of his Roman sojourn Algardi was sought by illustrious patrons from Emilia or bound to the Ludovisi circle who differed in their choices as much as possible from the Barberini. The Oratorian Virgilio Spada commissioned Algardi to decorate the high altar of San Paolo Maggiore in Bologna with the marble group of the *Beheading of St Paul* that the sculptor carved in Rome. On this occasion too, Algardi worked practically next to Bernini since Gian Lorenzo was responsible for the architectural solution of the semi-circular niche crowning the altar in which Algardi's two statues were placed. The suggestive compositional idea for these two large marble statues—St Paul and his executioner—positioned in dramatic yet quiet isolation, probably derives from Andrea Sacchi's painting of the same subject at Castelgandolfo. Algardi's work during those years appears in utter harmony with the serene neo-Venetian tones and classically simple syntax of Sacchi's painting. The sculptor interprets even the most dramatic subject, the apostle's martyrdom, without asperity or emotional excitement; it is as though the two figures, with their acts, fulfilled a fatal destiny already determined by higher laws. With resignation and a "stoic" tranquillity, Paul seems to await the blow of the sword suspended in space while the executioner does his deed with a stolidly mechanical gesture. The clear, tragic contrast between the soldier's brutish insensibility and the saint's moral elevation is emphasised by the fact that the figures are physically separated from one another, isolated on the upper level of the altar as though on a stage. A thorough knowledge of Hellenistic, especially Pergamene, statuary is reflected in the executioner, in the way of rendering the twisted nude torso and the dishevelled head with its almost satyr-like features. However Algardi's truest, most profound

classicism can be found in the expression of the sublime "sentiments" of the figures, in the restrained pathos, the nobility of the intense sentiments that are never manifested but seem to be raised to a higher rationality. On the base of the front of the lavish altar, Algardi attached a gilt-bronze tondo like a precious stone that also represented the *Beheading of St Paul* (1647). This is one of Algardi's most successful accomplishments in the technique of metal low-relief, in which he produces a pictorial and vibrant mobility. The round form of the composition is reflected by the large curved figures, lithely leaning toward the centre in concentrated gestures. A large leafy tree in neo-Venetian style frames the scene on the right, as though in a painting by Sacchi; and in the background the profiles of the soldiers on horseback in the airy landscape are traced in with a few masterful lines.

In 1635, perhaps again thanks to the Oratorian Vittorio Spada, Algardi earned another prestigious commission, this time offered by Pietro Buoncompagni and relating to the sacristy in Santa Maria in Vallicella. This was a larger than life-size marble group representing *The Apotheosis of St Filippo Neri* for a recess inside the large room attached pl. 22 to the Oratorians' church. Completed in 1640, the marble presents the founder of the Roman Oratory plunged in mystical contemplation, eyes uplifted to heaven and his left hand pointing to the pages of an open book held by an angel kneeling at his feet. On the pages of the book are incised the words of Psalm 118: "VIAM MANDATORUM CUCURRI CUM DILATASTI COR MEUM" ["I HAVE FOLLOWED THE PATH OF YOUR COMMANDMENTS, FOR YOU HAVE SWELLED MY HEART"]. These refer to the swelling of St Filippo's heart, due to the intensity of his faith, which was said to be so great that it broke one of his ribs. Nothing miraculous nor prodigious is shown in the marble group, and the gentle, quiet gestures of the saint's hands suggest a religiosity all the deeper for its lack of display. Truly no artist better than Algardi could have so aptly interpreted the serene mildness and intensely spiritual character of the Oratorian faith. Moreover, the brilliant invention of the figure of the angel with the suave naturalism of its gesture and expression was to become a longstanding reference for seventeenth-century art in Rome. Even almost twenty years after *St Filippo* was completed, Antonio Giorgetti (documented 1657–69), one of Algardi's most faithful followers, presented anew the motif of the angel on one knee in the two figures of the *Angels Holding the* pl. 48 *Sudary* for the baluster of the Spada Chapel in San Girolamo della Carità.

On the strength of Algardi's significant earlier work, in 1646 the new pope Innocent X awarded him his most prestigious commission to date, which was undoubtedly one of the most coveted by the artists in Rome: the altarpiece for one of the altars in St Peter's. The chapel dedicated to St Leo Magno was to be decorated with the representation of the most celebrated event in the life of this fifth-century pope, who ardently defended Rome as the Apostolic See: the *St Leo Repulsing Attila*. The

commission, first given to a painter for a canvas (Cavalier d'Arpino and Lanfranco were unsuccessfully called upon), presented serious compositional difficulties. The outdoor scene was to teem with figures and horses within the narrow space of an altarpiece. The closest iconographic precedent, an unavoidable reference, was the fresco Raphael had painted in the Vatican Stanza di Eliodoro, which thronged with prelates, armigers and horses in a vast space. The different technique for the altarpiece, being produced in marble rather than on canvas, and the choice of Algardi were again the work of Virgilio Spada whose role in the options of the Fabbrica di San Pietro thrived during the Pamphilj pontificate. Thus Algardi was given the task of imbuing new life into the marble altarpiece, a genre hitherto rather disregarded in Rome, and most illustrious precedent of which was Pietro Bernini's *Assumption of the Virgin* in Santa Maria Maggiore. In the small clay model conserved in the Museo Nazionale del Bargello in Florence, Algardi had already planned for all the protagonists of the story to be on foot, with the horses appearing only partially in the background. In the terracotta relief the figures appear on a very small scale as if seen from a great distance, while more space is left for the background over which swirling clouds loom with vividly picturesque effects. In the large terracotta model conserved in the Oratorians' Biblioteca Vallicelliana, Algardi introduced all the variations on the first idea that were to appear in the St Peter's marble carved with the assistance of his pupil Domenico Guidi. The large, more autograph model Spada obtained for the Oratorians offers a more sensitive and skilful modelling, partly lost in the marble due to rather brittle carving. The figures in the foreground are protruding, almost in the round, whereas in the middle ground most of the bystanders stand out only a few centimetres, and in the background the soldiers with their insignia are just superficially incised. This diversified handling of the marble appears to derive from Roman low reliefs and deliberately excludes illusionistic or strongly perspective effects. In this way the story acquires a grandiose epic tone underscored by the expressiveness of the figures and the explicit reference to the grand tradition, including Raphael (for example, the two apostles who descend from heaven brandishing their swords and put the Huns to flight) and the admired Roman imperial marbles (in the soldiers sounding the Roman bugles as on Trajan's Column). The success of this low relief in late seventeenth-century Roman sculpture was immense and it might be claimed that it inspired an entire trend in sculpture—led by the pupils of Algardi, Guidi and Ferrata—that almost became an alternative to Bernini's production.

pl. 10

Algardi's altarpiece for St Peter's favourably impressed the Pamphilj who henceforth turned repeatedly to the Bolognese artist for their commissions. For the 1650 jubilee Alessandro Algardi was assigned to create a large statue of *Innocent X*, seated and blessing, in the Sala degli Orazi e dei Curiazi in the Conservatori Palace. It proved extremely difficult in technical terms due to its size, and because an accident during

casting gave Algardi serious problems. Yet the outcome was excellent and the statue of Pope Pamphilj definitely surpasses the result Bernini had obtained a few years before in the effigy of *Urban VIII* placed in the same room. The flowing, nearly liquid effect of the bronze enhances the cascade of folds in the pope's rippling chasuble that opens under the lavish, impetuously ruffled cope. The delicacy, comparable to a goldsmith's, focuses on the elderly, wrinkled face, the hands which are rendered with an impressive vitality, and the minute ornaments of the cope.

At the time Algardi was also engaged in the decoration of the Casino del Belrespiro in the villa young Cardinal Camillo Pamphilj was building. Here the artist was the foreman of the building site, the restorer of the antiques used for the outdoor decoration, and the crafter of the precious stucco ornaments that alternate with frescoes by Giovan Francesco Grimaldi (1606–80) in the rooms and galleries. In the company of this Bolognese painter, who was a renowned landscapist in Domenichino's wake, Algardi had gone to the Villa Adriana in Tivoli in 1645 to select marbles for the Casino Pamphilj. His familiarity with stuccoes of the imperial period and vivid recollection of those by Raphael and Giulio Romano, which he had known since his years in Mantua, are reflected in the delicate compositions of the Galleria di Ercole. According to a courtly myth the Pamphilj descended from Hercules, so both Grimaldi's frescoes and Algardi's stuccoes celebrate the hero in a light fairy-tale mood suggestive of the antique. For the scene depicting *Hercules at the Crossroads*, for instance, of which a pl. 26 preparatory watercolour exists, the sculptor drew his inspiration from Annibale Carracci's famous painting in the Farnese *camerino*. But the ensemble is rendered with utter simplicity and economy of means as well as a palpitating but tender vitality.

The Pamphilj also had a preference for Algardi as a portraitist. The series of family busts in the Galleria Doria Pamphilj in Rome perfectly illustrates his maturity in this genre. Besides the marble representing *Innocent X* with a concentrated, mild expression unlike the one Bernini gave this pope at the same time, Algardi carved half lengths of *Benedetto Pamphilj* and *Olimpia Maidalchini*. The first is depicted with the countenance of a distinguished young gentleman above a large "ruff", with his shoulders wrapped in the cloak crossed over his breast in a manner Algardi's followers frequently imitated later on. The famous marble portraying *Olimpia Maidalchini*, the pope's influential sister-in-law, brings out the noblewoman's resolute, wilful temperament, even though the artist has not emphasised her expression, nor used artistic devices such as parted lips to make her face "speak".

Alessandro Algardi's last works, largely executed by his pupils because the master was hindered "by his corpulence which greatly slowed him down" (Bellori), were commissioned by Camillo Pamphilj and concerned the decoration of churches and

chapels the prince had built or renovated. Algardi made a terracotta model, now conserved in the Biblioteca Vallicelliana, for the altarpiece of Sant'Agnese in Piazza Navona but this was never carved in marble. The work, the *Miracle of St Agnes*, is marked by a "sublime" style and deep pathos and profoundly influenced his pupils, for example, Ferrata. Also probably intended for the same church in Piazza Navona, as the theme and the presence of the Pamphilj coat-of-arms imply, *St Constantia's Vision of St Agnes* is a small low relief of which there is a bronze version at Santi Vittore e Carlo in Genoa and one in painted plaster in the Museo Nazionale in Palazzo Venezia in Rome. This is one of the most grandiose works from Algardi's mature period: Constantine's sister is shown languidly abandoned on St Agnes's sarcophagus, while the saint, wrapped in clouds, speaks to her in her dream encouraging her to convert. The mobile neo-Venetian pictorial quality is especially apparent in the background enlarged by the foreshortened arch from which hangs the lantern that lights the underground chambers of the cemetery.

pl. 24

For the high altar of the church of San Nicola da Tolentino Algardi designed a large full-relief marble group of *St Nicholas of Tolentino's Vision of the Madonna and Child with Sts Augustine and Monica*. The composition on several levels, entirely executed by Guidi and Ferrata on the master's models, influenced the two artists' further development. In 1652 Cardinal Fabio Chigi, the future Alexander VII, decided to commission Algardi and Bernini with a statue each for his family chapel in Santa Maria del Popolo, thereby increasing the appreciation of the skills of the two greatest sculptors in Rome by this joint commission. However, in 1654 Algardi died prematurely and the execution of both statues inevitably passed to Bernini. This almost emblematic event soon confirmed Bernini's primacy over the sculptural world in Rome in the second half of the seventeenth century. In the decades following Algardi's death his teaching was mainly conveyed by Ferrata and Guidi, notwithstanding the obvious compromises resulting from the dominant influence of Bernini, with whom the two often collaborated.

Ercole Ferrata (1610–86) from Como had a long and complicated career of which the early stages are still unclear. A pupil of the Genoese Tommaso Orsolino for at least seven years, he assisted his master in carving marble groups in Genoa and the Certosa in Pavia. In 1637 Ferrata is documented in Naples where he had moved to work with another great Lombard sculptor, Cosimo Fanzago (1593–1678), who was the most prominent in the capital of the Vice-Kingdom. This experience was of major importance to Ercole as he retained Cosimo's more natural and appealing solutions and rejected the more sophisticated, expressionist ones less suited to his temperament. The sculptures in the San Diego d'Alcalà chapel in Santa Maria Nova in Naples—see *St Thomas Aquinas* and *St Andrew*—are a fine expression of young Ferrata's delicate,

tender, entirely Lombard manner that is also seen in the statue of *St Anthony of Padua* for the facade of the barons de' Nardis' oratory in L'Aquila (1647). From L'Aquila—where, as Filippo Baldinucci recalled, Ferrata lived for several years and left several works in Fanzago's manner—the sculptor went to Rome just before the mid-century jubilee and spent the rest of his life there. Like all the sculptors in Rome at the time, he was engaged by Bernini in the decoration of the nave of St Peter's to execute, on the master's design, low reliefs bearing busts of saints or Doctors of the Church. But this experience did not modify Ferrata's style at a time when he was beginning to follow Algardi's more congenial manner.

A practised plasterer, in 1649 Ferrata also began working with Pietro da Cortona, Algardi's close friend, on the decoration of the dome and interior facade of Santa Maria in Vallicella, where he worked alongside another sculptor with whom Ferrata had a great deal in common, Cosimo Fancelli (1620–88). The latter, after a brief apprenticeship with Bernini, soon entered the circle of Pietro da Cortona who introduced a number of stucco decorations in his work in Florence and Rome in the 1650s. Although Fancelli's presence is not documented in the Sala dei Pianeti in the Pitti Palace, among other projects he assisted his master in the decoration of San Luca e Martina in Rome and in the Chiesa Nuova. On Pietro da Cortona's design, in 1657 Fancelli executed the clay model of the *Trinity* for a low relief, cast in pl. 34 bronze by Giovanni Artusi, commissioned for the Chigi Chapel in Santa Maria della Pace. The variant of this relief, compared to Pietro da Cortona's hasty pencil sketch, reflects the degree of Cosimo's independence. Again probably on Cortona's design, the sculptor carved the low relief with the *Madonna of Savona* for the Gavotti Chapel in San Nicola da Tolentino of which the model, which is far more delicate and detailed than the marble, is kept today in the Museo Nazionale in Palazzo Venezia. Giuliano Finelli also greatly admired Cortona, especially after breaking ties with his first master Bernini at the time of the execution of *St Cecilia* for Santa Maria di pl. 30 Loreto (1632). This statue, which even in its pose is reminiscent of Bernini's *St Bibiana* on which Finelli had collaborated, displays a different sweetness in the features and a solemn mildness in the rhythms that particularly recall several figures Cortona painted in the same church dedicated to the martyr.

At this point it would be appropriate to return to the plastic decoration directed by Pietro da Cortona in the Sale dei Pianeti in the Pitti Palace. Documents suggest it was the work of plasterers who came from Rome in the great Tuscan painter's wake. These stuccoes, largely designed by Pietro da Cortona, are of outstanding quality. Yet the positioning of the figures within the frames differs entirely from the Roman production of the time and even more from Algardi's neo-Raphaelesque, classicising style. The syntactic relationship between the frames, medallions, niches, mascarons and

mythical figures is rather evocative of some French decorative models of Marie de Médici's day, like the chapel in the château at Fontainebleau (1615–25). This observation suggests the Florentine stuccoes should be attributed to the early years of Pierre Puget (1620–94), the great sculptor from Marseille who is recorded to have worked with Pietro da Cortona in the Pitti Palace between 1640 and 1644. It is only necessary to compare the tritons with their malleable, mobile bodies in Jupiter's Room with the two *Telamons* in the Hôtel-de-Ville in Toulon, Puget's first certain work after his return to France (1656), to be sure they are by the same hand. But during that first stay in Rome Puget had occasion to reflect on Algardi's grand statuary, always vividly recalled in his delicate marble chiselling, and on works like the *Apotheosis of St Francis* by Francesco Baratta for the Raimondi Chapel in San Pietro in Montorio. In fact this low relief to be discussed later inspired Puget in one of his masterpieces, the *Assumption of the Virgin* that he carved for Mantua in 1665 (Berlin, Staatliche Museen). Since he obviously was familiar with Bernini's models for the *Cathedra Petri* (St Peter's Throne) under way at the time and that so deeply impressed him, we must assume he returned to Rome toward 1660. The *St Ambrose* Bernini modelled for the Vatican ensemble is vividly echoed in the dramatic figure of the *Blessed Alessandro Sauli* swathed in his whirling cope that Puget carved for Santa Maria Assunta of Carignano again in Genoa (1668). Puget was also influential in disseminating in France these essential components of the Roman style that would guide young French sculptors on their way to Rome at the turn of the century, such as Pierre Legros the Younger and Pierre-Émile Monnot.

<div style="margin-left:2em; font-size:0.8em;">pl. 25</div>

THE NEO-VENETIAN TREND

François Duquesnoy (known in Italy as Francesco Fiammingo), was born in 1597 in Brussels and had already made his way to Italy by 1618. He became the third great sculptor prominent in Rome under the Barberini. We do not know his works before circa 1625, which were mainly ivory and wood carvings that bear testimony to his training in Flanders in the *atelier* of his father Jerome the Elder. In any case the Netherlandish artist's real cultural turning point appears to have come about through his friendship with the young Nicolas Poussin, who came to Rome in 1624 in Giambattista Marino's retinue. The great revelation for the two northern European artists, the experience that influenced them more than any other at this early stage of their careers, was Titian's paintings entitled *Bacchanals* which came to Rome from Ferrara (1598) when they were acquired by the Ludovisi collections. In his biography of Fiammingo, Giovan Pietro Bellori writes that the two artists shared lodgings in Via Paolina. They were enthralled by Titian's warm palette and inspired by his *putti*, and expressed this playful motif in painting, marble and clay. Titian's chromatic

awareness, his dense painting which exudes colour, and the painting of Ferrarese artists like Dosso and Scarsellino were enthusiastically welcomed in the galleries of Roman collectors, as well as being favoured by budding painters like Pietro da Cortona and Andrea Sacchi. Poussin's two *Bacchanals of putti*, which came from the Chigi collection and are now in the Galleria Nazionale d'Arte Antica in Palazzo Barberini, were painted just when Duquesnoy was carving two marble low reliefs of the same subject, described in detail by Bellori, in the Galleria Doria Pamphilj. pl. 27 Duquesnoy's fame began with these "finely-styled *putti*" that stand out with their smooth flesh on a gradine-worked background, and which convey the vibrant, shifting effects of a woodland atmosphere. Poussin and Duquesnoy worked so closely together on these brilliant Titianesque inventions that the extent of their involvement is unclear. At this time Fiammingo also sculpted *Cupid Carving his Bow* (Staatliche Museen, Berlin) which emphasises the touching concentration of the chubby, curly-haired baby, like a sculpted Poussin cherub. In time, while Poussin's painting grew richer in composition and contents, Duquesnoy turned more and more to emulating ancient models, even becoming a reference for Roman sculptors in recalling the "idea of Beauty". The studies he undertook with Poussin on the Belvedere *Antinoös*, a paradigm of classical art, clearly influenced his works such as the small Doria Pamphilj marble *Bacchus* or the *Mercury and Cupid* carved for Vincenzo Giustiniani. This statuary group is the only modern piece to appear in Joachim von Sandrart's folio volume devoted to the *Galleria Giustiniana* (1631) that illustrates the marchese's extraordinary collection of antiques with handsome etchings. The privilege granted to Duquesnoy of displaying his work next to antique sculptures indicates the great esteem he was held in by collectors and connoisseurs. Although *Mercury and Cupid* (see the bronze version in the Prado) was derived from the antique prototype, the softly supple pose of the nude, and the sensual, idyllic mood the artist created in the diagonal relationship between the god and the *putto* illustrate Duquesnoy's subtly modern interpretation in modelling his works.

As Antonia Nava Cellini has explained, around 1630 a change became apparent in the artistic mood in Rome that was to affect Duquesnoy's development deeply. If hitherto the production of artists like Pietro da Cortona, Nicolas Poussin and Andrea Sacchi had by and large proceeded with a certain unity of intent, guided by their shared discovery of Venetian use of colour, henceforth they would increasingly part ways. On Bernini's recommendation, at the end of the 1620s Poussin painted the *Martyrdom of St Erasmus*, which was commissioned by Francesco Barberini for an altar in St Peter's. The composition is vertical and dramatic in atmosphere, a far cry from the Norman painter's pictorial manner in subsequent years. It was in this open mood, receptive to a diversity of solutions, that Duquesnoy created his *St Andrew* for the same Vatican basilica, stirred by an impetus that still echoes Bernini's style. The sculptor's famous

pl. 28 *St Susanna* in Santa Maria di Loreto is utterly different, which, though executed almost contemporaneously, was conceived only slightly later than the giant statue in St Peter's. It is not easy to distinguish the statue from its aura, which was soon promoted by artists and intellectuals who regarded the statue as the utmost expression of the beauty of antique sculptures. Placed composedly in her niche, the saint is represented with a slightly twisted torso that gives the whole figure a solemn yet gentle tone. A great deal of her charm comes from the admirable handling of the drapery, which is soft, smooth and gently furrowed with folds. According to Bellori, with this statue Duquesnoy "left the example of robed statues to modern sculptors". And a few years earlier the sculptor Orfeo Boselli had said the same thing in his manuscript treatise, recalling of *St Susanna* that "there had never been such fine draperies nor such a lovely expression in all time". Boselli (1597–1667), who had been Duquesnoy's pupil and raised in the veneration of antique marbles, was mainly a restorer and the sculptor of only a few of his own statues, like *St Benedict* in Sant'Ambrogio della Massima in Rome. He emulated Duquesnoy's style and maybe even carved using the models proposed by his master. Toward the middle of the century he wrote his *Osservazioni sulla scultura antica* as a handy treatise for artists, in which he based his theoretic approach on the norms learned from the ancients and Duquesnoy as opposed to the experimentalism, excessive naturalism and grandiloquence of modern sculpture. Thus Duquesnoy's work, in the interpretation of these followers and later Bellori's sound and far more ambitious historiographic construction (1672), inevitably became a reference for those who did not want to succumb to the "mistakes" and "licence" of Bernini's new style. Yet this tended to obfuscate the pictorial vividness and tender naturalness of the great Flemish artist's oeuvre and over-simplify the leading trends of seventeenth-century statuary.

pl. 29 The epitaphs dedicated respectively to Adrien Vryburch and Ferdinand van den Eynde placed on two pillars in Santa Maria dell'Anima, the church of the German and Netherlandish communities, were carved between the late 1630s and the end of the 1640s. Regardless of their typological affinities, the two cenotaphs illustrate the remarkable changes in Duquesnoy's artistic vocabulary over just a few years. In the memorial to Uryburch two *putti*, very similar to the Doria Pamphilj *Bacchanal* in their Titianesque inspiration, hold a drapery that displays an inscription and falls gently over a small cylindrical urn. The soberness of the monument, the absence of symbols of the Catholic faith and the austerity of the urn, the one emblem of death, form a contrast with most of the tombs produced in Rome at the time. The lack of references to sacredness or of the *memento mori* that were so frequent in Catholic iconology—and which seems instead to allude to the cult of the "hidden God" worshipped in France—also characterises the memorial later dedicated to Van den Eynde (ca. 1640). In this work the urn is replaced by a small linear-profile sarcophagus, whose edges

are trimmed with a laurel wreath, and recalls the sarcophagus Poussin put in his contemporary canvas *Et in Arcadia ego* in the Louvre. Two funerary genii rendered with a more incisive line and more protruding forms draw aside the veil that covers the long epitaph commemorating the defunct, who was born in Antwerp and died a premature death. The *putto* on the right holding the sand-glass veils his face in mourning with a gesture also seen in some of Poussin's most intensely elegiac paintings. Meanwhile Duquesnoy's fame, just like that of his Norman friend, was growing so widespread in Europe that Louis XIII called him to Paris in his service. The artist intended to accept the sovereign's hospitality in 1643, two years after Poussin's Parisian sojourn, but when embarking on his voyage he died unexpectedly in Livorno.

ASPECTS OF ROME UNDER THE BARBERINI

Soon after 1620 Bernini carved several marble busts depicting living persons, bringing about an authentic revolution in seventeenth-century portraiture. After his brilliant inventions of the previous years still partly reflecting his father's manner, Gian Lorenzo undertook a vigorously naturalistic production. This magnificent series began with the half-length of *Monsignor Pedro Foix de Montoya* which was placed in pl. 17 the Spanish prelate's tomb in San Giacomo degli Spagnoli toward 1622. The realistic characterisation of the hollow, highly intense face is unlike anything else of the period with the exception of certain portraits on canvas by Diego Velasquez who at that time was discovering Caravaggio's great naturalistic work. Perhaps a year before the Montoya bust, Bernini carved the bust of *Giovanni Vigevano* in which the subject appears to be gazing like a hawk from the top of his tomb in Santa Maria sopra Minerva. Pietro Bernini's treatment of soft marble and vaguely impressionistic effects have completely disappeared and been replaced by accurate, incisive carving that creates strong chiaroscuro contrasts and a stunning expressive vitality. Around the same time Bernini sculpted the half-length of *Antonio Cepparelli* for San Giovanni dei Fiorentini. This portrait is impressively life-like with its slightly dilated weary eyes above puffy rings, and its garment reproduced down to the last detail, including the buttons in their squared buttonholes. For these wonderful pieces Bernini had apparently discovered the portraits by the Lombard sculptors active in Rome in the sixteenth and seventeenth centuries, like Ippolito Buzio and Antonio Valsoldo. These sculptors brought the taste for true-to-life effigies to the papal city, this truth also being an essential element of the great Lombard tradition in painting. But it was not until this time that someone revived this quickly-forgotten trend in portraiture (masterful examples can be seen in Valsoldo's half-length depiction of the Bergamese Cardinal *Giovanni Girolamo Albani* in Santa Maria del Popolo, and those of

pl. 5 Clement VIII's relatives by Buzio in the Aldobrandini Chapel in Santa Maria sopra Minerva). The development was brilliantly renovated and raised to a formal genre that swept across Europe.

Bernini's realistic works proceeded with half-length portraits of several prelates, for instance, the Archbishop *Carlo Antonio del Pozzo*, currently in the Edinburgh National Gallery, the Cardinal *Alessandro Peretti Montalto* in the Kunsthalle in Hamburg and the Cardinal *Roberto Bellarmino* (1640) which is in the cenotaph designed by Girolamo Rainaldi for the church of Il Gesù in Rome. In an attitude of perpetual adoration, in keeping with Valsoldo's sculpture of Giovanni Girolamo Albani in Santa Maria del Populo, the Cardinal is shown turned slightly toward the Eucharistic altar with which he forms an authentic "composite" artwork. In 1624 the marble effigy was sculpted for the Conservatori Palace of *Virgilio Cesarini* of the Accademia dei Lincei; during the first years of the Barberini pontificate he was one of the outstanding intellectuals in Rome but he died at an early age. The thin face consumed as though by disease, the highly intense expression, and the softness of the fur shoulder-wrap and hair on the forehead reveal Bernini's hand. Taken as a whole, the work is a fine example of this phase of Bernini's interest in realistic portraiture.

The Cesarini effigy has also been attributed to Duquesnoy, who in the same period certainly sculpted two half-length portraits—those of *Bernardo Guglielmi* in San Lorenzo fuori le Mura and *John Barclay* in the convent of Sant'Onofrio on the Gianicolo—that seem at least in part inspired by different criteria. The decisive connection for these two works seems to be the portraiture by Anton van Dyck, the Netherlandish Duquesnoy's friend and fellow-countryman who arrived in Rome in 1622. Among other works, it was perhaps in that very year that Van Dyck painted an oil portrait (now in Brussels) of Duquesnoy in a rather Hamlet-like attitude holding an antique sculpture of a satyr's head. It is above all the tender, relaxed style of the bust of *John Barclay*, as opposed to Bernini's energetic vitality, that reveals an understanding of Van Dyck's use of colour in the large planes and the malleable, fused rendering of the hair and beard. These characteristics of Duquesnoy become even more evident in the next decade when he carved the half-length sculpture of Cardinal *Maurizio di Savoia* currently in the Galleria Sabauda in Turin. The aristocratic founder of the Accademia dei Desiosi is portrayed with an expression of serene superiority, his head erect on the very elongated bust without creating uneven folds on the mozetta. The fame of this very idealised bust, which almost conflicts with Bernini's work of the time, is recorded by Agostino Tesauro in his *Panegirici* as the "perfect Image that caused to sweat the chisellers of the famous Fiammingo who brought stones to life, and now brings us but solace". The tone of the small marble half-length of the *Dwarf of the Duke of Crequi*, now in the Galleria Nazionale in Palazzo Barberini, is obviously

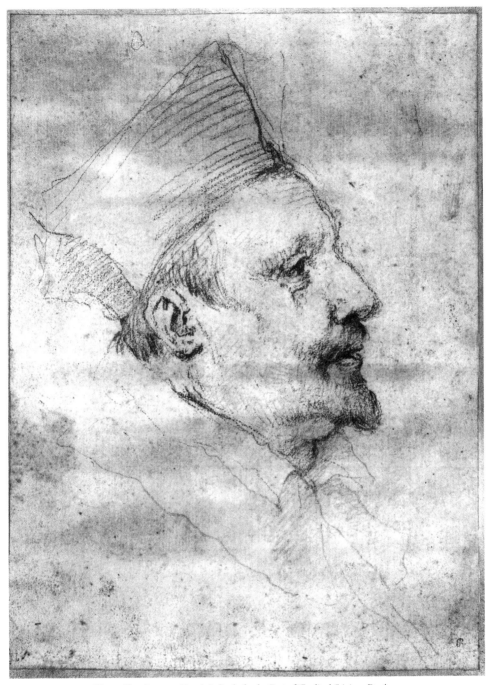

Fig. 3. Gian Lorenzo Bernini, *Study for the Bust of Cardinal Scipione Borghese*.
New York, Pierpont Morgan Library, inv. IV, 176.

burlesque, like several painted portraits of the genre, for example, the Habsburg court jesters immortalised by Velasquez. With the grotesque head and defiant expression under fluffy hair, the half-length seems a parody of an ancient togaed figure and illustrates Duquesnoy's proficiency in making marble look like carved ivory.

Algardi's first half-lengths also date to the 1640s and provide examples of a portraiture indebted to Bernini's adoption of naturalism, but one that soon looked in another direction from the animated vitality and acuteness of spirit Gian Lorenzo sought. The three busts of *Muzio Frangipane* and his sons *Lelio* and *Roberto* were placed in the Frangipane Chapel in San Marcello al Corso. More idealised, the half-lengths of the two men-at-arms seem to recall the heroism of the ancient Roman portraiture of the Republican period. Here Algardi tends to celebrate a solemn, even austere decorum rendered tangible by the martial expression, very short hair and slight, barely visible beard of the hero of Lepanto who displays the insignia of the Order of St Michael. The half-length of Cardinal *Giovanni Garzia Mellini* in the niche of his funerary monument in Santa Maria del Popolo is probably from the same period. The bust of Mellini in perpetual adoration follows the model of Bernini's *Roberto Bellarmino* for the church of Il Gesù, yet it shows the hands in a different manner, one open on the chest indicating contrition, the other holding the prayer book. Despite this expressive vitality Algardi presents the gestures of his figures steeped in calm and concentration, their faces marked by a sense of duration that shies from ephemeral, fleeting expressions. For each effigy Algardi seems to seek the essence, the true, almost eternal and intimate nature of the person portrayed. The marbles with the likenesses of *Urbano Mellini*, also in the aristocratic chapel of Santa Maria del Popolo, *Giovanni Savenier* in Santa Maria dell'Anima and *Edoardo Santarelli* in Santa Maria Maggiore also reflect this strong move away from Bernini.

pl. 21

Just how far Algardi's evolution in portraiture in the course of the 1630s departed from Bernini's manner can be measured by comparing the half-length portraits mentioned above with Gian Lorenzo's work of the same period, especially the *Scipione Borghese* in the Galleria Borghese [fig. 3]—"that is truly alive and breathes", in Fulvio Testi's words—and the *Costanza Bonarelli* in the Museo Nazionale del Bargello in Florence (ca. 1632). Taking advantage of two commissions that might be described as "related" with these two "speaking likenesses", Bernini broke away from the rigid rules of the posed portrait, whether celebratory or naturalistic, to render the figures in their immediate expressive mobility while speaking to an interlocutor who is either the artist himself or the viewer. A dialogue is created, a connection, a new "composite" relationship between the person portrayed and the observer in keeping with a procedure that, as has already been seen, had begun with the *David* in the Galleria Borghese.

pl. 18

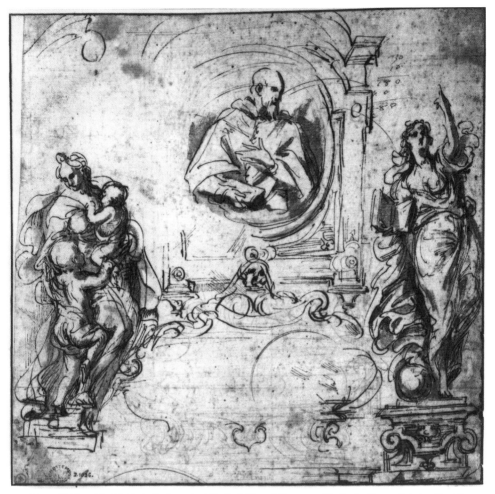

Fig. 4. Giuliano Finelli, *Study for the tomb of Cardinal Ginnasi*. Besançon, Musée des Beaux-Arts, inv. D 1036.

No one understood Bernini's "speaking likenesses" better than Giuliano Finelli, the lessons of which he aptly expressed in several admirably intense and virtuoso half-lengths like the early and rightly famous *Michelangelo Buonarroti as a Young Man* in the Museo di Casa Buonarroti in Florence. In the same period, almost concurrent with Bernini's effigies, Finelli carved the half-length of *Scipione Borghese* (Metropolitan, New York) and *Francesco Bracciolini*, the Pistoia scholar of the Barberini household who had composed the complex iconographic programme for the dome Pietro da Cortona frescoed with the *Allegory of Divine Providence*. The surface naturalism that Finelli drew on from Bernini's works can be seen in the minutely drilled hair and lace, and the softness of the fur lying on the chest.

pl. 31

Most of Bernini's portraits represented his illustrious commissioners with their features and official symbols. That is how the famous bust of *Cardinal Richelieu* should be interpreted, which Mazarin ordered from Paris for his celebrated protector the year before his death (1641). The precise, narrow, cold and impenetrable face, frozen in an expression of haughtiness and laden with political undertones, seems to have lost the liveliness of earlier portraits and to assume the official tone of the state portrait in the age of absolutism. In the image of Richelieu we notice the gradual widening of the bust to include the shoulders and upper part of the arms visible under the hooded cape, so as to bring the entire figure to life and give it movement. Analogous traits can be seen in Bernini's papal and princely half-length portraits produced during the coming decades: for example, *Innocent X* in the Galleria Doria Pamphilj (ca. 1650), *Alexander VII* in the Chigi Zondadari collection in Siena (1657), *Francesco I d'Este* in the Galleria Estense in Modena (1665), and *Louis XIV* in Versailles (1665).

THE "MARAVIGLIOSO COMPOSTO" OF THE ARTS

As Irving Lavin pointed out, Bernini's colossal works in St Peter's deeply influenced the evolution of his art. Most important, Gian Lorenzo conceived of sculpture as being organically connected with architecture, the latter being the stage on which the action of the statues was to be projected, thus achieving the unity of the arts. *St Longinus* with his wonderment, *St Veronica* with her animation, placed in the niches of the piers had been imagined to involve the observer directly, making him participate psychologically as well as aesthetically in the saints' physical gestures and emotively persuasive deeds.

pls. 20, 15

One of the first works in Bernini's production of what the artist himself was to call "il maraviglioso composto"—the "wonderful composition" or fusion of the arts—was the decoration of the Raimondi Chapel in San Pietro in Montorio that he carved between 1640 and 1647. The rich priest Francesco Raimondi planned the chapel to receive his own remains and those of his uncle Girolamo. Placed on the side walls, the tombs are two sarcophagi crowned by recesses out of which loom the figures of the two meditative individuals. *Girolamo* and *Francesco Raimondi*, imagined as though they were kneeling on a prie-dieu, contemplate the miraculous scene taking place behind the altar that represents the *Apotheosis of St Francis* borne to Heaven by angels. The chapel dome frescoed by Guidobaldo Abbatini depicts the *Apotheosis of St Francis* after his ascension. In this way, architecture, sculpture and painting merged for the first time to create in the observer's eyes a highly unified and effectively touching vision. The half-lengths of the two prelates were carved by Bolgi and express the communicative spirit and outgoing, occasionally bantering temperament that Carrarino

pl. 32

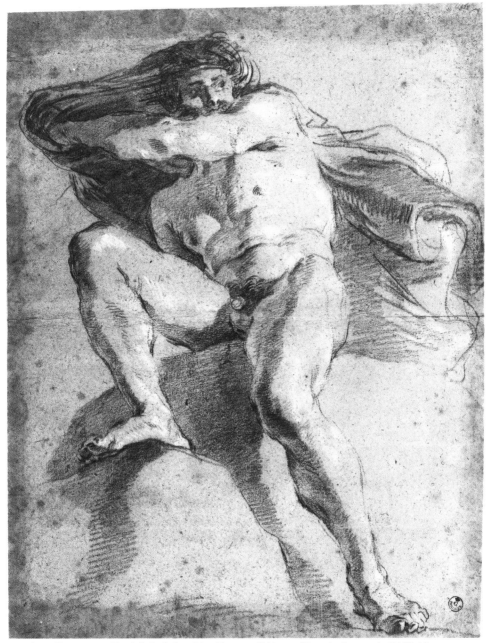

Fig. 5. Gian Lorenzo Bernini, *Study for a River*. Florence, Gabinetto Disegni e Stampe degli Uffizi, inv. 11922.

(as Bolgi was called) conveyed in his portraits. Francesco Baratta (ca. 1600–66), who was also from the Apuan region, was engaged to sculpt the altar low-relief of the *Apotheosis of St Francis*. This is not an actual marble altarpiece like Algardi's because pl. 25 its somewhat receding surface, with respect to the altar, is slightly curved, creating

a greater impression of continuous, plausible spatiality. Furthermore, Bernini opened a window to the left of the altar so as to let natural light fall on the composition, giving it the rare sense of an enveloping atmosphere. Baratta's masterpiece with the different planes on which figures and landscape are arrayed offers effects that seem to emulate the vaguely visionary, mystical painting of contemporary painters like Lanfranco, even heralding several concepts in the manner of Baciccio. The front of Girolamo Rainaldi's sarcophagus—with its low-relief of the *Last Judgement*, subtly suggestive of remoteness—and the delicate rose stems on the base of the tomb show

pl. 23 that Baratta had also studied the *Funerary monument of Leo XI* by Algardi.

In the meantime Urban VIII's death and Giovanni Battista Pamphilj's election as Innocent X (1644–55) temporarily caused Bernini's star to decline since the new pope had a strong aversion to the Barberini and their court. So while at least formally Gian Lorenzo retained the role of leading Architect of the Fabbrica di San Pietro, criticism and malicious accusations were soon raised so that his plans were obstructed in the Vatican. During the short time that he was out of grace at court, Bernini was more assiduously engaged by private patrons who took advantage of the artist's relative freedom. This period, more or less toward the mid-seventeenth century, was one of Bernini's most creative: he may have felt he had to prove even more convincingly the exceptional nature of his talent since it was being unfairly penalised by his adversaries' calumnies. Then, so that he and his heirs would everlastingly recall this wretched situation, Bernini designed a highly elaborate sculptural group that was only partially completed called *Time Discovering Truth Hidden in a Cave*. A pencil drawing in Leipzig shows a first idea for this marble allegory of which the artist only carved the nude *Truth* currently in the Galleria Borghese. The invention was to represent Time, represented using traditional iconography, as a winged old man holding a scythe about to raise the veil to reveal Truth's nude features. It is difficult to say how Bernini would have solved the problem of the flight of the marble statue of Truth and defy the laws of gravity. Perhaps the full-relief figure of *Truth*, with its plump Rubenesque forms, would have borne *Time* aloft in high relief with a solution similar to the one used in the *Apotheosis of St Francis* in the Raimondi Chapel. Undoubtedly the theme of levitation and the resulting challenge to the laws of gravity was one that fascinated Bernini at the time and was strikingly expressed in the Cornaro Chapel in Santa Maria della Vittoria.

The chapel was commissioned in 1647 by the Venetian cardinal residing in Rome, Federico Cornaro, the son of doge Giovanni. Positioned to the left of the high altar in the church of the Discalced Carmelites of Santa Maria della Vittoria, it was dedicated to St Teresa of Avila, the order's founder. In some aspects, in the Cornaro Chapel Bernini carried to extremes several tendencies he had previously tried out in the

Fig. 6. Gian Lorenzo Bernini, *St Joseph with the Sleeping Child*, Ariccia, Palazzo Chigi, Chapel.

Raimondi Chapel. Here too the decoration follows a unified programme involving the altar wall, the two side walls and the dome, blending the various techniques in a structured vision. The free-standing sculpture with the *Ecstasy of St Teresa* is placed pl. 36 in the lavish polychrome altar whose convex tympanum is supported by four twin columns. In this way Bernini replaced the altarpiece, which would have featured a low relief like the one in the Raimondi Chapel, with a sculpture in the round that he always preferred. Behind the tympanum he opened a window hidden to the observer facing the chapel so that the rays of natural light permeate the statue and create the illusion of a mystical heavenly light merging with the artificial rays. Teresa is portrayed in mid-air as the angel plunges the arrow of divine love into her heart. This mystical vision narrated by the saint in her memoirs represents transverberation, a state of total

abandon and spiritual delight that assumes accents of true sensuality. The body of the Spanish saint disappears beneath her flowing cassock, falling in countless folds meant to cancel earthly weight, the matter of which the saint is made. In creating his masterpiece Bernini was once again inspired by the great painting of his time, in this case Lanfranco's canvas with the *Apotheosis of St Marguerite of Cortona* now in the Galleria Palatina in Florence. But what hitherto had been illustrated in a rather abstract way in the two-dimensional image of a painting now took on a new, tangible concreteness that totally absorbs the observer, thus giving credibility to the miracle taking place before his eyes.

During the years he spent working in the Cornaro Chapel, Bernini also performed the feat that would entirely rehabilitate him in the eyes of Innocent X and, more largely, enable him to obtain new commissions at court: the *Fountain of the Four Rivers* in Piazza Navona. Conceived as a gigantic allegory of the Church of Rome and particularly the Pamphilj pontificate diffusing divine Grace throughout the world, the invention of the fountain is in itself utterly fantastic and daringly imaginative. A huge travertine "rock" standing in a vast basin full of fearsome fancies is crowned by the obelisk Innocent X replaced on its original site, Domitian's circus, which today is Piazza Navona. In his later designs for the Louvre and the Palazzo di Montecitorio, Bernini reused the landscape element of the picturesque rock, adapting it with metamorphic imagination to his architectural facades. A marble statue was placed at each corner of the rock to represent the four known principal rivers in the world at that time: the *Nile* for Africa, the *Ganges* for Asia, the *Rio de la Plata* for the Americas, and the *Danube* for Europe [fig. 5]. Very few classical attributes of river iconography can be seen in these colossal figures for which Bernini instead appears to have used the repertory of male nudes Annibale Carracci conceived for the Galleria Farnese. The peculiar typologies of the Rivers (like the figure of the *Rio de la Plata* with his negroid physiognomy), the emphatic attitudes (like the *Nile* veiling his eyes), the apparently unstable positions (see the *Danube* poised with arms outspread), combined with the animals and plants hidden in the water and among the rocks, make the fountain a constantly shifting spectacle depending on where the observer is standing.

Bernini's new position at court was consolidated in 1655 when Monsignor Fabio Chigi, who had already wanted him to work in the family chapel in Santa Maria del Popolo, became Pope Alexander VII. The ideas of the new pope, who was Bernini's age and also bound to the Barberini family, so agreed with Bernini's that the artist once again took centre stage in the artistic world of "modern" Rome [figs. 6, 7]. In these fifteen years, between 1655 and ca. 1670, Bernini fully carried out his notion of the "*maraviglioso composto* of the arts", conceiving sculpture as more and more organically connected with architecture. It was in Santa Maria del Popolo that the

Fig. 7. Gian Lorenzo Bernini, *St Ursula*. Leipzig Museum der Bildenden Künste, inv. 7917.

sculptor had the opportunity to initiate this successful period with the decoration of the Chigi Chapel and the nave and transept of the Augustinian church. In Agostino Chigi's mausoleum-chapel Bernini placed the statues of *Daniel* and *Habbakuk and the* pl. 37 *Angel* in the niches Raphael had designed, in a space that appears too small to hold the two dynamic marble groups with their closely-connected iconographies.

The grandiose dramatic anxiety stirring the two prophets in Santa Maria del Popolo was just an anticipation of the extraordinary ideas the artist was to carry out in his titanic execution of the *Cathedra Petri* in St Peter's. Begun in 1657 and completed ten years later, the altar containing the relics of St Peter's throne gradually extended its dimensions and complexity until it achieved a truly unrivalled magnificence. In terms of *bel composto* the *Cathedra* should be considered Bernini's greatest work. Indeed the various techniques and materials aim toward a unitary end, that of a spectacular, prestigious apparition wherein traditional boundaries between architecture, sculpture and painting entirely disappear in a new organic unity. The four bronze Doctors of the Church (see *St Augustine and St Atanasio*), with their pathos-filled expressions pl. 38 and impetuous gestures, provide another reference to Rubens' great painting, while the *Glory of Paradise* in gilt stucco, bronze and glass is the crowning of figurative

experiments on the theme of heavenly apparitions and boundless space that had interested Italian artists since Correggio.

For Bernini the Chigi pontificate was like a new, happy and more mature Barberini era. Several aspects seemed to bloom once more, beginning with his lasting credibility with the court's literati, poets and intellectuals, many of whom had been young in the days of Urban VIII and become recognised men of culture. Pietro Sforza Pallavicino (1607–67), Gian Lorenzo's Jesuit friend whom Alexander VII had raised to the dignity of cardinal, was the most determined and enlightened supporter of Bernini's art [fig. 8]. He admired the sculptor's great capacity, using artifice, to make lifelike and visually acceptable what in ordinary experience is not so, as he theorised in his treatise on aesthetics *Del Bene* (1644). And in 1661, under Alexander VII's aegis, the most important text specifically devoted to the sculpture of the whole century

Fig. 8. Gian Lorenzo Bernini, *Portrait of Cardinal Pietro Sforza Pallavicino*. New Haven (Conn.), Yale University Art Gallery, inv. N.1961.61.36.

was published: *Delle statue* by Giovan Andrea Borboni. Despite its rather muddled style, Borboni's treatise is far removed from Boselli's and Bellori's views and gives a very balanced picture of the relationship between ancient and modern sculptors. Although he venerated the ancients, the writer firmly believed the moderns have "matched and even surpassed their forebears in art". Borboni even looked at antique statues with the awareness of someone who has before his eyes the products of modern statuary and expressed purely formal comments, as if he were looking at Bernini's "polymaterial" sculpture.

The combination of sculpture and architecture characteristic of Bernini's mature production was also expressed in the decoration on the crown of the colonnade erected for Alexander VII by Bernini in the space in front of the basilica during the same years he was working on the *Cathedra* (1656–67). For the dozens of travertine saints arrayed on the crown of the "great Vatican theatre", Gian Lorenzo prepared a rough sketch that his large group of pupils first modelled in clay and then carved in

stone. This was a real training-ground for young sculptors, most of whom belonged to the second generation of Bernini's pupils or followers active in Rome in the second half of the seventeenth century and beyond. Visible even from afar with their persuasive gestures and ecstatic expressions, this throng of statues spreading a popular, ardent, optimistic faith from the gigantic arms of the *Colonnato* is also a symbol of a Church at a time when it was striving to become more universal and ecumenical. In this way the statues of saints that in the days of Maderno in the early seventeenth century shyly began to lean out of the niches on the facades of churches, with Bernini even peopled the external crowns, as we see for instance on the front of the twin churches—Santa Maria di Montesano and Santa Maria dei Miracoli—in Piazza del Popolo, both commissioned by Alexander VII.

THE METEOR OF MELCHIORRE CAFFÀ

"Bernini had been told a number of times that a young Maltese would surpass him one day in his craft". This sentence in a letter sent in 1665 from Rome to the Grand Master of the Order of Malta is telling of the admiration aroused by the extraordinary talent of Melchiorre Caffà (1638–67), the Maltese sculptor who came to Rome toward 1660 and died seven years later at the early age of twenty-nine. According to Pascoli, the fervid imagination and the "living fire" of the artist inspired him to work especially in clay "because he wanted to finish it off in no time", whereas the slow carving of marble was probably made insufferable to him by his creative frenzy. Confirming the biographer's words, we have a fair number of Caffà's terracotta models and even some drawings—unusual for a seventeenth-century sculptor, aside from Bernini and Algardi—but very few marble pieces. In Rome Caffà attended Ercole Ferrata's very popular *bottega*, setting up with him an unusual relationship in which the pupil was in no way the master's subordinate. In fact Ferrata, who, according to the sources, lacked imagination and was a poor draughtsman, often produced in marble the Maltese artist's brilliant *concetti*. Then, when Caffà died, he inherited all his unfinished commissions and completed them. On the other hand Caffà had learned from his master the special softness of tone that Ferrata had inherited from his Lombard origin and which the passionate Mediterranean Caffà made languidly tender, and he also acquired the rare ability to interpret a most intense, profound religiosity, though not in a style comparable to Bernini's sense of drama.

One of Caffà's most important commissions was offered him by Camillo Pamphilj for the marble altarpiece with the *Martyrdom of St Eustace* in Sant'Agnese in Agone. The clay model for this complex composition, very unlike the frigid marble execution by Ferrata's workshop, reflects Algardi's influence in positioning figures on several levels

and the admirable use of suggestive atmospheric effects to connect heaven and earth. Each single figure was executed separately, sometimes in the round and in several versions, like the miraculously gentle lions crouching like big cats at Eustace's feet. Compared to contemporary sculptors' figures, the ones Caffà modelled always have a slender, slight anatomy occasionally bent in supple poses, with small heads and inspired expressions. These stylistic effects signal a real change in Roman sculpture, usually characterised by solid, monumental forms derived from Bernini, and were to have significant repercussions up to the early eighteenth century. Nonetheless, the dialogue with Bernini was equally very beneficial to Caffà, who in particular drew

pl. 45 from the great master ideas for his masterpiece, the *Apotheosis of St Catherine of Siena*, for the church of Santa Caterina a Magnanapoli. The altarpiece composition presents entirely original technical solutions, its only precedent being the reliefs Bernini placed in the four loggias that hold the relics in St Peter's crossing. The saint swathed in the flowing folds of her habit, frail and suffering like a Dominican Teresa, rises amidst the clouds toward a heaven resembling a mystical vision, all gold and flames, achieved with the illusionistic veins of the coloured marbles. Beside the saint a circle of white marble cherubs looms out of the ethereal clouds modelled in stucco in a device recalling, albeit in lighter tones, the effects of the *Glory of Paradise* in the *Cathedra Petri*.

A sensibility steeped in intensely Mediterranean stimuli, bred under the influence of Caravaggio at his greatest and most tragic, as in the *Beheading of St John the Baptist* at Valletta, inspired Caffà to interpret the sublimity of Spanish mysticism in two other

pl. 46 famous sculptural groups. The first is the *Charity of St Thomas of Villanova* for the Pamphilj altar in the Roman church of Sant'Agostino, whose autograph clay model is kept in the Museum of Valletta. The second is the *Apotheosis of St Rose of Lima* carved in Rome for the church of San Domingo in the Peruvian capital. It bears the date 1669, two years after Caffà's death [fig. 9]. The composition of the *Charity of St Thomas of Villanova* displays a very daring invention with the full-relief figures of the alms-giving saint and the woman on two different levels as though they were at the entrance portal of a palace. Caffà portrays the saint-bishop of Valencia frail and wavering like one of Zurbaran's priests, entirely "wrapped in the flowing, vibrant motion of the drapery". With this figure the Maltese artist created a new ideal iconography of sanctity in sculpture, unlike Bernini's heroic view, in "this sincere and unrhetorical intimacy", in "the soft face full of mild unction" (Nava Cellini). In the Malta model, quite different from the final execution despite being autograph, the animated group of children begging at the mother's feet is far more elaborate and seems to anticipate the ragged, doleful urchins that later appeared in Serpotta's stuccoes.

Caffà was equally inspired by Bernini's *St Teresa* for the *Apotheosis of St Rose of Lima*. But his reworking was so great and innovative that it was even used as a reference by

Fig. 9. Melchiorre Caffà, *The Virgin with St Rose of Lima*. Paris, Musée du Louvre, Cabinet des Dessins inv. 9599.

Bernini when he carved the *Vision of the Blessed Ludovica Albertoni* (1671–74) for the pl. 40
Altieri Chapel in San Francesco a Ripa. St Rose, with her adolescent features, still
belongs to this vital, tender humanity of Spanish mysticism that Caffà so aptly

expressed. In all probability, as has been suggested, in conceiving this group in which the angel lifts the crown of thorns and the habit to bring the prostrate, lifeless Dominican back to life, Caffà remembered Caravaggio's painting with the *Apotheosis of St Francis* now in Hartford. And has been seen, naturalistic models, albeit reinterpreted in a "visionary" sense, continued to be fundamental references for both Caffà and Bernini. The *Glory of the Image of St Mary in Portico* overlooking the high altar in Santa Maria in Campitelli, again completed by Ferrata and Johann Paul Schor, is also one of the Maltese artist's inventions. Again the theme of angelic glory is derived from the *Cathedra* but in a lighter, airier version, influenced by the ephemeral effects contrived for the Forty Hours Adoration. Looking at these last designs by Caffà, we notice effects similar to those of the most experimental painter in Rome at the time, Baciccio (as Giovan Battista Gaulli was known), Caffà's close friend. The young sculptor's growing fame induced Alexander VII, undoubtedly the most illustrious connoisseur of modern statuary, to have him carve his impressively true-to-life clay effigy with its hollow yet highly mobile face, now conserved in Palazzo Chigi at Ariccia, a few months before his death. Later this thin model—the quality of which can compete with Bernini's half-length busts—was cast in bronze (its two copies are in the Siena Duomo and the Metropolitan Museum in New York) causing regret that Caffà did not work in this genre more often. When the young Maltese sculptor died that same year, Bernini no longer had to fear being ousted from his supremacy, but sculpture in Rome had lost a leading character who might have guided it toward new horizons.

pl. 47

MASTERS AND PUPILS

To celebrate the 1650 jubilee, commissions for impressive carved decorations were assigned to Bernini and Algardi for the naves respectively of the most important Roman basilicas, St Peter's and San Giovanni in Laterano. Since the works had to be completed in a very short time, the two artists recruited a number of collaborators, those "youths" who made their first massive appearance on this occasion. The term "youth" was used to refer to a sculptor who worked with an established master as pupil or apprentice, but also to a mature sculptor who was still working in a subordinate position with an artist-contractor who ensured him work and provided the design for the overall decoration. These assistants had the task of translating the master's model into marble, stucco or bronze, occasionally giving it a special tone, the mark of their own personality. The two jubilee celebratory works—especially the one of the medallion-bearing *putti* for the nave of St Peter's—do not reflect considerable differences due to the haste with which they were executed and share a kind of homogeneous *koine*. For the evangelical and biblical stories in the nave of the Lateran basilica, Algardi's collaborator was the artist from Como, Antonio Raggi (1624–86,

known as "Lombardo"), who would soon attract notice as the most brilliant of the "youths". Despite this first contact with the Bolognese master, Raggi soon became a protégé of Bernini's and in 1647 carved the marble group *Noli me tangere* on his model pl. 43 for the church of Santi Domenico e Sisto. A blast of fitful energy appears to seize these two stupendous, vivacious, elongated figures whose draperies form the shifting ridges that would become characteristic of Raggi's style. From then on Bernini used Lombardo almost systematically, beginning with the *Four Rivers* fountain, and in 1652 he recommended him to the duke of Modena as the most gifted of all the young sculptors in Rome. In Bernini's *bottega* Raggi won a certain freedom that allowed him to design several decorative sections alongside the master, as he did in Santa Maria del Popolo in the 1650s. The work in this church continued at a slow, thoughtful pace under Alexander VII's attentive eye. The stylistic variations between the "youths" are evident in the stucco saints placed on the arches of the nave and the frame-bearing angels of the two altars. After Algardi's death Ferrata had also gone to work with Bernini and the two Lombards were the best examples of the two different spirits in Bernini's new studio. The *Sts Catherine and Barbara* modelled by Raggi, for instance, displays "an emotional intensity" (Westin) that is a far cry from the plastic solidity and tranquil gestures of the *Sts Claire and Scholastica* Ferrata executed in plaster.

Few of Bernini's assistants were able to express their own personality in these collective work-yards like the two Lombards. In this kind of fragmented work (that Judith Montagu has referred to as "the industry of art") where the great master's mark prevailed, most of the youths ended up by losing their own figurative identity. And Bernini tended to prefer sculptors like Giulio Cartari (documented in Rome from 1655 to 1691) who, with their less affirmed personalities, were more docile to his directions. Even a talented sculptor like Lazzaro Morelli (1619–90) who prepared the models for the *Cathedra* and carved at least forty-six statues for the *Colonnato* never really broke free. Others, like Paolo Naldini (1614–91), only temporarily collaborated with the master for the opportunity to work but retained their independence. Naldini had trained with Andrea Sacchi and in his mature years, after working assiduously in Bernini's yards, his friendship with Carlo Maratti allowed him to refresh his most authentic classicist vein in the busts of *Raphael* and *Annibale Carracci* carved for the Pantheon on Giovan Pietro Bellori's commission.

Raggi's great versatility as a plasterer led Bernini to engage him for the decoration in the churches he had built in the days of Alexander VII, San Tommaso da Villanova at Castelgandolfo and Sant'Andrea at the Quirinale. The convulsed agitation of his twisted angels and the dramatic apparitions of God the Father and of St Andrew over the tympani of the altars are the highest expression of Bernini's teaching carried out with the utmost originality.

Raggi also worked with Baciccio decorating the dome of Il Gesù commissioned by Giovan Paolo Oliva, Bernini's friend and confidant. To execute the lovely allegorical stucco figures, Raggi worked from Gaulli's designs, but the unmistakable traits of his style prove the degree of independence he had gained. Besides, in Il Gesù the admirable blending of frescoes and stucco in a lavish illusionistic decoration was closely bound to the *Cathedra*'s "*bel composto*" in which Raggi had personally taken part. In the vault, Baciccio's groups of figures hovering in mid-air are the amplified pictorial expression of some of the *Cathedra*'s plastic solutions, while the presence of Raggi's white stucco angels reflects the continuity of the yards inspired by Bernini. Raggi was also the author of several important altarpieces such as the *Death of St Cecilia* in

pl. 44 Sant'Agnese in Agone and the *Angel Announcing the Flight into Egypt to St Joseph* in the Ginetti Chapel in Sant'Andrea della Valle. The principal figures in this intense, highly elegant composition, stirring the sharp folds of their draperies, stand out against the background as though carved in the round. The similarities between the impressive statue of Cardinal *Marzio Ginetti* kneeling in prayer in the same chapel and some of the most intense portraits from Bernini's circle, whose authors are for the moment unknown, lead us to suggest Raggi's name for these works as well. For example, the beautiful half-length image of *Bernardino Naro* (died 1671) in Santa Maria sopra Minerva: the feverish physiognomy and electric hair even led Nava Cellini to advance Bernini's name. There is also the half-length of Cardinal *Fausto Poli* in San Crisogono in Trastevere: even if it was carved from "a drawing by Bernini" (Titi), the large splintered folds on the mozzetta, the curly hair plunged into shadow, and the expressive torsion of the torso are suggestive of Lombardo's execution, as Andrea Bacchi has pointed out. Raggi displayed this intense way of treating drapery in the *Angel Carrying the Column*, part of the series of the *Angels with the Symbols of the Passion* for the Ponte Sant'Angelo executed by Bernini and his pupils for Pope Clement IX just prior to 1670. As Montagu rightly pointed out, perhaps more than other Bernini commissions the angels for the bridge illustrate the variations in style deriving from the youths' different personalities. Ferrata's and Fancelli's angels are steeped in a quiet, gentle classicism openly contrasting with the "fire" of those by Raggi and with Cartari's faithfulness to Bernini's model. This lively polyphony is still ruled by the work of the old master who in his *Angel with the Crown of Thorns* and *Angel with the Superscription* seems in turn sensitive to Baciccio's vigorous painterly qualities.

As regards Algardi's pupils, Domenico Guidi (1627–1701), who was born in Massa Carrara and was Finelli's nephew, had been one of the master's closest assistants. The only one of the great sculptors along with Mochi to be an expert caster as well, Guidi was particularly skilled in working in bronze, executing for Algardi one of the andirons for Philip IV of Spain. It was to Algardi that he owed his proficiency in portraiture, which was expressed, for instance, in the half-length study of *Natale*

Rondanini in Santa Maria del Popolo, in those of Rondanini's parents, *Alessandro Rondanini* in the Zeri collection at the Accademia Carrara in Bergamo, and of *Felice Zacchia Rondanini* in the Galleria Borghese. The latter already displays the rather pl. 50 heavy realism found in the portraits of the sculptor's mature period. From the 1660s, when Guidi carved the vigorous *Charity* for the *Falconieri Monument* in San Giovanni dei Fiorentini, the sculptor adopted a formal classicism that became very popular even outside Rome and Italy. The rather noble, rhetorical tone of Guidi's funer-ary production can be seen in the *Monument of Cardinal Lorenzo Imperiali* in Sant'Agostino in Rome with its grandiose theatrical effects (1674). Algardi's distinguished heir, Guidi created large low-relief compositions for altarpieces like the *Pietà* in the Monte di Pietà and the *Holy Family* in Sant'Agnese in Agone, but the heightened emotions he pl. 49 represented may seem slightly weakened by the thronged figures in declamatory attitudes in a background that lacks a true sense of depth. Guidi's severe classicism could not but appeal to the court of Louis XIV where the presence of his works, like *Fame writing the History of Louis XIV* for Versailles, influenced the training of French sculptors in Rome at the time, in particular Jean-Baptiste Théodon. In the definitely Francophile mood influencing late seventeenth-century Rome, Domenico Guidi also executed the large marble statue of *Louis XIV* as a *condottiere* in a heroic attitude (1697), now at the Villa Medici. The artist's last major marble group was the *Dream of St Joseph* in Santa Maria della Vittoria where the angel's intense animation is emphasised by draperies characterised by sharp creases.

One of Algardi's most important pupils was Ercole Ferrata, who has already been mentioned as a key figure in Roman statuary. Although close to Bernini, Ferrata remained faithful to his first master's classicism which he interpreted with a nat-uralism and a tenderness that differed entirely from Guidi's austerity. Consider the delicate harmony of the sweetly modelled figures in the low-relief *Martyrdom of St Emerenziana* in Sant'Agnese in Agone. *St Agnes at the Stake*, again on an altar of the church patronised by the Pamphilj, is one of the most fascinating seventeenth-century marble sculptures in Rome, with its ideal recollection of some of Domenichino's female figures, yet it is placed in an illusionistic architectural context and given a melodramatic atmosphere. *Faith*, which Ferrata carved for the *Tomb of Cardinal Lelio* pl. 41 *Falconieri* in San Giovanni dei Fiorentini, was the result of a lengthy meditation reflected in the four clay models prepared for this project. Solemn yet delicately featured, the allegory, swathed in an ample ancient-style garment, holds up the effigy of the dead Cardinal inscribed in a medallion with the help of a cherub, in keeping with a funerary typology that would evolve up to the neo-Classical era. Ferrata was an excellent portraitist as well and even in his mature years his marble half-lengths reflected the amiable delicacy in the handling of marble and the formal balance that were the most lasting effects of his training with Algardi. His most famous busts, those

of *Gualtiero Gualtieri* in Santa Maria dell'Anima and *Ottavio Acciaioli* in San Giovanni
pl. 42 dei Fiorentini (ca. 1659), are comparable to the *Bust of a Youth* that Andrea Bacchi
opportunely attributed to Ferrata and that might be the "portrait of Marchese
Centurioni" mentioned at the time of the artist's death among the many sculptures
left in his famous workshop.

Ferrata's main role was to run the *bottega* as master for a whole generation of
sculptors. Brilliant pupils converged in his workshop from various cities and regions,
like the Roman Filippo Carcani (1644–88), the Lombards Francesco Aprile
(mentioned 1670–85) and Camillo Rusconi (1658–1728), Michel Maille known as
Borgognone (documented in Rome between 1668 and 1703), the Sienese Giuseppe
Mazzuoli (1644–1725) and Pietro Balestra (documented in Rome between 1675 and
1729), and of course Melchiorre Caffà. But maestro Ercole mainly exercised his
institutional role on the Florentine sculptors Cosimo III sent him, following the
French example with study bursaries at the Accademia di Villa Medici where Ciro
Ferri taught painting and Ferrata Roman sculpture. In emulation of Lombardo,
Giovanni Battista Foggini, Massimiliano Soldani Benzi and Carlo Marcellini imported
to Florence this Roman "heroic manner" that permanently supplanted the late-
Mannerist culture practised by Giambologna's followers, such as Gianfrancesco Susini
and Ferdinando Tacca. The fact that Ferrata's pupils took this style of carving home
with them after their training in Rome allowed the master's teachings (with their
moderate Bernini influence) to become widely diffused in many parts of Italy.

During the 1670s several youths like Mazzuoli and Balestra worked alongside older
sculptors under Bernini's direction in the execution of the most imposing funerary
monument the artist ever conceived, that of Alexander VII in St Peter's. For this
last undertaking Bernini carried out a highly evocative and theatrical idea for a
"repository" that had long tempted him. Bernini conceived and carefully directed the
work, dividing the labour perfectly between the youths in the yard—a real "proletariat
of sculptors" (Montagu)—who could be interchanged even in the middle of a task
without the artwork suffering major changes.

Giuseppe Mazzuoli had the privilege of being introduced to Caffà by Ferrata and
becoming his sole pupil. Mazzuoli's finest works, like the early relief with the
Dead Christ in the frontal of the high altar of the church of the Annunziata in Siena
pl. 58 (ca. 1670) or the later group with the *Angels carrying the Eucharistic Tabernacle to Heaven*
in San Martino in Siena (1700) with a recollection of Baciccio's flights of angels, were
truly brilliant inventions bearing the stamp of Caffà's genius. Mazzuoli soon became
a true master himself, creating his own studio and working from his own inventions
recorded, as Caffà had done, in a great number of drawings that have been conserved

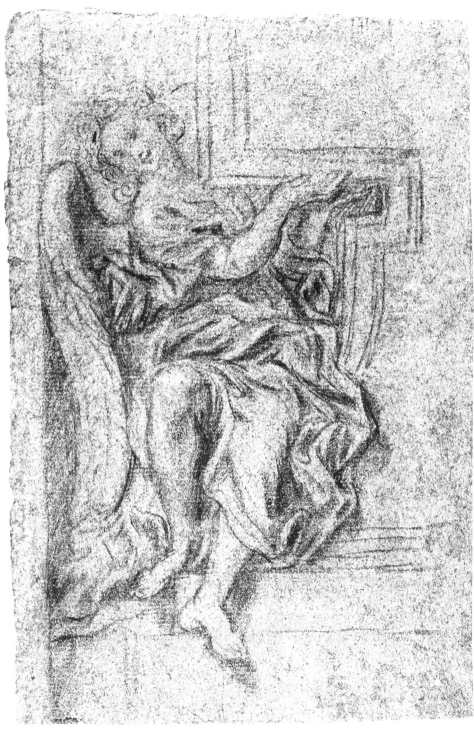

Fig. 10. Giuseppe Mazzuoli, *Study for an Angel holding a Frame*, Siena,
Biblioteca comunale degli Intronati, inv. 15.I.E, c. 21.

[fig. 10]. This role as master enabled him to be appointed to direct the Villa Medici Accademia when Ferrata died, to instruct the young Tuscan sculptors Cosimo III had sent to Rome.

After Bernini's death, the decoration of the interior of the Nome di Gesù e Maria in the Corso (1681–86) was sponsored by Cardinal Giorgio Bolognetti, who turned it into a family mausoleum. Here Ferrata's pupils offered evidence that sculpture was perhaps entering the most significant period of late Roman Baroque in terms pl. 54 of unity. The busts of *Pietro* and *Francesco Bolognetti* carved by Francesco Aprile or of *Ercole* and *Luigi Bolognetti* by Lorenzo Ottoni lean out of the tombs as though out of a theatre box. Compared to the work of Bernini, their acute sense of portraiture stresses lively gesturing and formal restraint. The spectral, mystical emotiveness of one pl. 39 of Gian Lorenzo's last busts, *Gabriele Fonseca* in San Lorenzo in Lucina (ca. 1668), yields here to a more serene reflection on death on behalf of the Bolognetti even if they are portrayed in intensely stirring, live moments. Francesco Cavallini from Massa (documented in Rome from 1672 to 1692) created the pendant tombs of *Monsignor Giorgio Bolognetti* and his brother *Cavaliere Mario Bolognetti*, a man-at-arms in a declamatory pose defined with the rather emphatic features that appear at the same time in Lorenzo Ottoni's portraits. The sculptors skilfully fitted their marble or stucco statues inside Carlo Rainaldi's ribbing. In this way Mazzuoli executed the two figures of *St John the Baptist* and *St John the Evangelist* arrayed around the altar, which were derived from Bernini's style tempered by Ferrata. And Maille's unaffected stucco *King David with the Harp* on the entrance wall seems to make way for rocaille formal synthesis and grace.

As a final remark on Ferrata's collaborators, mention should be made of Francesco Aprile's inventiveness. A rare yet intense sculptor, one of his major works is the pl. 51 *St Anastasia* later completed by Ercole Ferrata in the homonymous Roman church. Set in the horizontal space of the altar, the gentle maiden reclining in a mystical rapture on the burning logs of her torture does not appear to feel the flames. Working with Aprile in the church of the Nome di Gesù e Maria was Lorenzo Ottoni (1648–1726). Most of his oeuvre was produced in the eighteenth century but in his youth he carved several vigorous half-lengths that seem, at least in part, close to pl. 53 Guidi's portraits. Cardinals *Antonio* and *Francesco Barberini*, now in the Museo di Roma, count among his most significant marble statues: the liveliness in their countenances creates a certain expressive deformation.

In the last two decades of the seventeenth century architects like Rainaldi and Fontana directed the building sites of the Roman churches with groups of subaltern sculptors executing their designs. Several painters were called upon as well. Toward

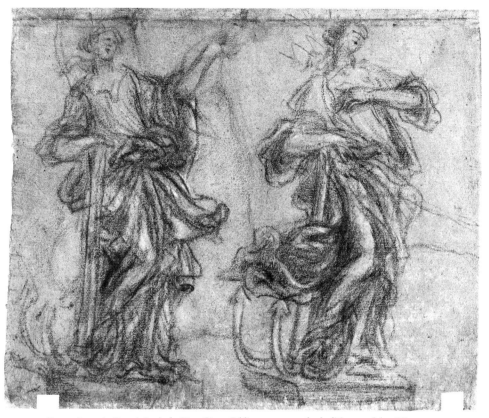

Fig. 11. Antonio Raggi, *Study for Hope*. Siena, Biblioteca comunale degli Intronati, inv. S.I.2, c. 3v.

1685 the artist Ludovico Gimignani (1643–89), who had lived in Bernini's shadow, produced the design for the lavish *Tomb of Monsignor Agostino Favoriti* in Santa Maria Maggiore. The monument was modelled in terracotta and carved in marble by Filippo Carcani, who worked cleverly here with motifs derived from Bernini's and Ferrata's funerary compositions like the *Monument of Cardinal Domenico Pimentel* in Santa Maria sopra Minerva, a far earlier work. Ciro Ferri (1634–89) was another painter and architect who worked closely with sculptors and even borrowed their drawings, thus following a practice inherited from Pietro da Cortona. Even more interested than his master in the technique of clay models, Ferri executed the gilt-bronze *Canonised Saints with St Ignatius* in Il Gesù (1687–89) and designed the lavish Eucharistic tabernacle for the high altar in Santa Maria in Vallicella with two hovering angels that really seem to be in mid-air. One of the most complex works Ferri supervised was for the Barberini Chapel in San Sebastiano fuori le Mura which contains the statue of the canonised martyr carved by Giuseppe Giorgetti (documented from 1670 to 1679). Giuseppe, Antonio's brother, obviously executed a design by Ferri, the true author of

pl. 52

pl. 56

this unusual idea for *St Sebastian*, who lies lifeless after his martyrdom in the urn beneath the altar (1672).

Raggi and Ferrata died the same year (1686) and with them the last masters of the century were gone. The confidence the Jesuits had in Raggi after his decoration of Il Gesù led them to engage him just before he died to decorate the two chapels in the presbytery of Sant'Ignazio with eight allegories of *Virtue*. Antonio had time to draw the admirable designs for these stuccoes that other youths [fig. 11] (including Jacopo Antonio Lavaggi, Simone Giorgini, Francesco Nuvolone and Giovanni Rinaldi) faith-
pl. 57 fully sculpted. Another, making his first appearance, was Camillo Rusconi, who would prove to be the greatest carver of statues of the early eighteenth century in Rome.

THE FRENCH IN ROME

For Bernini the last decade of his life, from 1670 to 1680 under the pontificates of Clement Altieri and Innocent XI Odaleschi, was by far the most melancholy. The papacy was facing increasing financial difficulties and the new popes' lack of interest in the arts merged with a widespread demand for austerity that imposed restrictions particularly in the artistic sectors. The new French political hegemony exercised by the young Louis XIV over Europe was felt all the way to Rome with obvious consequences on culture. On the occasion of his trip to France in 1665 Bernini had already directly experienced how difficult it was to communicate with the prime minister Jean-Baptiste Colbert (1619–85) who tended to impose rigid centralising planning marked by grandiloquent classicism on all the art produced at the French court. Colbert's rationalism and protectionism expressed in Charles Le Brun's (1619–90) influential role in the arts essentially affected the reform of the Académie Royale in Paris and the founding of the Roman section of the Académie in 1666. Young French artists were to visit Italy with a four-year bursary, the Prix de Rome and the Grand Prix, to study antiquity and learn the manner of great Italian art. Besides, the French policy was welcomed by influential people in Rome, the most renowned in the milieu of the arts being Giovan Pietro Bellori, the author of the *Vite* of the modern artists published in 1672 and significantly dedicated to the French prime minister. A great friend and admirer of Poussin, champion of the theories of classicism and "idea of Beauty" that were so warmly welcomed at Versailles, Bellori avoided as much as possible even quoting Bernini's name in his ponderous work. On the whole he was highly critical of the fanciful experiments of modern sculpture which he deemed time and again too naturalistic and emphatic. After Poussin's death Bellori's new favourite artist was Carlo Maratti (1625–1713) who seemed to be the ideal heir to a pictorial tradition whose references were Annibale Carracci, Francesco

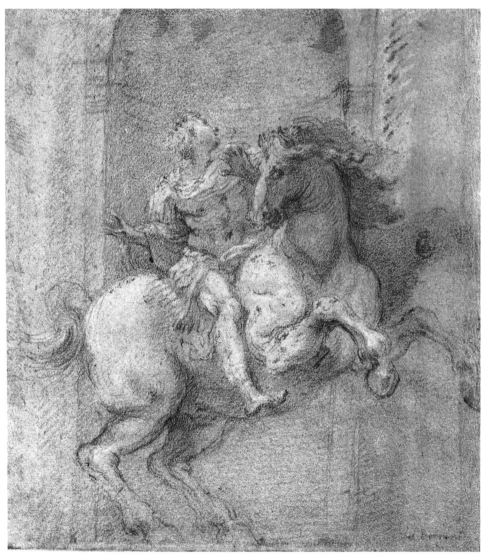

Fig. 12. Gian Lorenzo Bernini, *Study for the conversion of Constantine*. Madrid,
Real Academia de Bellas Artes de San Fernando, inv. W 73.

Albani and Andrea Sacchi. Maratti's role in statuary at the end of the century was fundamental as well. Like Carlo Fontana, on several occasions he prepared drawings and designs for major sculptural ensembles, inspiring them with a balance and formal reserve that largely clashed with Bernini.

The Curia's Francophile policy slowed with the election of Innocent XI (1676–89). This very severe Lombard pope was little inclined to patronise the arts but played an important role in relaunching a strong, triumphant image of the Roman Church,

opposing France's "Gallican liberties" as well as the Ottoman expansion (Vienna was liberated in 1683). Innocent's *Ecclesia Triumphans* had undeniable effects on iconography and the figurative arts, as is revealed by the great decorative programmes the religious orders and private patrons promoted in the city's palaces and churches. In spite of this change of official policy in alliances, the French artists in Rome continued to enjoy notable prestige in the years in which the Académie in Palazzo Mancini was attended by very talented sculptors, certainly among the most gifted. As Robert Enggass has rightly pointed out, most of the French artists in Rome during the seventeenth century strived to be integrated in the city's cultural atmosphere, including the most famous case of Poussin, an "*academicus romanus*" who found a second home in Rome. This had also been the case of sculptors like Cordier, Maille and even the great Puget. Instead, towards the end of the century, because the Académie pupils were supported by the Crown, they formed a separate group even though they worked in yards with artists of other nationalities and longed to take home the lessons they learned in Rome.

The first of the youths Colbert sent to Rome was Jean-Baptiste Théodon (1645–1713). He stayed in Italy from 1677 to 1705, from where, among other pieces, he sent hermae and terms for the gardens of Versailles. Whereas in Rome statuary was mostly in demand for the decoration of altars and churches, in Paris the patrons were above all laymen. In the French capital, artistic interest mostly centred on the styles typical of antiquity; the works were often military and commemorative in nature and mainly used to ornament palace facades, fountains and gardens. Even compared to the other Académie pupils, Théodon's culture was more largely based on ancient art so it must have been important to him to have met at an early date an Italian artist like Guidi who had already worked for Versailles.

Several years later, after receiving training in Paris (though this is still unclear), the *pensionnaires* Pierre-Étienne Monnot from Besançon (1687) and Pierre Legros the Younger (1690) arrived in Rome. For both sculptors the elderly Puget's example in their own country may have been decisive: he still worked for the Court despite tensions with Colbert and was the author of famous low-reliefs such as *Alexander and Diogenes* and the *St Charles Borromeo Praying for the Victims of the Plague in Milan* (1694). It is also worthwhile mentioning that this lovely marble had been executed for the Abbé de la Chambre who had been an unconditional admirer of Bernini, his companion on the return journey from France to Italy in 1665 and the Italian's very first biographer. Monnet's and Legros's facility to compose crowded scenes and move figures in torsion in space, displayed in their first Roman low-reliefs—see Monnot's
pl. 61 *Adoration of the Shepherds* and *Flight into Egypt* in Santa Maria della Vittoria—is indebted to the style of the great master who for these youths must have embodied

the bond between Rome and Paris. The greatest work engaging Théodon, Legros and Monnot together in the 1690s was the large altar dedicated to St Ignatius built in the new chapel of the transept of Il Gesù. The Jesuits had always sought to be on good terms with the French Court, even at the time of the worst tensions between Louis XIV and the pontifical Curia, for example, when in 1664 Padre Oliva and even Sforza Pallavicino had done their utmost to make Bernini accept the invitation from the Versailles Court against his will. On the very occasion of the huge undertaking of St Ignatius' altar, the sculptors connected with the Académie were given the exceptional opportunity to prove their admirable qualities by carving monumental statuary groups. The painter and sculptor Andrea Pozzo (1641–1709) was assigned to design the altar. He too was a Jesuit and in 1695 presented the design for this altar that was to become the most lavish ever seen in a church, partly as a result of the wealth of the materials, beginning with lapis lazuli. The large niche is faced with marbles and gilt-bronze that make it almost dazzling, and it contains the monumental bronze statue of *St Ignatius* (replaced in 1801) executed from a model designed by Legros; for his part, Monnot carved the two lively marble angels nearby that hold the plaque with the initials IHS, the company's symbol. The two sculptors also carved the allegorical marble groups that stand on each side of the altar: *Religion Overthrowing Heresy (in* pl. 59 *cornu Epistolae)* by Legros and *Faith Crushing Idolatry (in cornu Evangeli)* by Théodon. pl. 60 In designing this complex allegory, Théodon drew on what he had learned from Guidi's works, such as the *Monument to Frederick of Hesse* in Bratislava, but also drew inspiration from Ferrata's famous *Faith* in San Giovanni dei Fiorentini. To contrast is pl. 41 companion's rather rhetorical classicism, Legros produced a more mobile, harmonious composition characterised by the elegance of the slender *Religion*, the falling figures symbolising heresy and the whimsical invention of the zealous *putto* tearing the pages of the indexed books. René Fremin (1672–1722), who reached Rome in 1694, was the author of two of the most attractive bronze low-relief *Stories of St Ignatius* that adorn the altar front, whereas Monnot was assigned another of the hagiographic episodes. However, the most successful individual work of them all was Legros's allegorical group *Religion*, and in 1697 the sculptor was given the commission for the large marble altarpiece with the *Apotheosis of the Blessed Aloysius Gonzaga* for the new altar pl. 63 in Sant'Ignazio designed by Pozzo. This amazing composition, with its oval format and mixtilinear frame derived from that of the *trompe-l'oeil* dome by Baciccio and Pozzo for the Jesuit churches, is set in the midst of the mystical heavens of beatitude. In this *gloria in excelsis*, recollections of Bernini's *Cathedra*, Caffà's languid sweetness, and Baciccio's boundless spaces seem to merge. Especially in the tenderly modelled angels bent in wavering motion, we find vivid references to Puget's relief of the *Assumption of Mary* presently in Berlin. But with Legros this entire figurative world steeped in mysticism and sublime tones is expressed in lighter, more elegant rhythms that heralded the coming century.

For the jubilee of 1700 the commissioned sculptures in St Peter's could not compare to the impressive, costly ones of fifty years before but they nonetheless involved three major projects. It is telling that Carlo Fontana and Carlo Maratti were called upon for the overall designs while once again French sculptors carried them out. Between 1691 and 1702 they carved the *Funerary Monument for Christina of Sweden* (1626–89), the queen who was the daughter of the Lutheran Gustavus Adolphus. Converted to Catholicism (1655), after abdicating from the Swedish throne she moved to the banks of the Tiber and created a Court and patronage in her residence in Palazzo Riario that nearly rivalled that of the popes. It should be remembered that Christina, a great admirer of modern sculpture, had opened an academy in her palace on the model of the French one (1686–89), where the Sienese Balestra taught. He was the author of several statuary groups for the queen that had clearly been inspired by Bernini, for instance, *Time Ravishing Beauty* now in the Grosser Garten in Dresden. Returning to the subject of the queen's tomb, Fontana designed it on paper with his usual accurate, neat tracing: it consisted of a bronze medallion with the effigy of the queen in profile above a sarcophagus ornamented on three sides with marble low reliefs representing the story of her life. Théodon's solemn, slightly stiff classicism is apparent in the large relief where the figures of *Christina Abjuring and Renouncing the Throne* unfold like an antique frieze.

The funerary monument in St Peter's that Livio Odaleschi wished to dedicate to his famous uncle, Innocent XI (1697–1701), derived from Bernini but only in its typology. A great admirer of Monnot, Odaleschi commissioned several sculptures from him. pl. 62 Monnot was first assigned the entire tomb but later Maratti took over the project and Monnot was content simply to carve it in marble. Maratti's formal construction, impeccably laid out within traditional schema, contrasts with the Frenchman's freer composition reflected in the clay model in the Museo Nazionale del Bargello. Fontana was also engaged to build the Battesimo Chapel for which Maratti painted the large preparatory canvas for the mosaic of the *Baptism of Christ*. Fontana even designed the elegant forms of the font, built around an antique porphyry vase with a gilt-bronze lid. Lorenzo Ottoni worked so closely with Pierre Monnot on the font that the extent of his involvement is unclear.

At the close of the seventeenth century, sculpture in Rome seems to have gradually lost the primacy in the arts that it had won in the middle of the century by virtue of Bernini's *bel composto*. The sculptor, whose role as designer had passed to painters or architects (some of whom, like Fontana, had also been Bernini's pupils) was placed in a subordinate position and his executive activity almost disappeared in the grandiose trappings and lavish pomp of the henceforth declining phase of the Roman baroque.

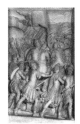

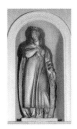

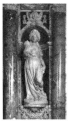

pl. 1. Stefano Maderno,
St Cecilia, 1600, marble,
ca. 210 cm, (length), Rome,
Santa Cecilia in Trastevere.
On the occasion of the jubilee in
the first year of the seventeenth
century, Maderno was engaged by
Cardinal Paolo Emilio Sfondrato to
carve a marble statue of St Cecilia,
representing her with the same
appearance and in the same
position in which the martyr's body
had been found in 1599 during
excavations performed on the site
of the ancient *confessio* in the
Trastevere basilica.

pl. 2. Stefano Maderno,
*Rudolf II of Hungary Attacking
the Turks*, 1613–15, marble,
93 x 71 cm, Rome,
Santa Maria Maggiore.
This relief belongs to the set of
marble panels adorning Paul V's
funerary monument in the Pauline
Chapel in Santa Maria Maggiore
and features the sculptor's
signature: "STEFANUS / MADERNI /
ROMANUS F." It is quite clear that
Maderno, who was born in Rome
but whose family was Lombard,
was perfectly integrated in the
milieu of the papal city.

pl. 3. Camillo Mariani,
St Catherine of Alexandria,
ca. 1600, stucco, h. 310 cm,
Rome, San Bernardo alle Terme.
This large-format stucco statue
is one of the series of eight saints
that Mariani modelled inside San
Bernardo alle Terme, the church
that Caterina Sforza countess of
Santa Fiora had built a short time
before the jubilee at the start of
the seventeenth century, making
use of one of the "rotundas"
from the Baths of Diocletian.

pl. 4. Ippolito Buzio, *Prudence*,
1604, marble, h. 133 cm, Rome,
Santa Maria sopra Minerva.
The allegorical figure stands in
a niche in Silvestro Aldobrandini's
tomb in Santa Maria sopra
Minerva. Admired in 1604, it is
still one of the most significant
works by the Lombard sculptor
who worked at length for the
Aldobrandini family both in
Rome and at Frascati.

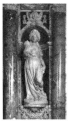

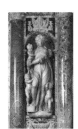

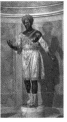

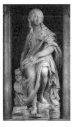

pl. 5. Ippolito Buzio,
Giovanni Francesco(?)
Aldobrandini, 1604, marble,
h. 70 cm, Rome, Santa Maria
sopra Minerva.
Like others in the same style,
this half-length, characterised
by a realism typically Lombard
in manner, is placed in an oculus
of the Aldobrandini Chapel
commissioned by Clement VIII
and consecrated in 1611.

pl. 6. Nicolas Cordier, *Charity*,
1604, marble, h. 134 cm, Rome,
Santa Maria sopra Minerva.
This dynamic statuary group
representing the theological
virtue of *Charity* is placed in the
Aldobrandini Chapel in the niche
to the left of the tomb of Lesa
Deti, Clement VIII's mother. *Hope*
by Camillo Mariani occupies the
niche on the right.

pl. 7. Nicolas Cordier, *Moor*,
ca. 1610, black marble, alabaster,
polychrome stone and pastille
inlays, gildings, h. 175 cm,
Versailles, Musée National
du Château, inv. SMD 1002.
This stunning polychrome statue
dates to the years in which Cordier
worked as a restorer of antiques
for Cardinal Scipione Borghese,
between 1607 and 1612. In 1808
the *Moor* was one of the works
sold by Prince Camillo Borghese
to Napoleon, and since then it
has been in the French State
collections.

pl. 8. Cristoforo Stati, *St Mary
Magdalene*, 1609–12, marble,
h. 210 cm, Rome, Sant'Andrea
della Valle.
Warmly recommended by
Maffeo Barberini, Cristoforo Stati,
who had trained in Florence in
Giambologna's workshop, created
his most successful religious
sculpture with this *Magdalene*.
He was also assigned, for the same
chapel in Sant'Andrea della Valle,
the statue of Francesco Barberini
and two angels placed on the
altar tympanum.

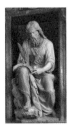

pl. 9. Ambrogio Buonvicino,
St John the Evangelist, 1610–12,
marble, h. 215 cm, Rome,
Sant'Andrea della Valle.
The statue of the Evangelist,
unquestionably Buonvicino's
masterpiece, belongs to the
sculpture ornamentation of the
Barberini Chapel in Sant'Andrea
della Valle, where the Lombard
sculptor worked alongside the
two Tuscans Pietro Bernini and
Francesco Mochi, and Cristoforo
Stati from Bracciano.

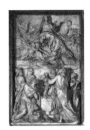

pl. 10. Pietro Bernini,
Assumption of the Virgin,
1610, marble, 245 x 390 cm,
Rome, Santa Maria Maggiore.
This was Pietro Bernini's first
undertaking in Rome after he
left Naples in 1606. Intended
to be placed in the outer wall of
the *basilica liberiana* forming a
pendant with the *cappella Paolina*,
it was instead placed in the choir
of the canons that later became
the baptistery.

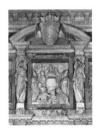

pl. 11. Pietro Bernini,
Coronation of Clement VIII,
1613–14, marble, 92 x 85 cm,
Rome, Santa Maria Maggiore.
The relief by Pietro Bernini is part
of Clement VIII's grandiose tomb,
commissioned by his successor
Paul V for the Pauline Chapel
in Santa Maria Maggiore. The
sculptor had first (1611) carved
another version of the same
"historia dela Incoronatione"
(story of the Coronation) that
later, for reasons unknown,
he himself replaced.

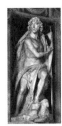

pl. 12. Pietro Bernini,
St John the Baptist, 1615,
marble, ca. 210 cm,Rome,
Sant'Andrea della Valle.
The execution of the statue of the
Precursor was first commissioned
to Nicolas Cordier by monsignor
Maffeo Barberini who intended
to include it in the decoration of
the family chapel (1609). But at
the death of the Lorrainer the
sculpture had still not been carved
and the commission was then
passed on to Pietro Bernini who
completed the marble with the
Baptist in 1615.

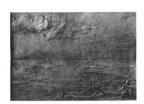

pl. 13. Francesco Mochi,
*Construction of the Bridge
on the Schelde*, 1625, bronze,
210 x 103 cm, Piacenza,
Piazza Cavalli.
The thin bronze relief is set in one
of the two long sides of the base
of the equestrian monument to
Alessandro Farnese. It shows a
particular moment during the
siege of Antwerp, a crucial episode
in the war of Flanders that was
won by the "*gran capitano*" for
Philip II against the rebels of the
northern provinces.

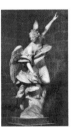

pl. 14. Francesco Mochi,
Angel of the Annunciation,
1605, marble, h. 185 cm, Orvieto,
Museo dell'Opera del Duomo.
In 1603, thanks to the good offices
of Mario Farnese, Duke of Latera
and Mochi's first protector in
Rome, the young Valdarno artist
was able to obtain from the
supervisors of the Opera del
Duomo of Orvieto the commission
for the two statues of the
Annunciation. Three years after
delivering the *Angel*, the artist also
consigned the statue of the *Virgin*.

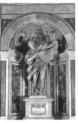

pl. 15. Francesco Mochi,
St Veronica, 1635–39, marble,
h. ca. 400 cm, Vatican City,
St Peter's.
The sculpture belongs to the set of
four statuary groups that Bernini
placed in the niches hollowed in
the supporting pillars of the dome
of St Peter's. The three other
statues are *St Longinus* by Bernini
himself, *St Andrew* by Duquesnoy
and *St Helen* by Bolgi.

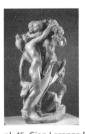

pl. 16. Gian Lorenzo Bernini,
Faun Teased by Children, 1616,
marble, h. 132 cm, New York,
Metropolitan Museum of Art.
The sculptural group, rediscovered
quite recently, was in Bernini's
home in Via della Mercede in
Rome. Believed to have been
executed by Bernini in his old age
in the same manner as an exercise
performed during his youth in his
father's workshop, the marble is
not mentioned in the biographies
of the artist written by Domenico
Bernini and by Filippo Baldinucci.

pl. 17. Gian Lorenzo Bernini, *Monsignor Pedro Foix de Montoya*, 1622, marble, ca. 70 x 50 cm, Rome, Santa Maria di Monserrato.
The wonderfully realistic portrait of Pedro de Foix Montoya was carved by Bernini when the Spanish prelate, who died in 1630, was still alive. The original destination of the Montoya tomb was San Giacomo degli Spagnoli, whence it was removed to its present location in the late nineteenth century.

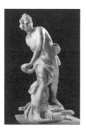

pl. 18. Gian Lorenzo Bernini, *David*, 1623–24, marble, h. 170 cm (base 103 cm), Rome, Galleria Borghese, inv. LXXVII.
Sculpted almost during the same period that Bernini was carving the *Apollo and Daphne*, the *David* was executed for the Villa of Scipione Borghese, where it was originally placed on the ground floor against a wall in the Sala del Vaso.

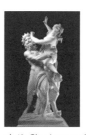

pl. 19. Gian Lorenzo Bernini, *Pluto and Proserpina*, 1621–22, marble, h. 225 cm, Rome, Galleria Borghese, inv. CCLXVIII.
The sculptural group was commissioned by Scipione Borghese, who magnanimously presented it to Cardinal Ludovico Ludovisi, nephew of Gregory XV (1621–23). The *Pluto* remained in the Ludovisi collection until 1908, when it was purchased by the Italian State for the Galleria Borghese.

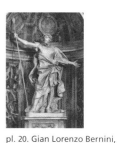

pl. 20. Gian Lorenzo Bernini, *St Longinus*, 1635–38, marble, h. ca. 440 cm, Vatican City, St Peter's.
The colossal statue of *St Longinus*, planned for one of the niches carved out of the pillars of St Peter's crossing, is the result of protracted preparation. This is attested by autograph preparatory drawings by Bernini in Dusseldorf, and by two clay models, conserved respectively in the Museo di Roma and the Fogg Art Museum in Cambridge (Mass.).

pl. 21. Alessandro Algardi, *Muzio Frangipane*, 1635–38, marble, h. 70 cm, Rome, San Marcello al Corso.
The bust was commissioned from Algardi by Mario and Pompeo Frangipane, the sons of Muzio, and belongs to a series of marble portraits placed since the sixteenth century in oculi along the lateral walls of the chapel that belongs to the noble Roman family. Algardi also carved the busts of Roberto and Lelio, the sons of the famous *condottiere* of the papal troops who had valiantly fought at Jarnac and at Lepanto.

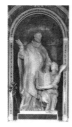

pl. 22. Alessandro Algardi, *Apotheosis of St Filippo Neri*, ca. 1636, marble, h. ca. 300 cm., Rome, Santa Maria in Vallicella, sacristy.
The large statuary group representing the *Apotheosis of Saint Filippo Neri*, commissioned to Algardi by Pietro Buoncompagni, was offered by the latter to the general congregation of Santa Maria in Vallicella to be placed in the sacristy of the New Church. A terracotta preparatory model for this impressive, suggestive marble, modeled by the Bolognese sculptor, is held in a private collection in Turin.

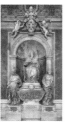

pl. 23. Alessandro Algardi, *Funerary Monument of Pope Leo XI*, 1634–44, marble: *Pope Leo XI* h. 267 cm, *Magnanimity* h. 285 cm, Vatican City, St Peter's.
The execution of this tomb was assigned to Algardi by Cardinal Roberto Ubaldini in memory of his illustrious uncle Alessandro de' Medici who, under the name of Leo XI, had ruled as pope in 1605 for no more than a few days.

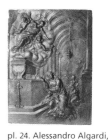

pl. 24. Alessandro Algardi, *St Constantia's Vision of St Agnes*, 1652–53, painted plaster model, 58 x 44 cm, Rome, Museo Nazionale di Palazzo Venezia.
Besides the present version of this work, there is a bronze relief that adorns the tabernacle of the Franzone Chapel in the church of the Santi Vittore e Carlo in Genoa. However, the Pamphilj coat-of-arms, inscribed on the plinth of the column, ascertains that the first commission was connected with the Roman church of Sant'Agnese of which Cardinal Giacomo Franzone had been a "representative".

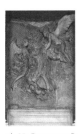

pl. 25. Francesco Baratta, *Apotheosis of St Francis*, 1647, marble, ca. 290 x 180 cm, Rome, San Pietro in Montorio.
In all probability designed by Bernini himself as part of the overall decoration of the Raimondi Chapel, this relief nonetheless bore the personal stamp of the artist from Massa, Francesco Baratta, who was also allowed to sign it: "FRAN/S BARATTA FACIEBAT."

pl. 26. Alessandro Algardi, *Hercules at the Crossroads*, ca. 1646, stucco, Rome, Casino di Belrespiro.
The stuccoes of the Galleria di Ercole, executed by Algardi following the "fine examples of Raphael and of Giulio Romano" (Bellori), were partly executed, on the master's design, by Giovanni Maria Sorrisi and Rocco Bolla. Hercules embodied the positive hero whose virtues guided Camillo Pamphilj, patron of the Villa and nephew of Innocent X.

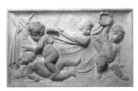

pl. 27. François Duquesnoy, *Divine Love Overcoming Profane Love*, ca. 1630, marble, 98 x 60 cm, Rome, Galleria Doria Pamphilj.
To date the relief with *Divine Love* correctly, the fact must be kept in mind that in 1631 the sculptor Tommaso Fedeli was engaged by Cardinal Francesco Barberini to make a copy of it in porphyry to be sent to Philip IV of Spain (it is still held in the Prado). Duquesnoy's prototype must therefore have been made shortly before.

pl. 28. François Duquesnoy, *St Susanna*, 1629–33, marble, h. 230 cm, Rome, Santa Maria di Loreto.
Duquesnoy was commissioned to carve the figure of St Susanna by the Pio Sodalizio dei Fornai. This confraternity of bakers was in charge of the church in the Forum of Trajan, and in 1627, with the help of a large donation, made the present arrangement in niches of two angels and four female saints assigned to Duquesnoy, Giuliano Finelli, Domenico De' Rossi and Pompeo Ferrucci.

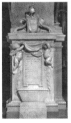

pl. 29. François Duquesnoy, *Tomb of Ferdinand van den Eynde*, 1633–40, marble, h. 253 cm, Rome, Santa Maria dell'Anima.
The funerary monument for the wealthy art dealer Ferdinand van den Eynde (born Antwerp – died Rome 1630) was carved by Duquesnoy at the base of one of the pillars of the German church in Rome.

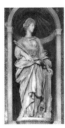

pl. 30. Giuliano Finelli, *St Cecilia*, ca. 1632, marble, h. 200 cm, Rome, Santa Maria di Loreto.
The statue of the martyr is part of the decoration of the apse of Santa Maria di Loreto, an ensemble on which several sculptors worked. An outcome of Finelli's new anti-Bernini stance, the figure of *St Cecilia* brings to mind the womanly heroism of several saints painted by Pietro da Cortona during the same period.

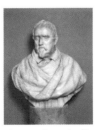

pl. 31. Giuliano Finelli, *Francesco Bracciolini*, ca. 1630, marble, h. 66 cm, London, Victoria and Albert Museum, inv. 8883-1863.
This is one of the most significant sculptural portraits by Finelli, one of Bernini's outstanding pupils, who was renowned for his vigorous rendering in marble effigies of this kind. Francesco Bracciolini was a poet from Pistoia who belonged to the literary circle attached to the Barberini family.

pl. 32. Andrea Bolgi, *Tomb of Girolamo Raimondi*, 1647, marble, h. ca. 430 cm, Rome, San Pietro in Montorio.
The tomb, executed by Bolgi to Bernini's design, is on the left wall of the Raimondi Chapel. It faces the funerary monument of Francesco, Girolamo's nephew who died in 1638, and to whom this extremely innovative funerary chapel is owed.

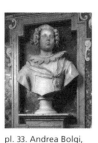

pl. 33. Andrea Bolgi,
Laura Frangipane Mattei,
1637, marble, h. 81 cm, Rome,
San Francesco a Ripa.
The half-length, dated and signed
by Bolgi, crowns the tomb of
Laura Frangipane that her husband
Ludovico Mattei had built. It is
one of the sculptor's most vivid
portraits, carved during the years
of his closest collaboration with
Bernini, when he executed the
statue of *St Helen* for the great
master in the Vatican basilica.

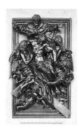

pl. 34. Cosimo Fancelli, *Trinity,*
1657, bronze, 80 x 53 cm, Rome,
Santa Maria della Pace.
The bronze relief is on the altar
in the Chigi Chapel in Santa Maria
della Pace and dates to the period
in which Alexander VII assigned to
Pietro da Cortona the renovation
and decoration of the entire
church. Fancelli, an assiduous
collaborator of the great painter,
on this occasion used one of his
drawings to create the terracotta
model, which was subsequently
cast by the famous bronze-founder
Giovanni Artusi.

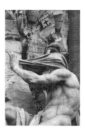

pl. 35. Gian Lorenzo Bernini,
Fountain of the Four Rivers,
detail, 1647–51, travertine and
marble, Rome, Piazza Navona.
The commission of the *Fountain
of the Four Rivers* that Innocent X
assigned to Bernini gave the artist
the opportunity redeem and
avenge himself on those detractors
who had vented their spleen
against him in the early days
of the Pamphilj pontificate, after
the happy, productive years under
the Barberini.

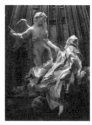

pl. 36. Gian Lorenzo Bernini,
Ecstasy of St Teresa, **1647–50,**
marble, Rome,
Santa Maria della Vittoria.
Placed in the Cornaro Chapel,
the marble group of the *Ecstasy*
or the *Transverberation of St Teresa
of Avila* was commissioned from
Bernini by Cardinal Federico, the
Patriarch of Venice and the son
of Doge Giovanni.

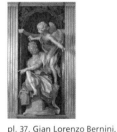

pl. 37. Gian Lorenzo Bernini,
Habbakuk and the Angel, **1661,**
marble, h. 180 cm, Rome,
Santa Maria del Popolo.
Commissioned by Alexander VII at
the behest of the librarian of the
Vatican Library, Lukas Holste, this
statuary group is iconographically
connected with the one of *Daniel
and the Lion* in the facing niche
in the Chigi Chapel.

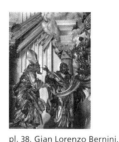

pl. 38. Gian Lorenzo Bernini,
St Augustine and St Atanasio,
1663–65, bronze, h. 535 cm,
Vatican City, St Peter's.
In 1660 Bernini and Alexander VII
decided to increase the dimensions
of the *Cathedra Petri* on a vast
scale; in consequence, the height
of the four Doctors of the Church
became colossal, exceeding five
metres. On this occasion too,
Giovanni Artusi was the expert
founder who cast the clay models
in bronze.

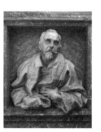

pl. 39. Gian Lorenzo Bernini,
Gabriele Fonseca, **ca. 1668,**
marble, h. ca. 90 cm, Rome,
San Lorenzo in Lucina.
Gabriele Fonseca, a noted
physician of Portuguese birth who
was also the papal archiater, died
in 1668 and left instructions to be
buried in the family chapel in San
Lorenzo in Lucina. The vivid half-
length sculpted by Bernini must
date to a short while afterwards.

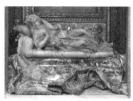

pl. 40. Gian Lorenzo Bernini,
*Vision of the Blessed Ludovica
Albertoni,* **ca. 1671–74, marble,**
Rome, San Francesco a Ripa.
Bernini's statue was carved after
1671, when Clement X enacted the
decree for Ludovica's beatification.
In terms of composition and
iconography, the marble sculpture
is closely linked to Baciccio's oil
painting of the *Madonna and
Child with St Anne* on the altar
behind the sculpture.

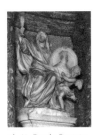

pl. 41. Ercole Ferrata,
Faith, 1665–70, marble,
h. ca. 195 cm, Rome,
San Giovanni dei Fiorentini.
The allegory of *Faith* stands in
the large niche at the centre of
the monument of Lelio Falconieri,
which was probably produced
from a design by Francesco
Borromini. Ferrata, who received
payments from 1669 to 1685,
devised the figure during a long
process, well-documented by at
least four preparatory sketches
held in various Italian and foreign
collections.

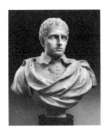

pl. 42. Ercole Ferrata,
Bust of a youth, ca. 1660,
marble, h. 78 cm,
private collection.
A striking example of Ferrata's
formal portraiture reflecting
Algardi's influence, this marble
effigy may be the "portrait of
Marchese Centurioni", a Genoese
nobleman whose bust is cited in
the workshop inventory in 1686
on the death of the sculptor.

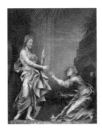

pl. 43. Antonio Raggi,
Noli me tangere, ca. 1647,
marble, Rome,
Santi Domenico e Sisto.
The marble group featuring the
encounter of the Risen Christ and
the Magdalene stands on the altar
of the Alaleona Chapel in the
Dominican church in Rome.
The yard for the chapel was
begun in 1649, when Sister Maria
Alaleona offered a huge sum for
the execution of this elaborate
decoration as a gesture of
atonement.

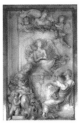

pl. 44. Antonio Raggi,
*Angel Announcing the Flight
into Egypt to St Joseph*,
ca. 1680, marble,
ca. 350 x 190 cm, Rome,
Sant'Andrea della Valle.
The laboured, protracted
decoration of the Ginetti Chapel
in Sant'Andrea della Valle,
designed by Carlo Fontana,
began in 1679 and was not
completed until the first years
of the eighteenth century. Raggi
carved the marble altarpiece, as
well as the statue of Cardinal
Marzio Ginetti worshipping and
the figure of the winged *Fame*
bearing the coat-of-arms of the
family owner of the chapel.

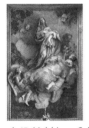

pl. 45. Melchiorre Caffà,
*Apotheosis of St Catherine
of Siena*, ca. 1667, marble,
ca. 310 x 195 cm, Rome, Santa
Caterina a Magnanapoli.
This is one of Caffà's most famous
works, partly because it is one of
the few he executed in marble that
are held to be entirely by his own
hand instead of being completed
by Ferrata following his premature
death. Caffà also probably devised
the design for the whole ensemble
of the apse of the church, though
this was not carried out until the
next century by Pietro Bracci.

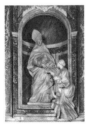

pl. 46. Melchiorre Caffà
(completed by Ercole Ferrata),
*Charity of St Thomas of
Villanova*, 1665–67, marble,
h. ca. 250 cm, Rome,
Sant'Agostino.
The statuary group is placed in
the niche crowning the altar of
the chapel dedicated to St Thomas
of Villanova, the overall design
of which was assigned by Camillo
Pamphilj to the architect Giovanni
Maria Baratta. Valletta Museum
has a clay model by Caffà showing
several variants compared to the
marble completed by Ferrata.

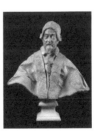

pl. 47. Melchiorre Caffà,
Alexander VII, 1667,
terracotta, h. 76 cm, Ariccia,
Palazzo Chigi, inv. 748.
This large terracotta model was
used for the famous bronze cast
of the only half-length portrait
executed by Caffà we know of.
Two copies bearing Caffà's
signature and the date of
execution were cast in bronze
by Giovanni Artusi and are
respectively held in the Cathedral
of Siena and at the Metropolitan
Museum in New York.

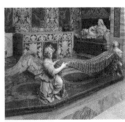

pl. 48. Antonio Giorgetti,
Angels Holding the Sudary,
1658, white marble,
wood, jasper, Rome,
San Girolamo della Carità.
The two kneeling angels holding
the variegated cloth were carved
by Antonio Giorgetti, a pupil of
Algardi. The overall composition
forms an illustrated transenna
placed in front of the altar of the
chapel commissioned by Virgilio
Spada and entirely faced with
gorgeous polychrome marbles.

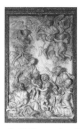

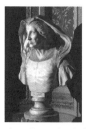

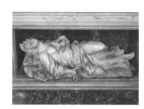

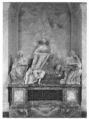

pl. 49. Domenico Guidi, *The Meeting of the Holy Family, St John the Baptist, St Elizabeth and Zaccharia*, 1677–87, marble, ca. 310 x 170 cm, Rome, Sant'Agnese in Agone.
This marble altarpiece, sculpted by Guidi on a commission from the Pamphilj family and placed on the high altar of Sant'Agnese in Agone, shows an episode seldom illustrated in the story of the Holy Family, and drawn from the *Meditationes Vitae Christi* by the Pseudo-Bonaventura. A terracotta model crafted by the sculptor for this altar depicts the scene in a more diffused, airier space.

pl. 50. Domenico Guidi, *Felice Zacchia Rondanini*, ca. 1660, marble, h. 60 cm, Rome, Galleria Borghese, inv. CCLXVII.
This expressive portrait of an elderly noblewoman has been correctly ascribed to Guidi, partly on the grounds of the information reported in a biography of the sculptor that Felice Zacchia Rondanini, depicted here, had the master execute several portraits of members of her family, including one of herself and one of her son Natale, to be placed on her tomb in Santa Maria del Popolo.

pl. 51. Francesco Aprile, *St Anastasia*, ca. 1685, marble, ca. 210 cm (length), Rome, Sant'Anastasia.
In 1678 the remains of St Anastasia were unearthed, and to celebrate the event Cardinal Francesco Maria Febei had the Lombard artist Aprile carve this statue of the martyr. By its horizontal arrangement in the niche of the altar, the figure recalls the composition of the famous *St Cecilia* by Maderno (Plate 1), although its style is already entirely baroque.

pl. 52. Filippo Carcani from a 1682 design by Ludovico Gimignani, *Funerary Monument of Monsignor Agostino Favoriti*, 1685, marble, h. ca. 300 cm, Rome, Santa Maria Maggiore.
The tomb of Monsignor Favoriti, canon of Santa Maria Maggiore and acclaimed poet, was designed by the painter Ludovico Gimignani and carved in marble by Carcani, one of Ferrata's most talented collaborators. The Museo di Palazzo Venezia also holds the Roman sculptor's autograph terracotta model for this magnificent tomb.

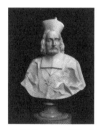

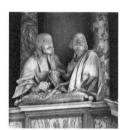

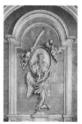

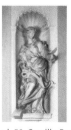

pl. 53. Lorenzo Ottoni, *Antonio Barberini*, ca. 1670, marble, 74.6 cm, Rome, Museo di Roma.
The youngest nephew of Maffeo Barberini, a cardinal at the early age of twenty, is shown here at a ripe age portayed by Ottoni during one of the high prelate's rare sojourns in Rome, doubtless in 1670, on the occasion of the conclave that was to elect Clement X. Antonio Barberini, a great protégé of Louis XIV, spent most of his life in Paris, where he was honoured with numerous decorations such as the cross of the Order of Saint-Ésprit that he wore on his breast as in this portrait.

pl. 54. Lorenzo Ottoni, *Funerary Monument of Ercole and Luigi Bolognetti*, ca. 1684, marble, Rome, Gesù e Maria.
Like the rest of the decoration of the church, which is practically a huge Bolognetti family mausoleum, this tomb is owed to the patronage of Bishop Giorgio Bolognetti. Lacking accurate supporting information, attribution of these two outstanding half-lengths, portrayed in the midst of a dialogue, has been debated, even though critics now tend to ascribe them to the hand of a great portraitist like Ottoni.

pl. 55. Michel Maille, *Angel Bearing a Medallion with the Bust of St Stephen*, 1682–86, stucco, h. ca. 250 cm, Rome, Santa Maria in Aracoeli.
This mobile figure of an angel with a medallion is part of the plastic decoration that the Burgundian artist Michel Maille modelled for the chapel dedicated to St Peter of Alcantara, designed by the architect Giovanni Battista Contini in Santa Maria d'Ara Coeli.

pl. 56. Camillo Rusconi, *Prudence*, 1686, stucco, h. ca. 195 cm, Rome, Sant'Ignazio.
This elegant stucco sculpture belongs to the series of the four *Cardinal Virtues* that the young Rusconi crafted on the walls of the Ludovisi Chapel in 1686, a short while after his arrival in Rome. As Robert Enggass has pointed out, on this occasion the sculptor kept in mind the drawings that Antonio Raggi, to whom the execution of the *Virtues* had first been assigned, had left at his death.

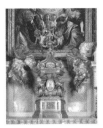

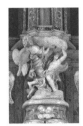

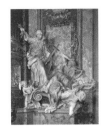

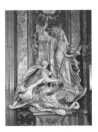

pl. 57. Carlo Marcellini and Francesco Nuvolone from a design by Ciro Ferri, *Tabernacle*, 1682–84, bronze, Rome, Santa Maria in Vallicella.
Elaborated over a long period, the tabernacle was designed by Ciro Ferri. Two drawings by the artist document the gradual variations of this extremely complex project.

pl. 58. Giuseppe Mazzuoli, *Angels Carrying the Tabernacle of the Eucharist*, 1700, marble, Siena, San Martino.
This group of angels in flight, carrying the tabernacle amidst the clouds, crowns the high altar in the church of San Martino at Siena, and was commissioned by Camillo de' Vecchi in 1700. Mazzuoli sculpted the group in his Roman workshop in Ripetta and then sent it to Siena by sea, as he did with many other sculptures for the churches and palaces of his native city.

pl. 59. Pierre Legros the Younger, *Religion Overthrowing Heresy*, 1698–99, marble, Rome, Il Gesù.
According to Cesare Ripa's *Iconologia*, Religion is shown as an attractive veiled maiden holding the Cross and the flame. The books the cherub is spitefully tearing apart contain the names of the great adversaries of the Roman Church, the heretics Zwingli, Luther and Calvin.

pl. 60. Jean-Baptiste Théodon, *Faith Crushing Idolatry*, 1698-1702, marble, Rome, Il Gesù.
This complex marble group is beside the gorgeous altar of St Ignatius of Loyola designed by Andrea Pozzo in the left transept of Il Gesù. *Faith* crushes the head of a dragon that guards a book on the spine of which are written the names of the false Eastern gods "CAMES - FOTOQUES - AMIDA ET XACA."

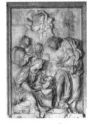

pl. 61. Pierre-Étienne Monnot, *Adoration of the Shepherds*, 1699, marble, ca. 180 x 130 cm, Rome, Santa Maria della Vittoria.
This relief, like the matching one representing the *Flight into Egypt* on the opposite side, flanks the altar of the Capocaccia Chapel where Guidi's marble group with the *Joseph's Dream* is placed. A sketch, formerly on the art market, exists that bears the sculptor's signature and the date 1695, the year Monnot was given the commission.

pl. 62. Pierre-Étienne Monnot, *Model for the Funerary Monument of Innocent XI*, 1697, terracotta, ca. 42 x 31 cm, Florence, Museo Nazionale del Bargello.
This is the model for the *Funerary Monument of Innocent XI* that Monnot began when he was engaged for the task by Livio Odescalchi, nephew of the Lombard pontiff and protector of the French sculptor. Subsequently the commission was assigned to Carlo Maratti, who vastly altered the overall composition, which Monnot then executed in marble.

pl. 63. Pierre Legros the Younger, *Apotheosis of the Blessed Aloysius Gonzaga*, 1698–1702, marble, 320 x 181 cm, Rome, Sant'Ignazio.
The large composite marble altarpiece designed by Andrea Pozzo stands in the monumental altar with coupled spiralled columns. The Detroit Institute of Arts holds a terracotta model with several variants connected with the relief by Legros; the model is certainly an autograph work by the great French master.

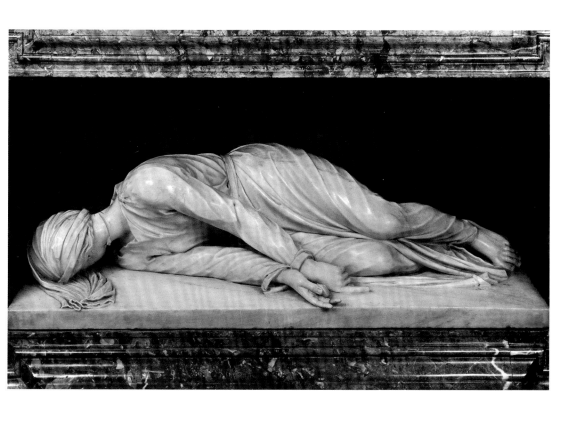

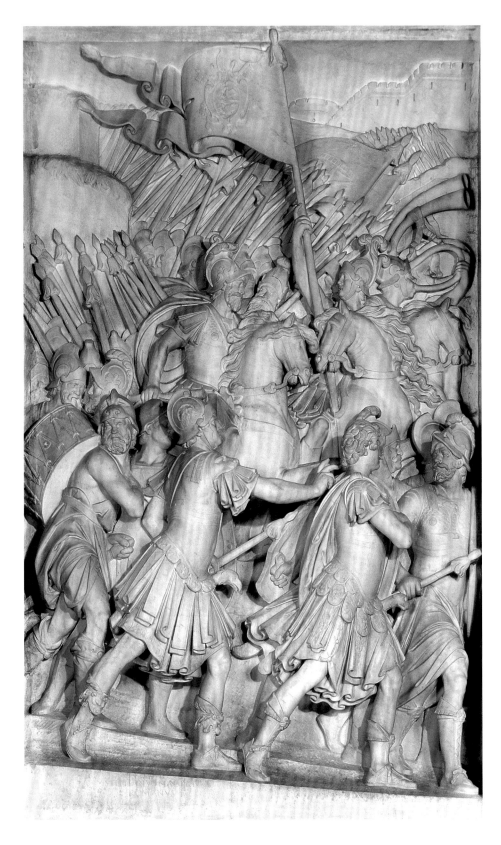

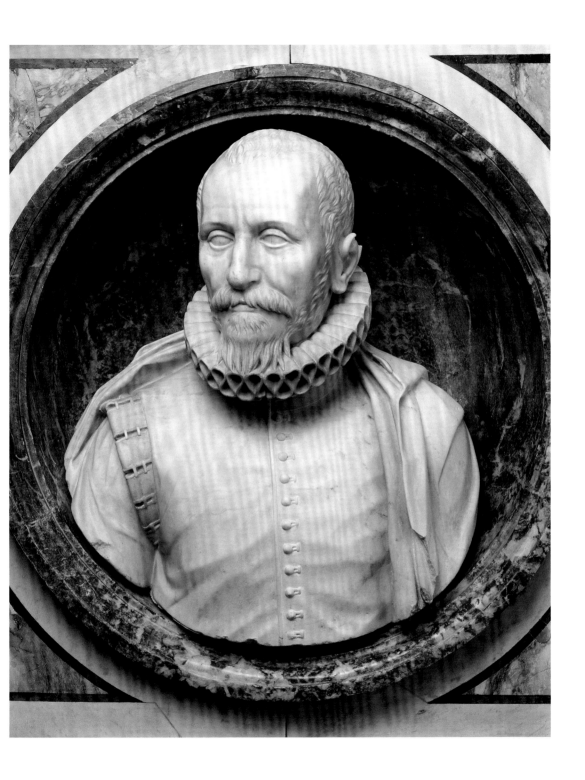

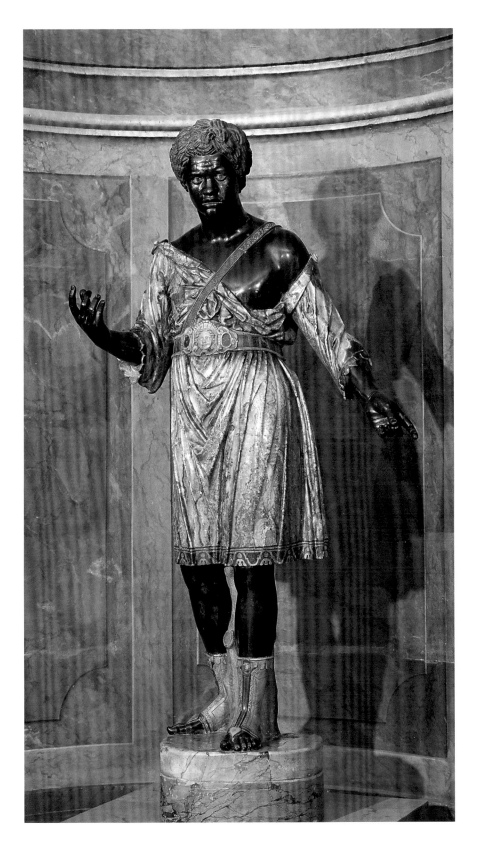

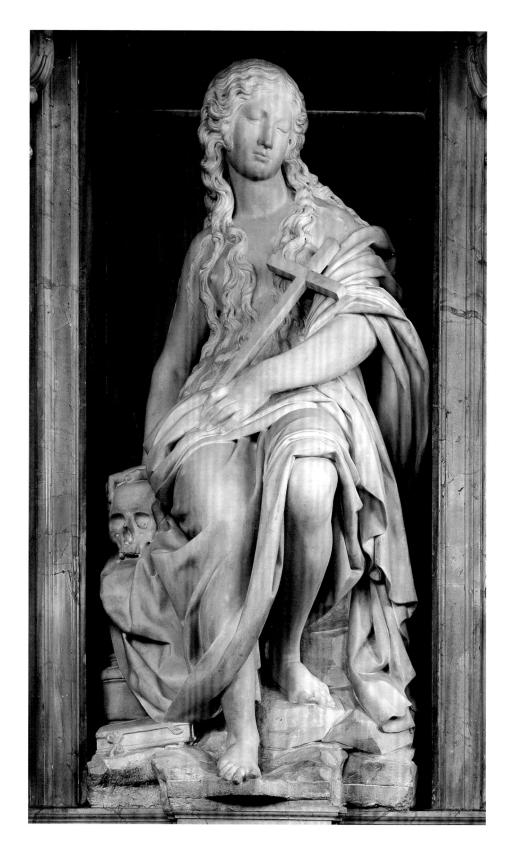

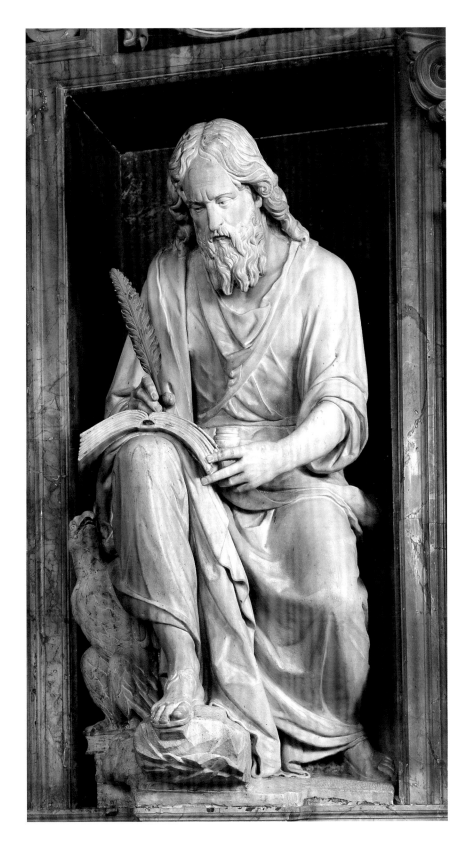

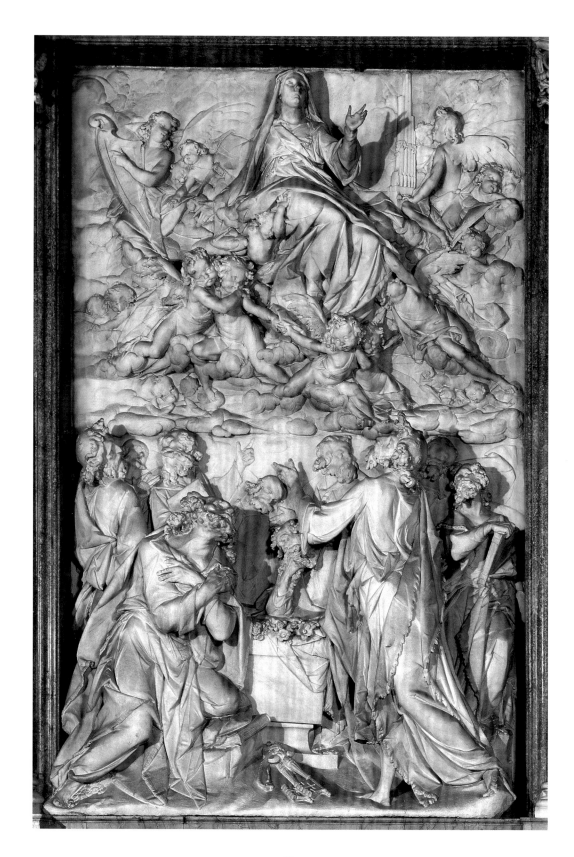

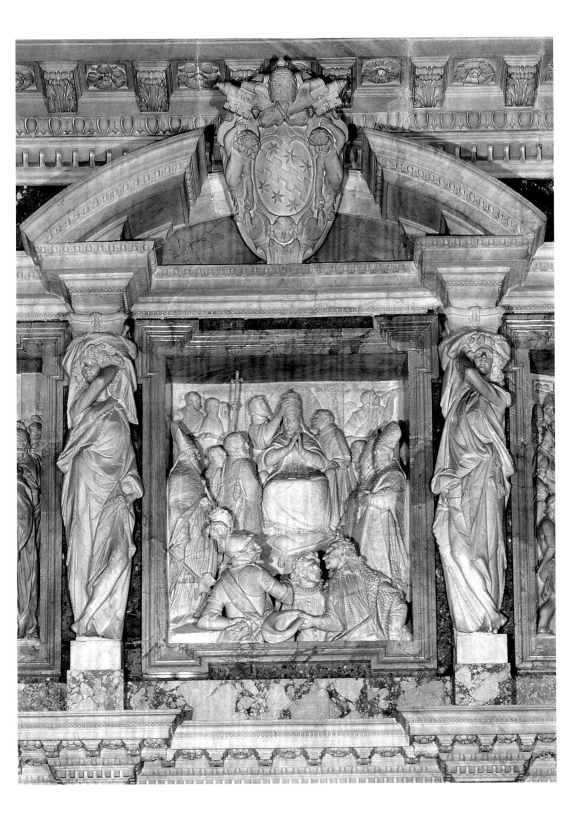

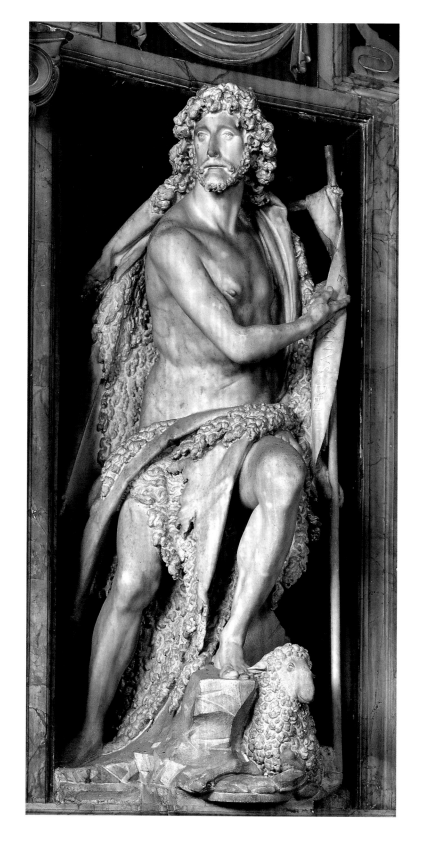

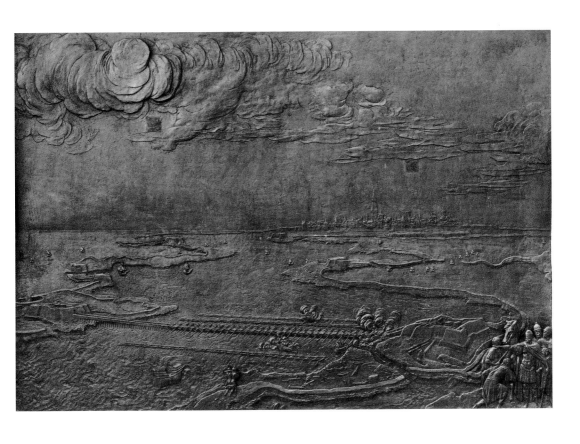

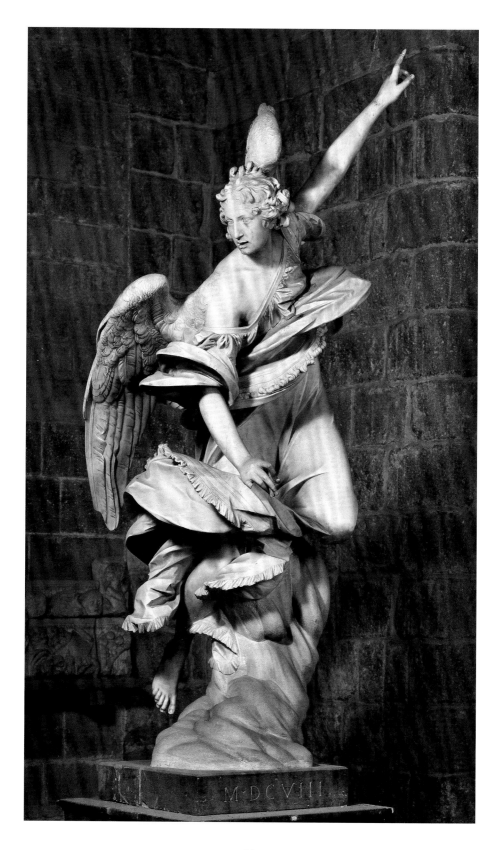

M·DC·VIII

14

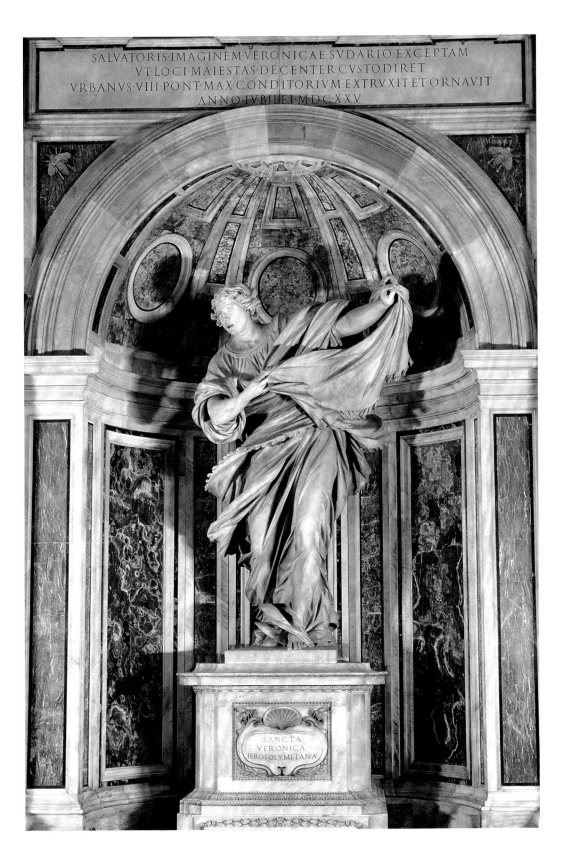

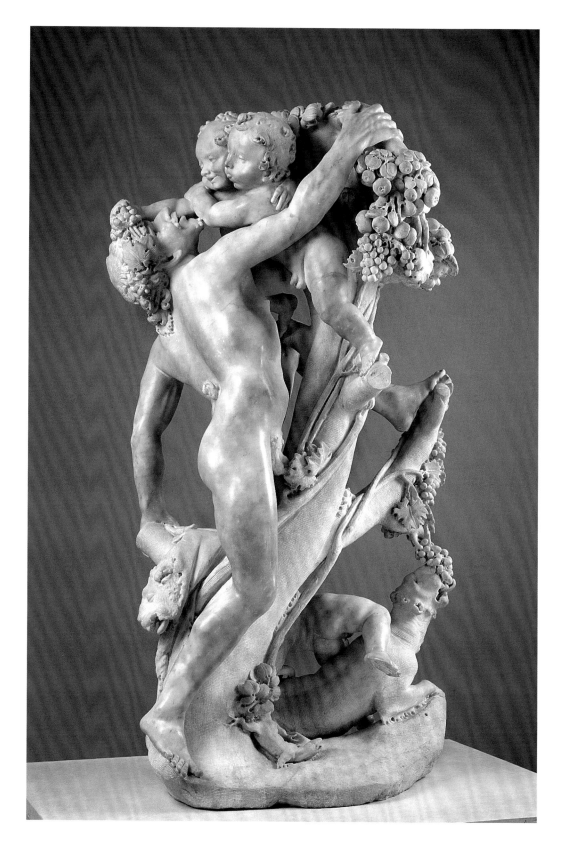

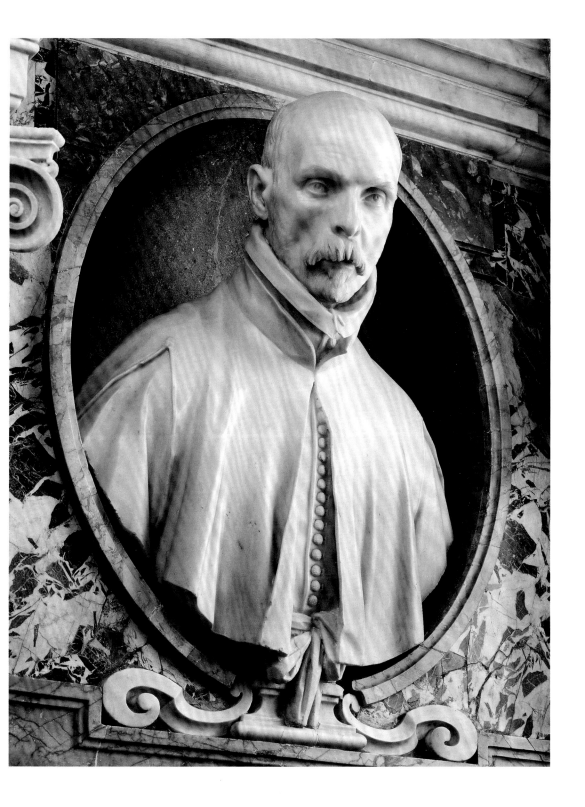

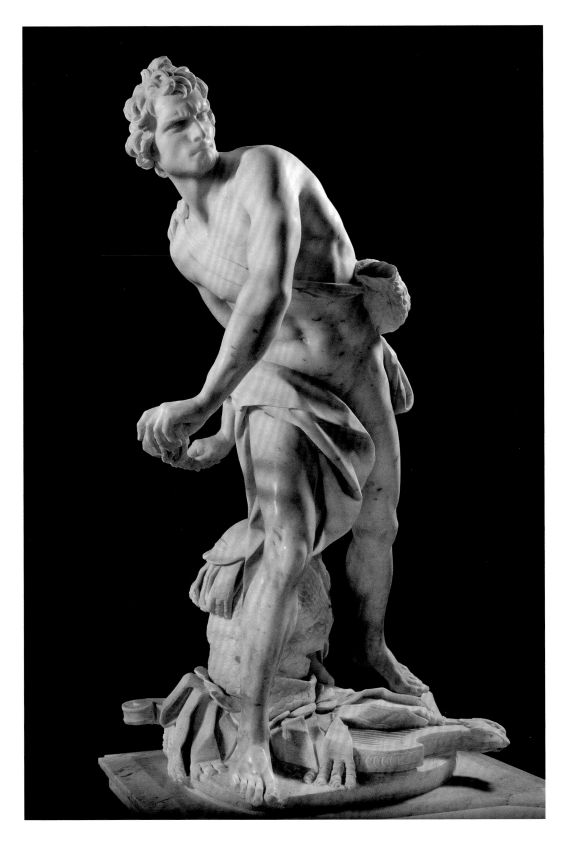

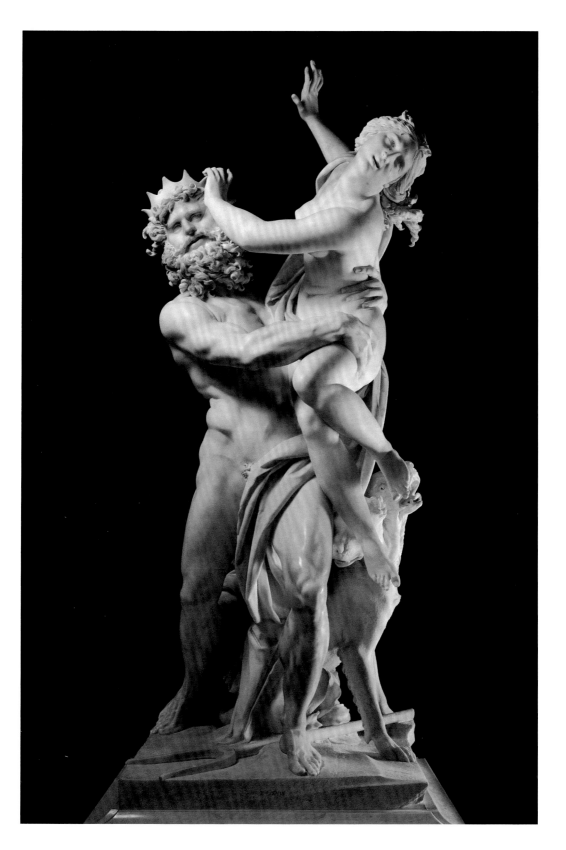

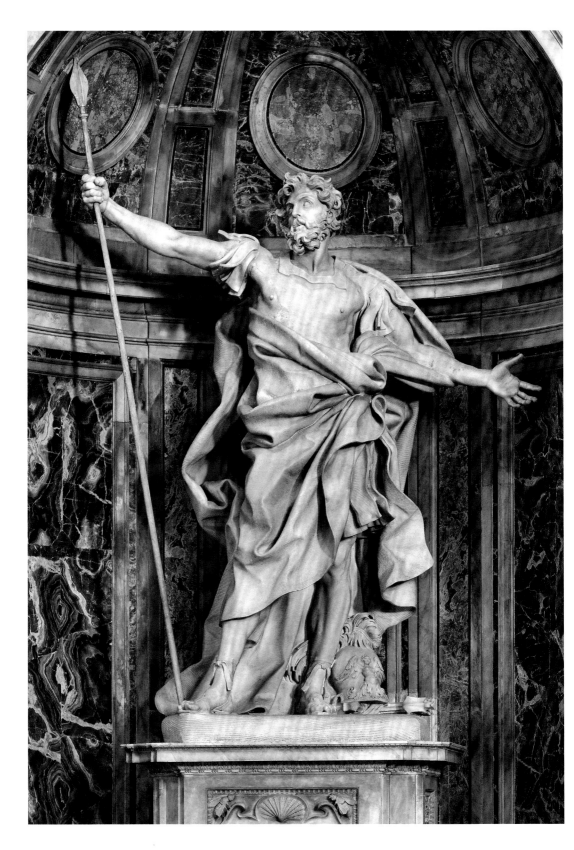

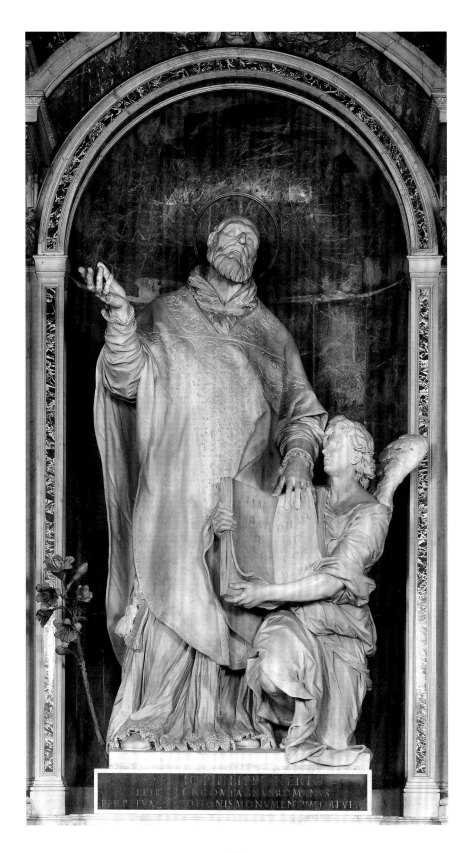

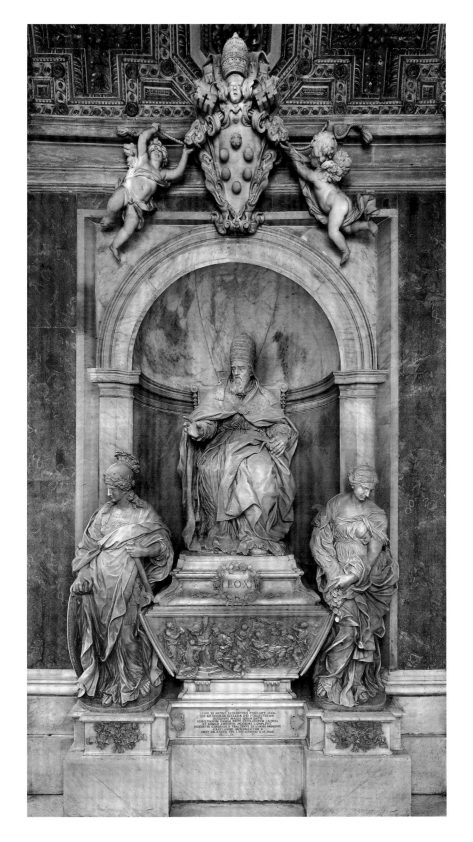

24

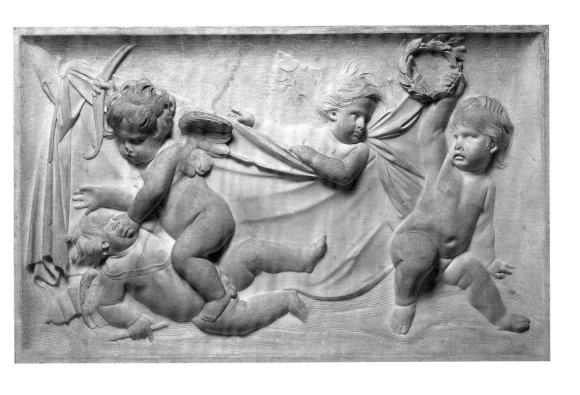

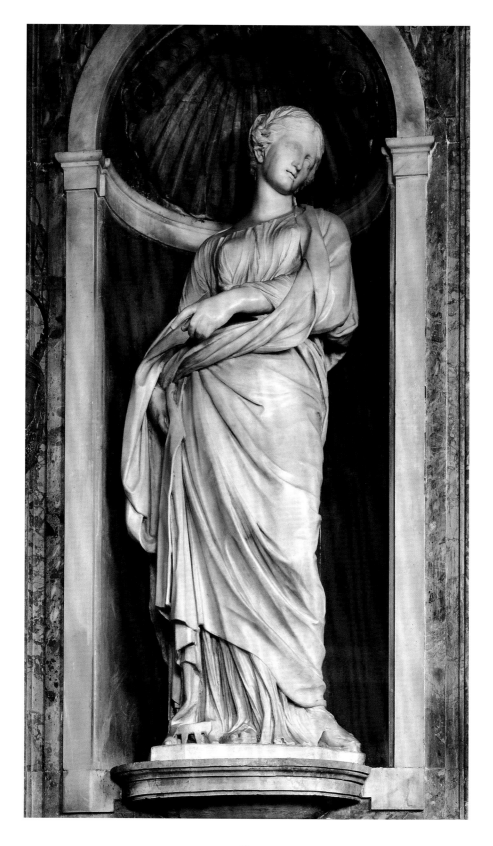

28

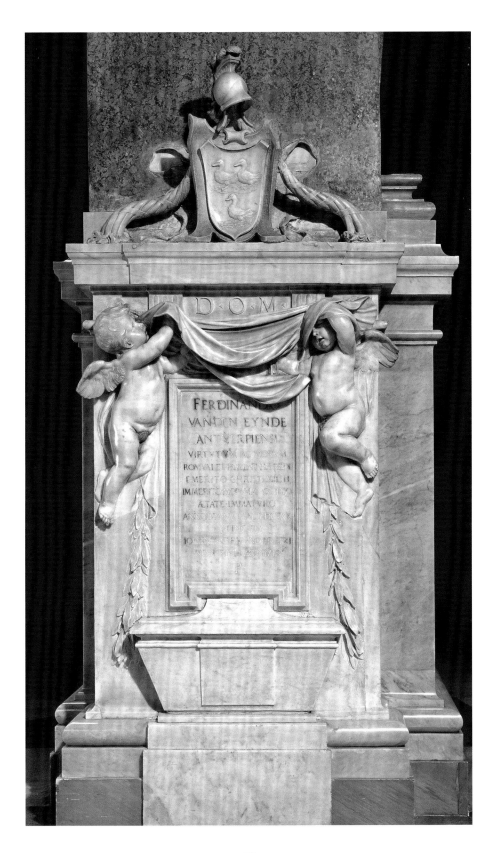

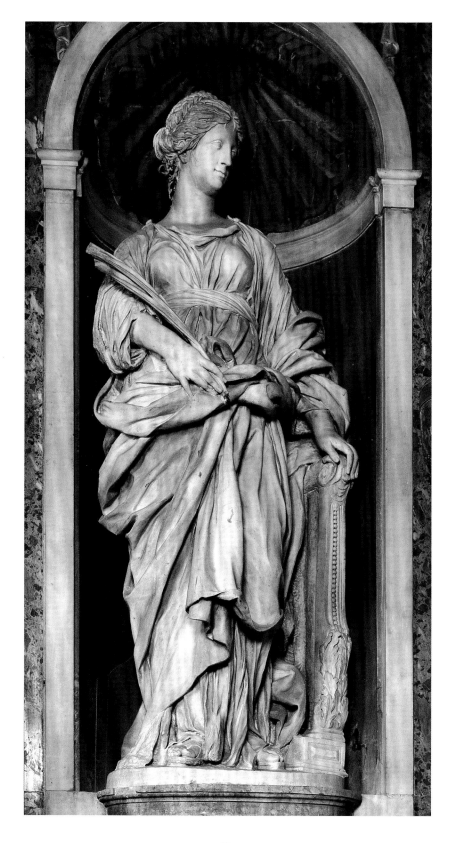

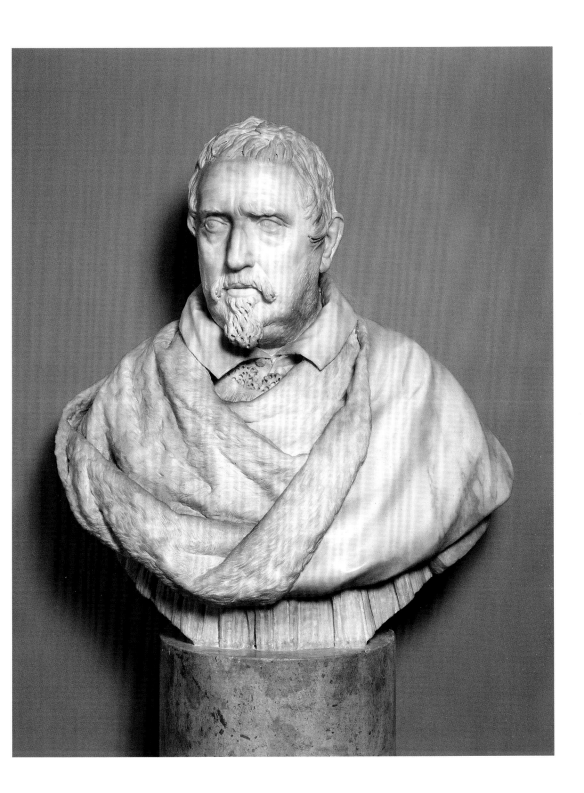

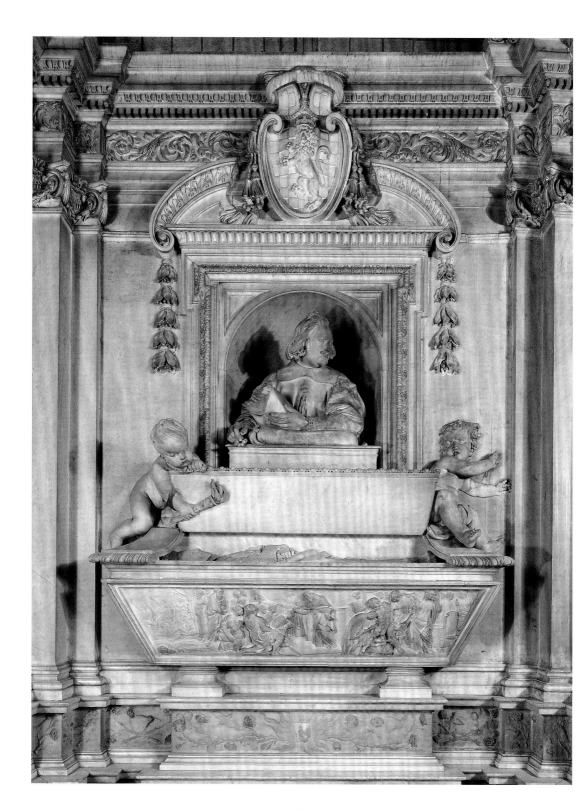

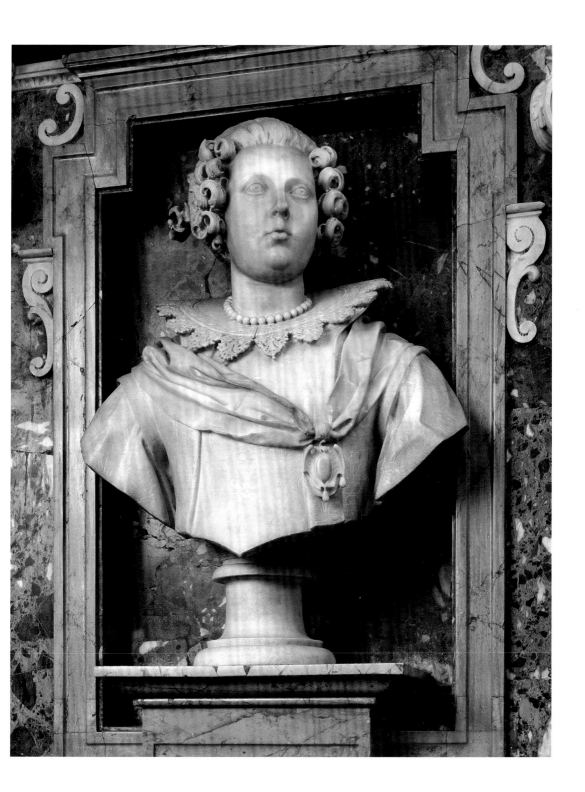

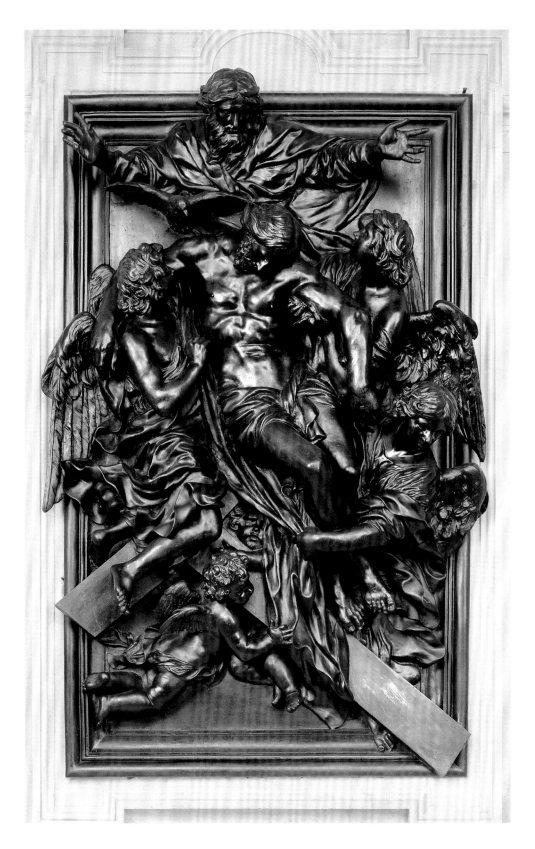

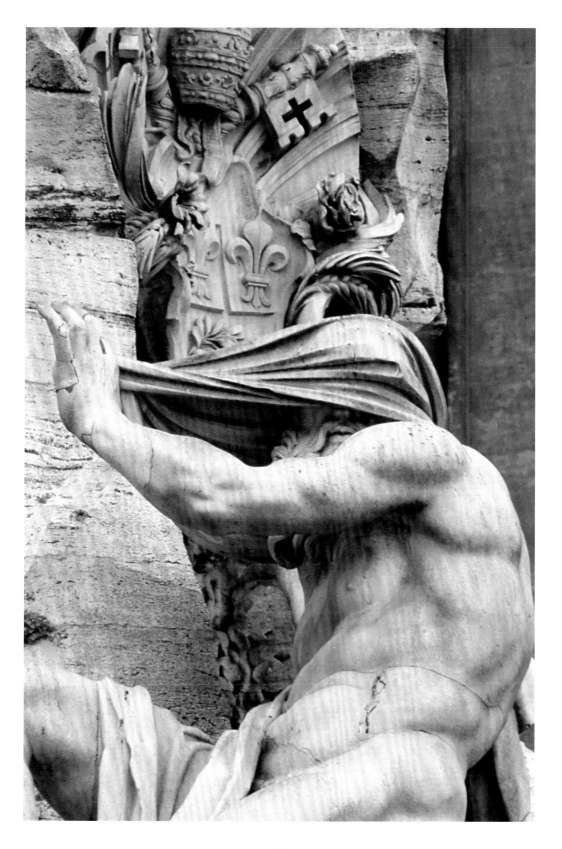

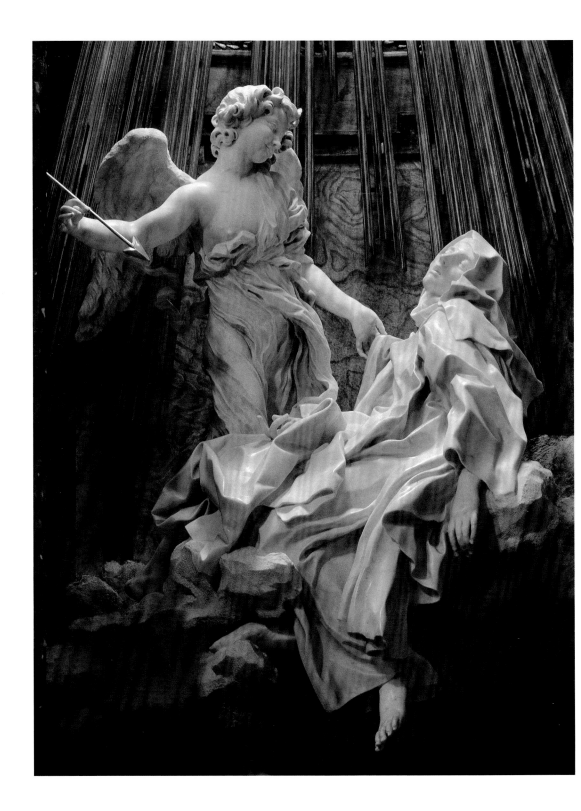

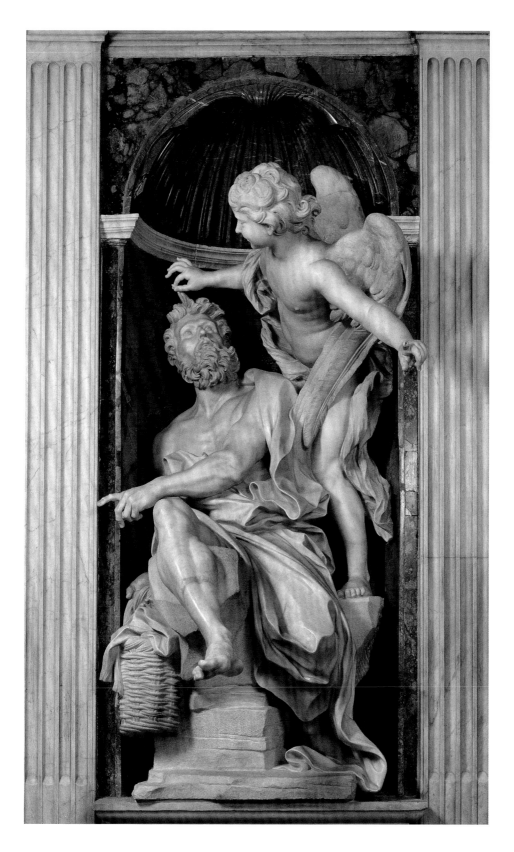

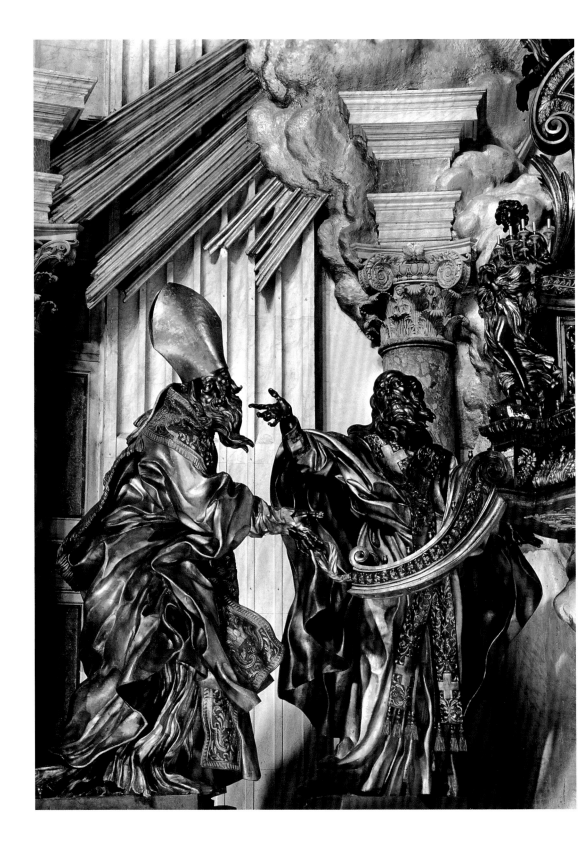

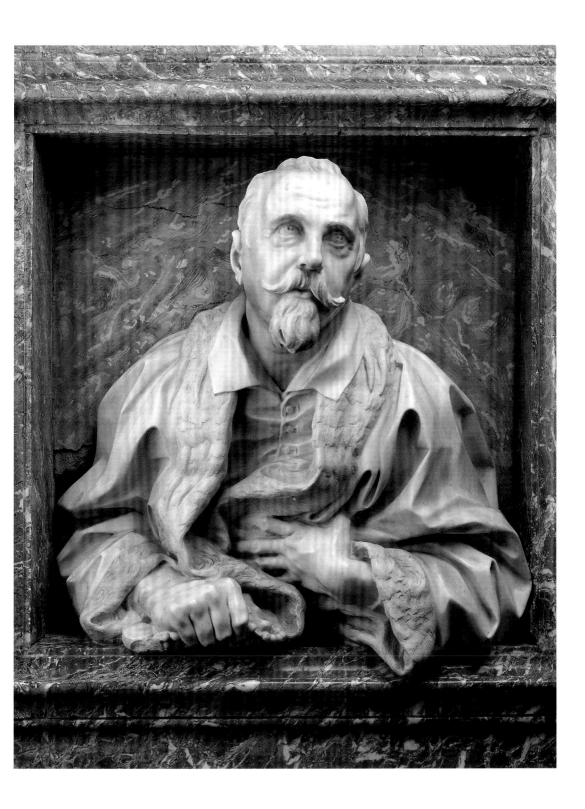

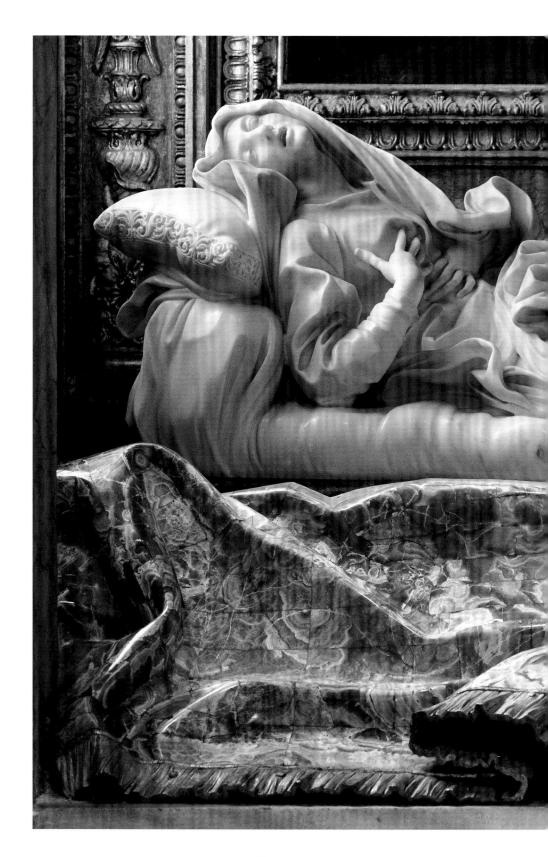

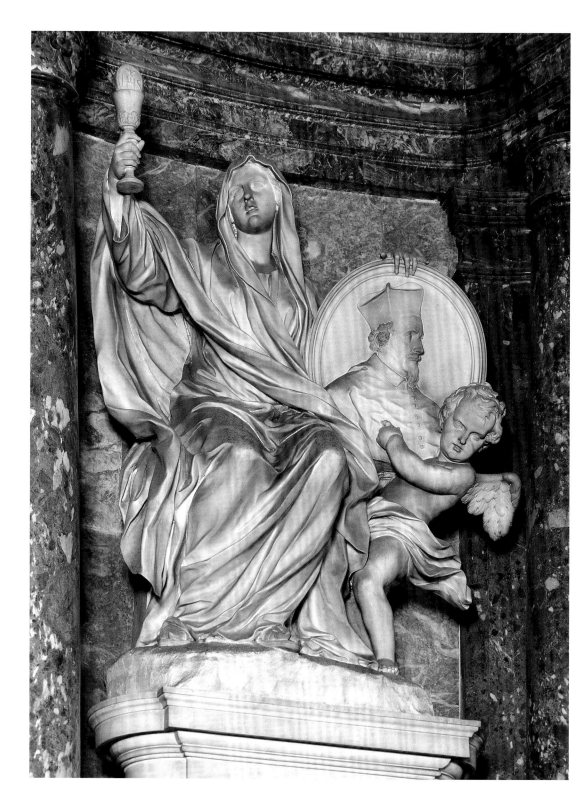

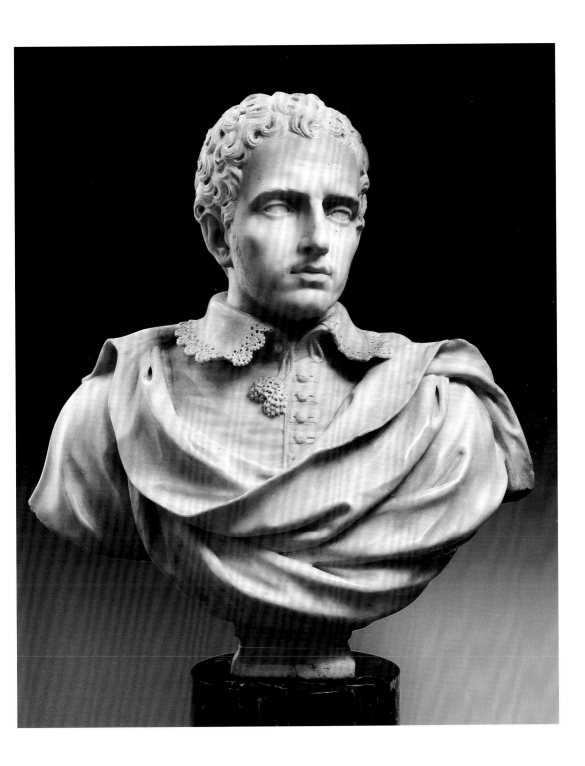

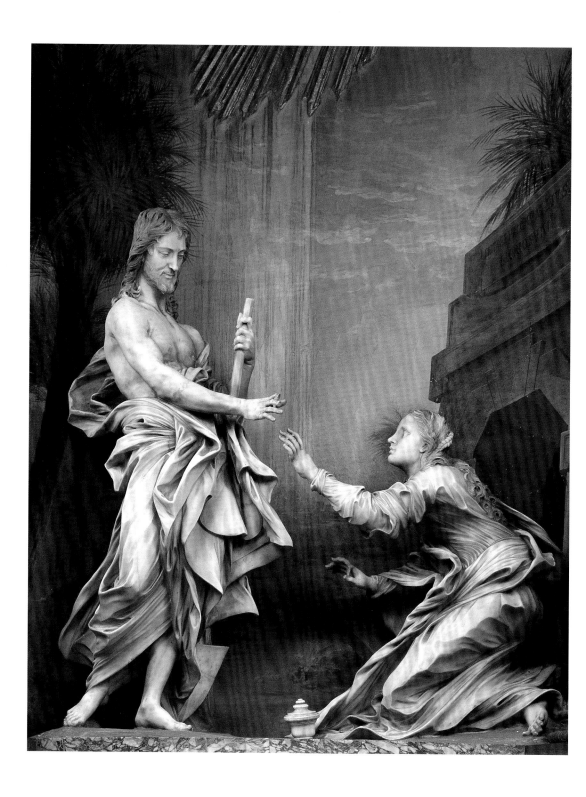

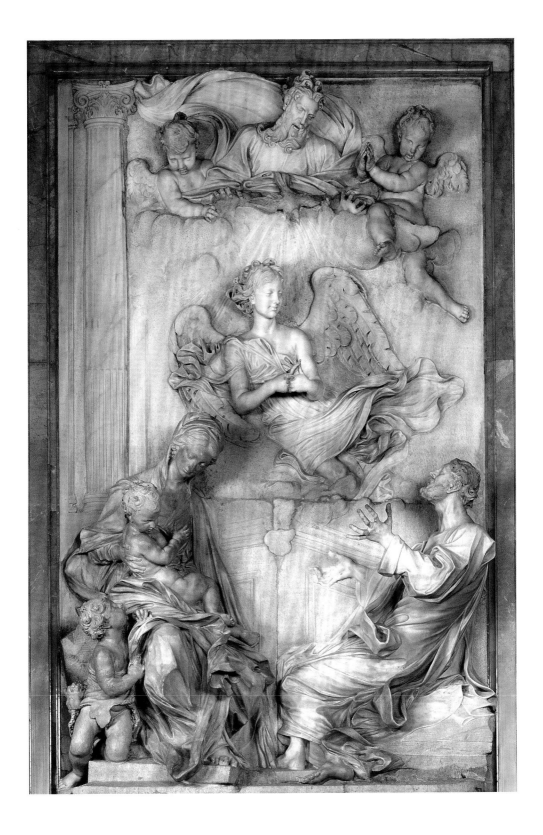

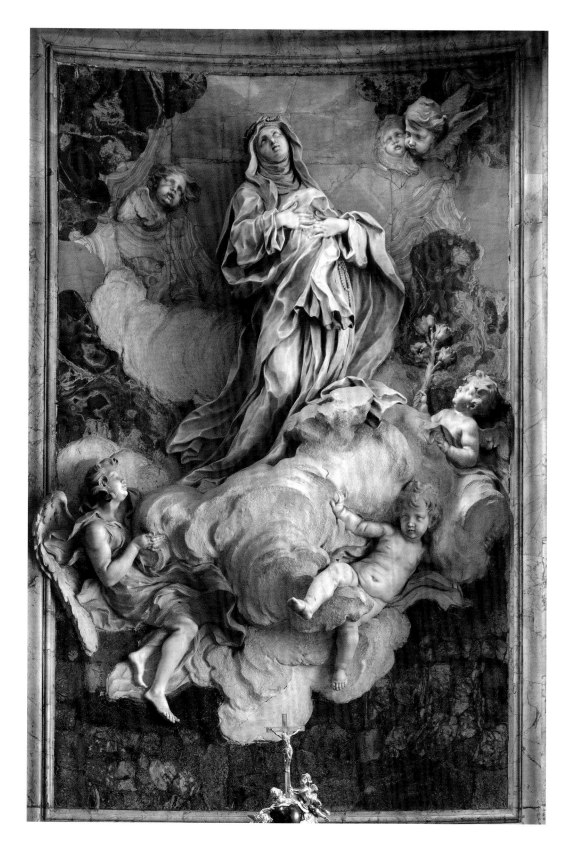

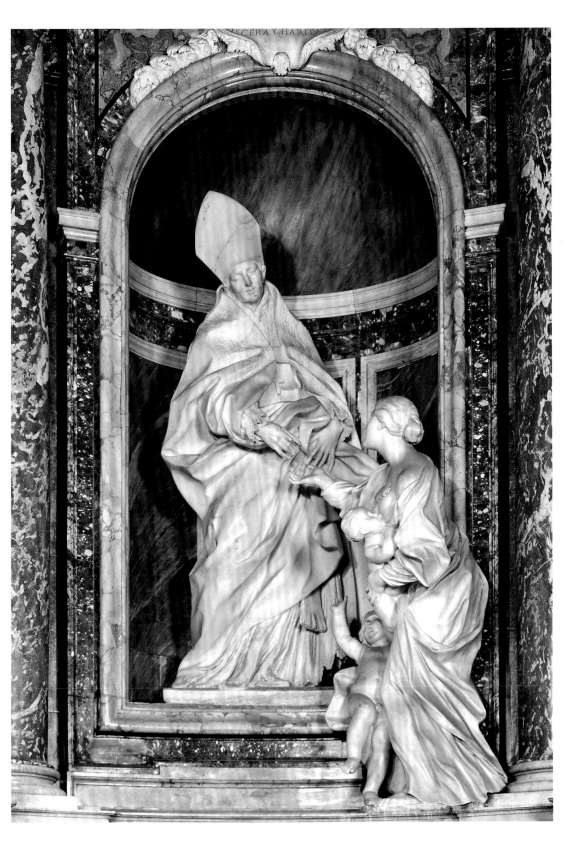

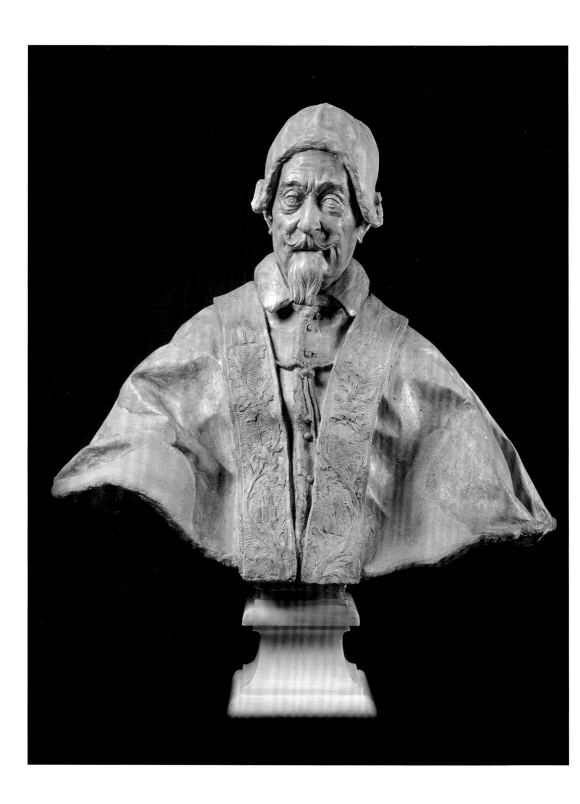

47

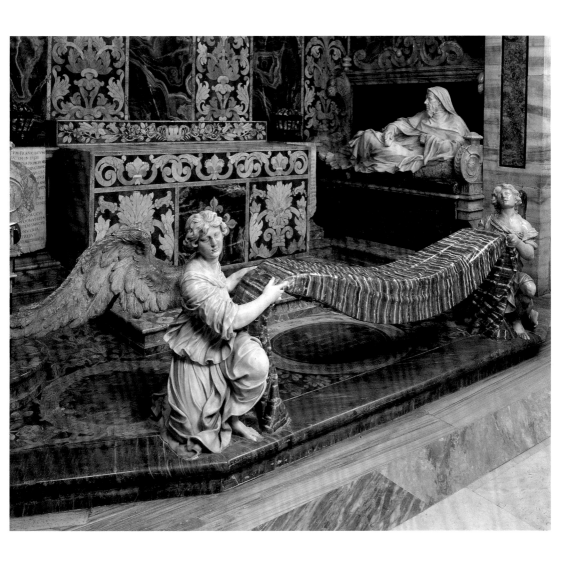

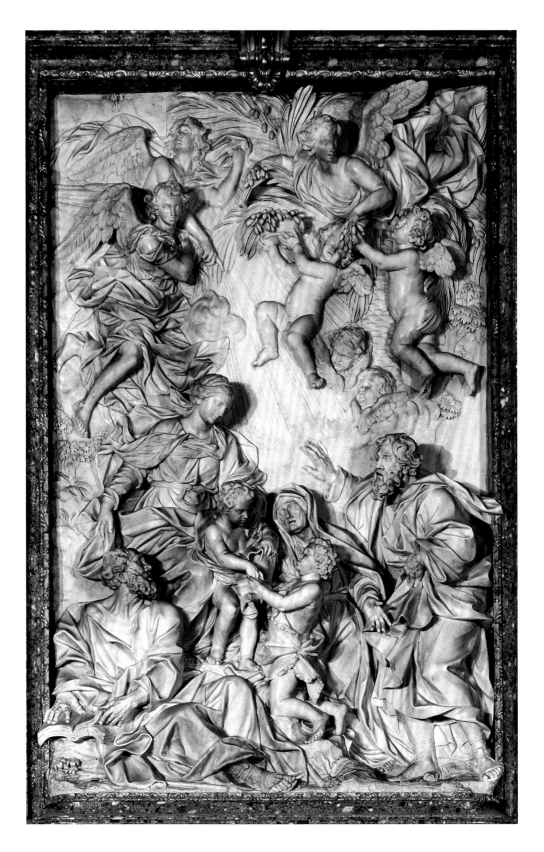

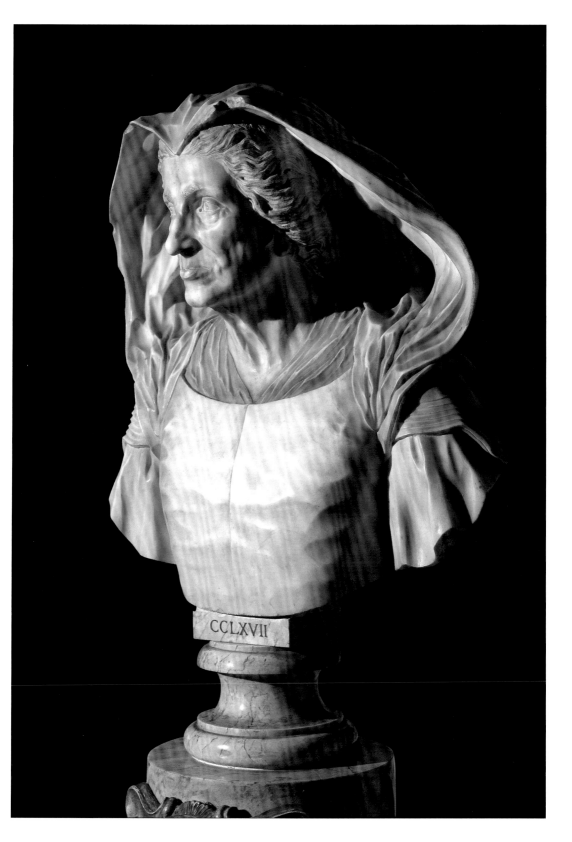

CCLXVII

50

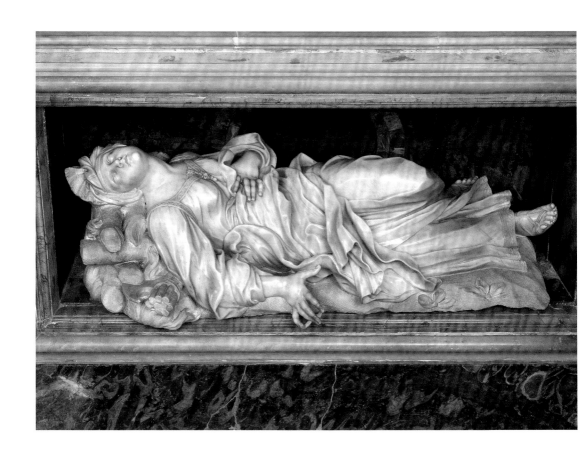

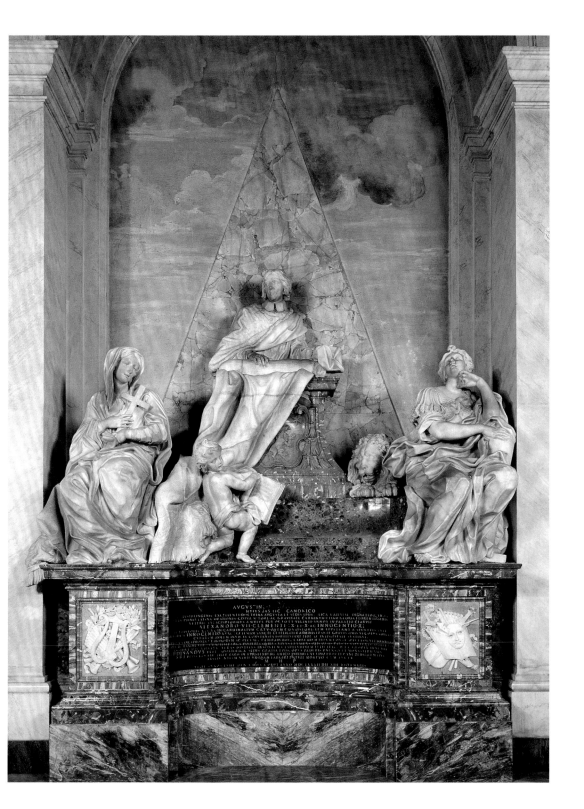

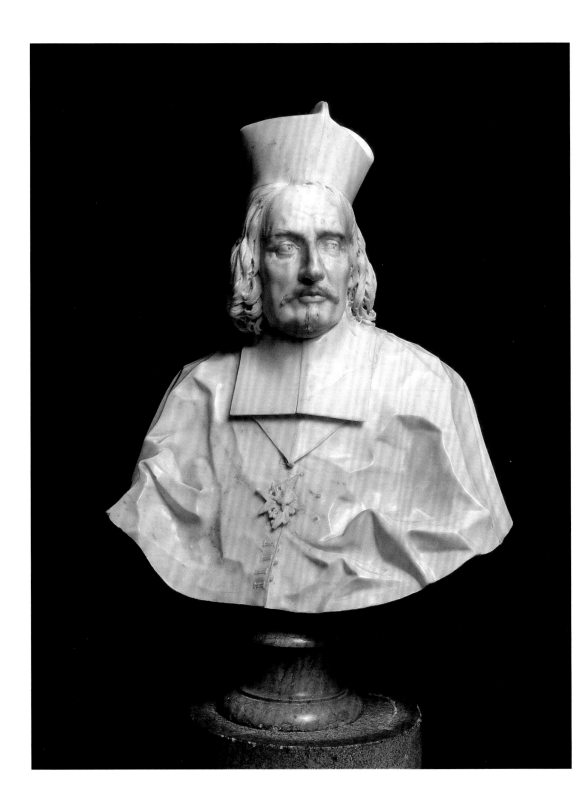

53

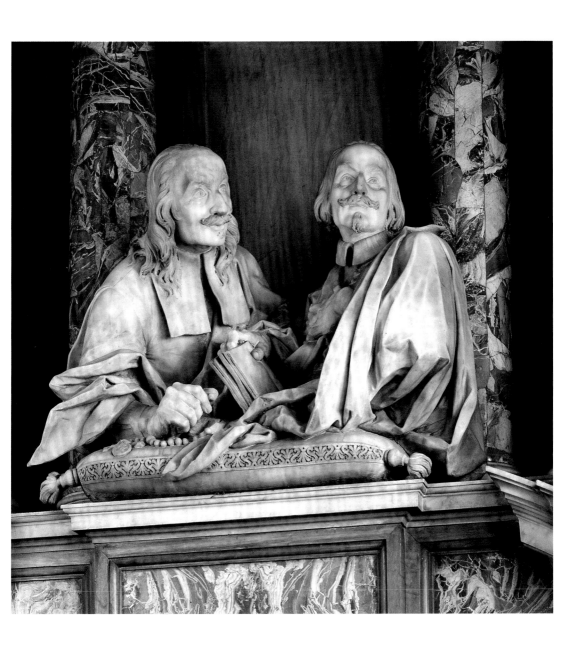

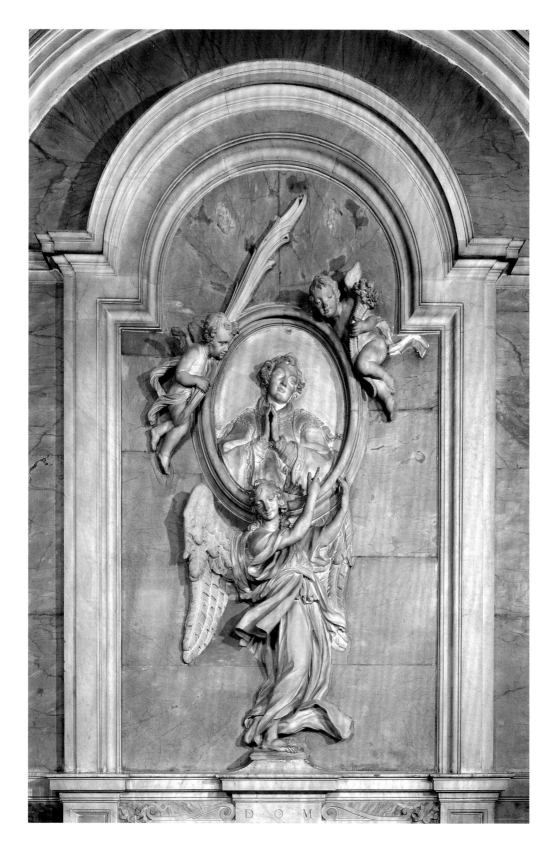

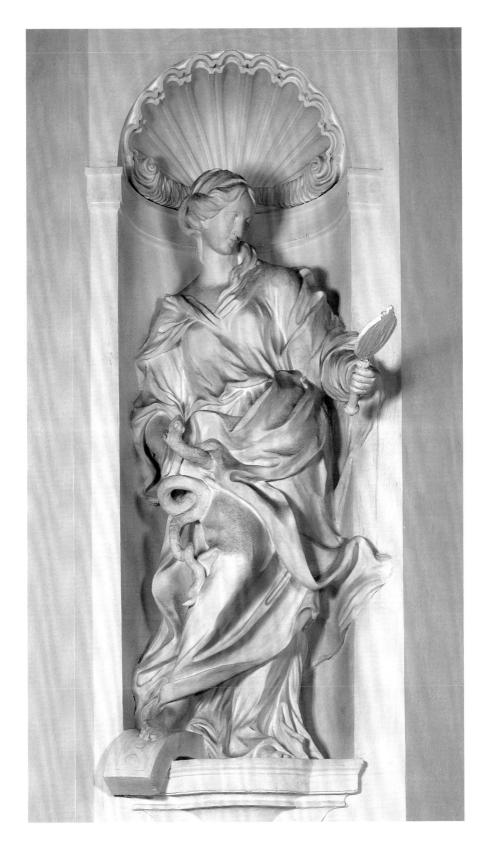

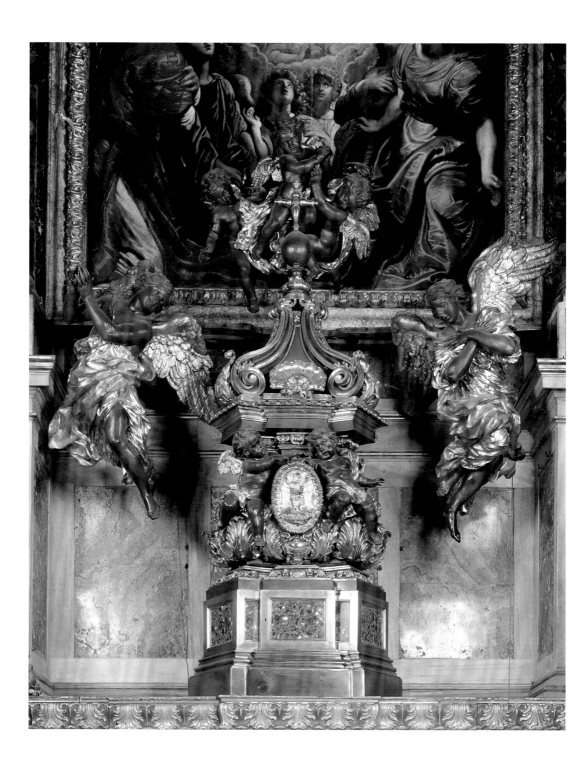

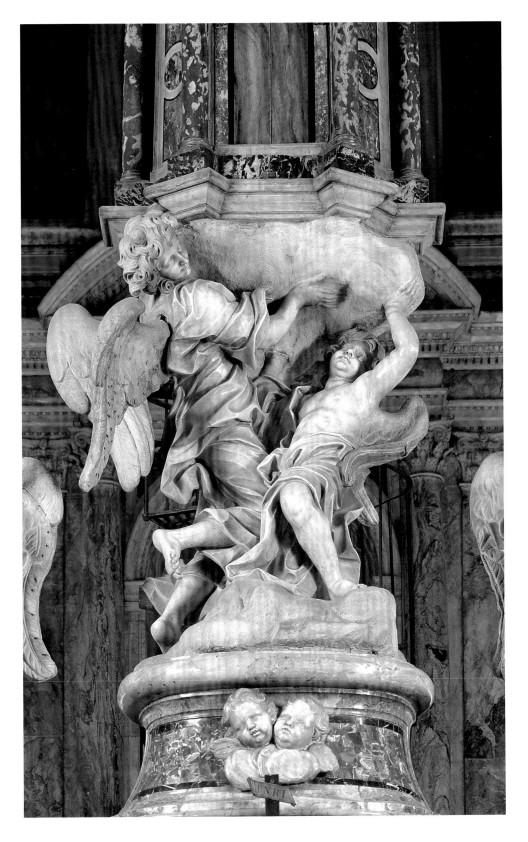

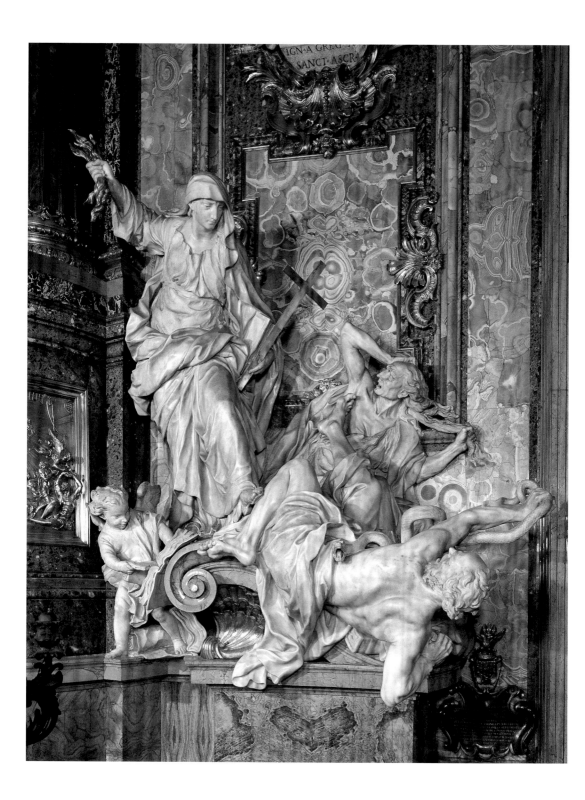

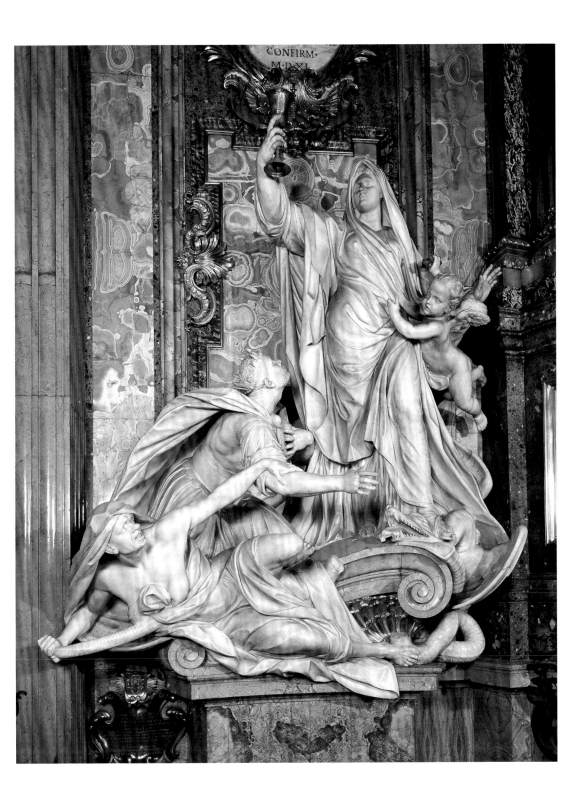

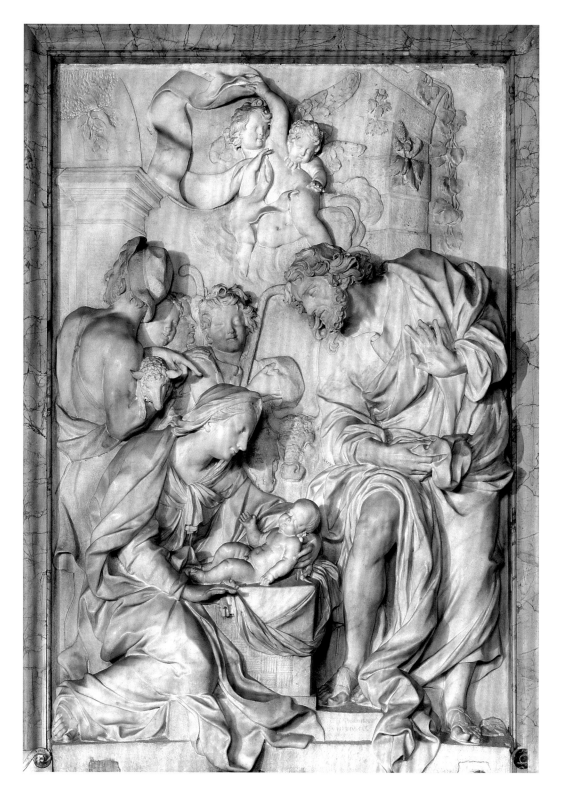

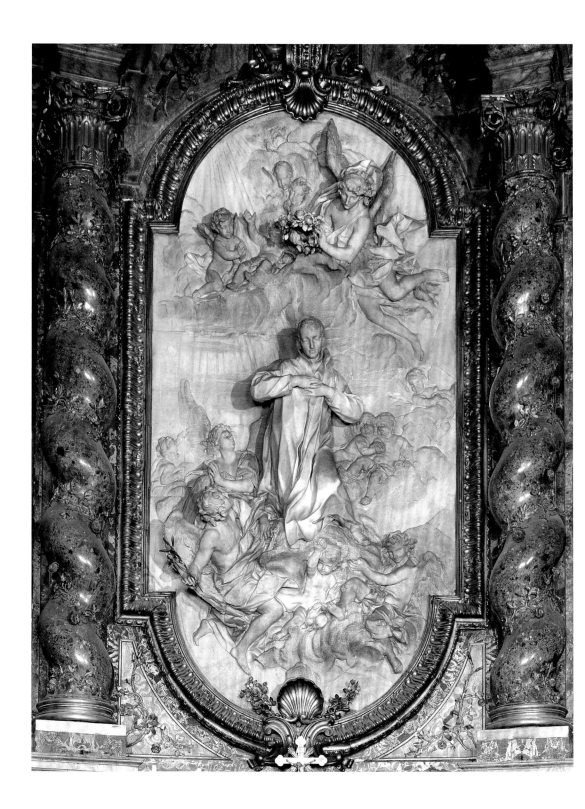

APPENDICES

CHRONOLOGY

1600
Solemn celebrations in Rome for the jubilee
year 1600; Giordano Bruno burned at the stake
in Campo de' Fiori in Rome.

1603
Founding of the Accademia dei Lincei
by Carlo Cesi.

1606
The "War of the Interdict" between
the Pontifical Curia and Venice.

1608
Publication in London of the *Istoria del Concilio
Tridentino* by Paolo Sarpi.

1608–20
Pensieri diversi by Alessandro Tassoni.

1610
Assassination of Henri IV of France.

1612
Ragguagli di Parnaso by Traiano Boccalini.

1616
Galileo is summoned by Cardinal Roberto
Bellarmino: the Church condemns the
Copernican theory.

1618
The Defenestration of Prague and beginning
of the Thirty Years' War.

1620
Battle of Bilà Hora; Gian Battista Marino
publishes the *Galerìa* in Venice.

1623
Maffeo Barberini is elected Pope Urban VIII;
publication in Rome of the *Saggiatore* by
Galileo; Marino publishes his *Adone* in Paris.

1624
Richelieu enters the King's cabinet in Paris.

1627–28
Siege of La Rochelle.

1630
Siege of Mantua; spread of the bubonic plague.

1632
Galileo publishes the *Dialogo dei Massimi Sistemi*.

1633
Trial of Galileo before the Inquisition.

1637
Discours de la méthode by Descartes.

1640
Augustinus by Jansen.

1642
Death of Richelieu; Mazarin prime minister
of France.

1643
Invasion of the Farnese territories by the papal
troops and the War of Castro.

1644
Election of Giovan Battista Pamphilj as
Pope Innocent X; Pietro Sforza Pallavicino
publishes *Del Bene*.

1647
Uprising against Spain in Naples.

1648
Uprising of the Fronde in France;
Peace of Westphalia.

1649
Trial and conviction of Charles I in England.

1650
In Rome great mid-century jubilee.

1651

Thomas Hobbes publishes the *Leviathan*.

1653

Oliver Cromwell becomes Lord Protector of the Commonwealth.

1655

Election of Fabio Chigi as Pope Alexander VII; conversion to Catholicism and abdication of Christina of Sweden.

1656

The bubonic plague spreads through Naples and part of Rome; publication of *Les Provinciales* by Pascal.

1659

Peace of the Pyrenees between France and Spain.

1661

Death of Mazarin; beginning of Louis XIV's absolutist rule.

1664

"Attack of the Còrsi" in Rome and diplomatic clash between the Pontifical Curia and the French monarchy; *Tartuffe* by Molière; *Storia del Concilio di Trento* by Pallavicino.

1669

The Turks conquer Candia.

1672–78

Franco-Dutch war.

1676

Election of Benedetto Odescalchi as Pope Innocent XI.

1678

Conflict between Louis XIV and Innocent XI on the issue of the King's right to administer vacant sees.

1683

Franco-Spanish war; Vienna delivered from the siege of the Turks.

1688

Second English revolution.

1699

Peace of Carlowitz.

THE ARTS IN ROME

1600 ca.

Cavalier d'Arpino and his assistants fresco the transept of San Giovanni in Laterano.

1600–01

Caravaggio paints the canvases for the Cappella Cerasi of Santa Maria del Popolo.

1603

Carlo Maderno completes the church of Santa Susanna.

1605

Annibale Carracci completes the decoration of the Galleria Farnese; Guido Reni paints the *Crucifixion of St Peter* for the Vatican basilica; Caravaggio paints the *Death of the Virgin* for Santa Maria della Scala.

1606

Caravaggio flees Rome and seeks refuge in Naples.

1607–12

Carlo Maderno executes the facade of St Peter's.

1608

Rubens leaves Rome and Italy.

1609–11

Guido Reni frescoes the Annunziata Chapel at the Quirinale.

1612–15
Domenichino paints the *Stories of St Cecilia*
in San Luigi dei Francesi.

1614
Communion of St Jerome by Domenichino
for San Girolamo della Carità; Reni
frescoes the dome of the Casino Borghese
(later Rospigliosi) with the *Triumph of Aurora*.

1616
Lanfranco frescoes the *Apotheosis of the Virgin*
in Sant'Agostino.

1616–17
Giovanni Lanfranco, Carlo Saraceni and others
agree to fresco the Sala Regia in the Vatican.

1617–21
Considerazioni della pittura by Giulio Mancini.

1621
The two *Bacchanals* by Titian are transferred
from the collection of Pietro Aldobrandini
to that of Ludovico Ludovisi; Guercino arrives
in Rome and frescoes the *Chariot of Aurora*
in the Casino Ludovisi.

1624
Nicolas Poussin arrives in Rome.

1624–26
Pietro da Cortona and Agostino Ciampelli
execute the *Stories of St Bibiana* in the church
of the same name.

1625–28
Assumption of Mary by Lanfranco in the dome
of Sant'Andrea della Valle.

1625–32
Maderno, Bernini and Borromini work
in the yard of Palazzo Barberini.

1627–29
Pietro da Cortona frescoes the chapel of Villa
Sacchetti at Castel Fusano.

1628–29
Poussin paints the *Martyrdom of St Erasmus*
for St Peter's.

1629–33
Andrea Sacchi frescoes the *Allegory of Divine
Wisdom* in Palazzo Barberini.

1630
Velázquez paints *Vulcan's Forge*; Valentin paints
the *Martyrdom of Sts Processus and Martinianus*
for St Peter's.

1631 ca.
Sacchi paints the *Vision of St Romuald*.

1634–41
Borromini builds the church and cloister
of San Carlo alle Quattro Fontane.

1635
Pietro da Cortona designes and rebuilds the
church of Santi Luca e Martina.

1636–40
Poussin paints the series of the *Sacraments*
for Cassiano dal Pozzo.

1637
Borromini completes the facade of the Oratorio
dei Filippini.

1639–49
Sacchi decorates the interior of the Lateran
baptistery.

1640–42
Poussin in Paris.

1642
Giovanni Baglione publishes the *Le Vite de'
Pittori, Scultori e Architetti*.

1642–62
Borromini at work on the yard of Sant'Ivo
alla Sapienza.

1646–49
Borromini's works on the nave of San Giovanni in Laterano.

1647–60
Decoration by Pietro da Cortona for the interior of the church of Santa Maria in Vallicella.

1650
Velázquez in Rome paints the *Portrait of Innocent X* (Galleria Doria Pamphilj).

1650–51
Mattia Preti frescoes the apse of Sant'Andrea della Valle with *Stories of St Andrew*.

1651–54
Pietro da Cortona executes frescoes for the dome of the gallery of Palazzo Doria Pamphilj.

1652
Publication of the *Trattato della pittura e scultura* by Pietro da Cortona and Domenico Ottonelli.

1657
Bernini opens the yard for the *Colonnato* of St Peter's; death of Cassiano dal Pozzo.

1658–65
Pietro da Cortona raises the facade of Santa Maria in Via Lata.

1662–66
Bernini executes the Scala Regia in the Vatican.

1664
Giovan Pietro Bellori holds the lecture on the *Idea* at the Accademia di San Luca.

1665
Bernini travels to France; Death of Poussin.

1665–67
Facade of San Carlo alle Quattro Fontane by Borromini.

1666
Founding of the French Academy in Rome.

1666–72
Baciccio represents the *Virtues* on the pillars of Sant'Agnese in Agone.

1667
Death of Borromini.

1669
Death of Pietro da Cortona.

1670 ca.
Triumph of Clemency by Carlo Maratti in Palazzo Altieri.

1671–79
Giacinto Brandi paints the *Fall of the Rebel Angels* in San Carlo al Corso.

1672–75
Baciccio paints the *Triumph in Jesus' Name* on the dome of Il Gesù.

1674–75
Giuseppe Maria Canuti paints the *Apotheosis of St Dominic* on the dome of Santi Domenico e Sisto.

1675–78
Giovanni Coli and Filippo Gherardi paint the *Victory of Lepanto* on the dome of the gallery of Palazzo Colonna.

1682
Christina of Sweden sponsors the publication of the *Vita del cavalier Gian Lorenzo Bernini* written by Filippo Baldinucci.

1682–83
Carlo Fontana executes the facade of San Marcello al Corso.

1685
Carlo Maratti paints the *Virgin and Saints* for the Spada Chapel in Santa Maria in Vallicella.

1691–94
Andrea Pozzo paints the *Apotheosis of St Ignatius* on the dome of Sant'Ignazio.

1693
Publication of the treatise *Perspectiva pictorum et architectorum* by Andrea Pozzo.

SCULPTURE IN ROME

1600
Stefano Maderno works on the statue of *St Cecilia* in Santa Cecilia in Trastevere; Camillo Mariani completes the decoration of the interior of San Bernardo alle Terme.

1602–03
Nicolas Cordier carves *St Gregory the Great* and *St Silvia* for the oratory of San Gregorio al Celio commissioned by Cesare Baronio.

1604–05
Cordier carves *St Agnes* for Sant'Agnese fuori le Mura.

1605
Francesco Mochi executes the *Angel Gabriel* for the Duomo of Orvieto.

1607–10
Assumption of the Virgin by Pietro Bernini for Santa Maria Maggiore.

1608
Mochi carves the *Madonna of the Annunciation* for the Duomo in Orvieto.

1609
Cordier completes the bronze statue of *Henri IV* for the porch of Santa Maria Maggiore.

1610
Mochi delivers the statue of *St Philip* to the Duomo in Orvieto.

1611
Consecration of the Aldobrandini Chapel in Santa Maria sopra Minerva; Camillo Mariani executes *St John the Evangelist* for the Pauline Chapel in Santa Maria Maggiore.

1612
Pietro Bernini is paid for the bust of *Antonio Coppola*; *St Martha* by Mochi for the Barberini Chapel in Sant'Andrea della Valle; death of Cordier.

1614–15
Gian Lorenzo Bernini sculpts *The Goat Amalthea* for Scipione Borghese; Pietro Bernini sculpts *St John the Baptist* for the Barberini Chapel in Sant'Andrea della Valle.

1614–16
Ambrogio Buonvicino carves the scene of the *Traditio Clavium* on the facade of St Peter's.

1616
Consecration of the Pauline Chapel; Pietro Bernini is paid for the "terms" of Villa Borghese.

1618
François Dusquesnoy arrives in Rome.

1618–19
Gian Lorenzo Bernini carves the group of *Aeneas and Anchises* for the Galleria Borghese.

1620–24
Alessandro Algardi at Mantua.

1621–24
Pluto and Proserpina by Gian Lorenzo Bernini for the Galleria Borghese.

1622
Giuliano Finelli joins the *bottega* of the Berninis; Gian Lorenzo Bernini executes the half-length portrait of *Pedro Foix de Montoya* for the tomb in San Giacomo degli Spagnoli.

1622–25
Apollo and Daphne by Gian Lorenzo Bernini
for the Galleria Borghese.

1624
St Bibiana by Gian Lorenzo Bernini; beginning
of the association between Poussin and
Dusquesnoy; unveiling of the *Funeral Monument
of Cardinal Roberto Bellarmino* in Il Gesù with
the bust carved by Bernini.

1624–33
Baldacchino for St Peter's by Gian Lorenzo
Bernini.

1625
Algardi in Rome.

1627–29
Bernini executes the *Barcaccia*.

1628
Bernini begins the *Funeral Monument
of Urban VIII* (completed in 1647).

1628–29
Sculptures by Algardi for San Silvestro
al Quirinale.

1629
Death of Pietro Bernini. In the *bottega* work
begins on the figures of *St Longinus* and
St Helen for St Peter's.

1629–33
St Susanna by Dusquesnoy for Santa Maria di
Loreto; Finelli carves *St Cecilia* for Santa Maria
di Loreto.

1630
Bernini and Algardi execute the statue of *Carlo
Barberini* for the Sala dei Capitani in the
Campidoglio.

1632
Bernini sculpts the bust of *Scipione Borghese*.

1633
Bernini begins the yard for the relics loggias
in the crossing of St Peter's.

1633–40
Dusquesnoy works on the *Monument
of Ferdinand van der Eynde* in Santa Maria
dell'Anima.

1634–44
Funeral Monument of Leo XI carved by Algardi.

1635–38
Algardi executes the Frangipane busts in the
Cappella di San Paolo in San Marcello al Corso
and carves *St Filippo Neri with an Angel* for the
sacristy of Santa Maria in Vallicella.

1635–40
Bernini executes the statue of *Urban VIII* in the
Palazzo dei Conservatori.

1636
Payment made for the two statues on the facade
of Santi Domenico e Sisto sculpted by Stefano
Maderno.

1637–38
Bust of *Garzia Millini* executed by Algardi
for Santa Maria del Popolo.

1640
Unveiling of *St Andrew* by Dusquesnoy and
St Veronica by Mochi for the crossing of
St Peter's.

1642–43
Fountain of the Triton by Bernini.

1644
Fountain of the Bees by Bernini.

1645–46
Bernini sculpts the low relief figuring *Pasce oves
meas* for the atrium of St Peter's.

1645–48
Decoration by Algardi at the Villa Doria
Pamphilj on the Janiculum.

1645–50
Algardi executes the bronze statue of Innocent X
for the Palazzo dei Conservatori.

1646–50
Algardi carves *St Leo Repulsing Attila* for St
Peter's. With his assistants he works on the stucco
Stories for the nave of San Giovanni in Laterano.

1647
Bernini executes the cenotaph of Sister Maria
Raggi in Santa Maria sopra Minerva;
completion of the yard in the Raimondi Chapel
in San Pietro in Montorio.

1647–50
Fountain of the Four Rivers in Piazza Navona
by Bernini.

1647–51
Bernini works on the Cornaro Chapel in Santa
Maria della Vittoria.

1649
Bernini and his assistants complete the
decoration of the pillars in the nave of St Peter's.

1649–51
Noli me tangere by Bernini and Antonio Raggi
for Santi Domenico e Sisto.

1650
Algardi stuccoes the interior facade
of Sant'Ignazio.

1654–55
Fountain of the Moor in Piazza Navona
by Bernini.

1655–61
Plastic decoration of Santa Maria del Popolo
under the direction of Bernini.

1657
Cosimo Fancelli executes the *Trinity* from
a design by Pietro da Cortona for the Chigi
Chapel in Santa Maria della Pace.

1657–66
Yard opened for the *Cathedra Petri* in St Peter's.

1662–65
Works by Raggi in Sant'Andrea al Quirinale.

1664
Ercole Ferrata delivers *St Agnes at the Stake*
for Santa Agnese in Agone.

1666–67
Bernini executes the *Elephant* with the obelisk
for Piazza della Minerva.

1667
Death of Melchiorre Caffà.

1668 ca.
Bernini carves the bust of *Gabriele Fonseca*
for San Lorenzo in Lucina.

1668–70
Bernini and his assistants sculpt the *Angels with
the Symbols of the Passion* for Ponte Sant'Angelo.

1669
Ferrata completes the *Charity of St Thomas
of Villanova* for Sant'Agostino started by Caffà.

1669–77
Bernini works on the *Equestrian Monument
of Louis XIV.*

1670
Unveiling of the *Emperor Constantine* by Bernini
in the atrium of St Peter's.

1670–74
Raggi executes the altar of the Ginetti Chapel
in Sant'Andrea della Valle.

1672
The statue of *St Sebastian* designed by Ciro Ferri and carved by Giuseppe Giorgetti is placed beneath the altar of San Sebastiano fuori le Mura.

1672–74
Bernini and his assistants work on the ciborium of the Sacrament in St Peter's.

1672–77
Bernini works on the *Funeral Monument of Alexander VII* in St Peter's.

1672–79
Stucco decoration of the interior of Il Gesù by Antonio Raggi.

1674
Bernini completes the *Blessed Ludovica Albertoni* for San Francesco a Ripa; Domenico Guidi carves the *Funeral Monument of Cardinal Lorenzo Imperiali* for Sant'Agostino.

1679–81
Lorenzo Ottoni works on the *Funeral Monument of Francesco Barberini* in the sacristy of St Peter's.

1682–86
Funeral Monument of Clement X in St Peter's from a design by Mattia de' Rossi.

1683–84
Francesco Aprile executes the busts of *Pietro* and *Francesco Bolognetti* in the church of Gesù e Maria.

1685
Unveiling of the *Monument of Monsignor Agostino Favoriti* in Santa Maria Maggiore.

1685–86
Camillo Rusconi models in stucco the *Cardinal Virtues* designed by Raggi for a chapel in Sant'Ignazio.

1686
Deaths of Ferrata and Raggi.

1695–96
Execution of the *Stories of St Ignatius* for the saint's altar in Il Gesù designed by Andrea Pozzo.

1696–1701
Carlo Fontana supervises the yard for the *Funeral Monument of Christina of Sweden* in St Peter's.

1697–1701
Funeral Monument of Innocent XI in St Peter's by Pierre-Étienne Monnot.

1698–99
Faith Crushing Idolatry by Jean-Baptiste Théodon and *Religion Overthrowing Heresy* by Pierre Legros for the St Ignatius altar in Il Gesù.

1699
Low reliefs by Pierre-Étienne Monnot with the *Adoration of the Shepherds* and the *Flight into Egypt* for Santa Maria della Vittoria.

ANNOTATED BIBLIOGRAPHY

In seventeenth-century official writings on the arts, sculpture was not given the wide reception reserved for painting. So, as mentioned in the essay, in the first decades of the century sculpture did not benefit from the presence of an authentic "connoisseur", as we would say today, in the way that Giulio Mancini benefited painting. On the theoretic level, sculpture suffered the consequences of the endless sixteenth-century argument over the "comparison" that decreed painting the loftiest and most liberal of the figurative arts, one capable of translating into its own language even the most complex contents, which was traditionally the prerogative of poetry. Even the fame of the great Michelangelo, the modern sculptor by definition, had not succeeded in overcoming the primacy of painting; and, as we know during the seventeenth century, even Buonarroti's popularity underwent an irresistible decline that was fully taken for granted and then codified by Bellori in his famous works. Furthermore, at the dawn of the century the presence in Rome of brilliant, highly innovative painters like Annibale Carracci, Caravaggio and Pieter Paul Rubens, who had no equivalents in the field of sculpture, confirmed the supremacy of painting in the artistic theory that was advanced more or less implicitly by the various historians. When, with the rise of Bernini, sculpture found its greatest representative, one who was able to impose his personal hegemony over all the arts, a certain number of historians and theoreticians perceived his brilliant, experimental art as deeply subversive of the golden rules passed down by the ancients.

Others did not forgive the artist his constant visibility, the privileged relationship he enjoyed with the popes, or the "dictatorship" he exerted over all the arts. Consequently, a sort of personal diffidence with regard to Bernini induced Bellori, the greatest historian of seventeenth-century arts, to omit the artist's name in his monumental volume entitled *Lives of the Artists*, which was published in 1672 but matured over the years. Nor did Giovanni Battista Passeri miss any opportunity to put Gian Lorenzo's personality in a bad light, and failed to devote a biography to the greatest sculptor of his time. Yet Bernini, perhaps as no other master of his day, was the object of panegyrical monographic writings like the *Vita del Cavalier Gio. Lorenzo Bernino* (1682), ed. S. Samek Ludovici (Milan: Edizione del Milione, 1948), written by Filippo Baldinucci, and the *Vita del Cavalier Gio. Lorenzo Bernino* (Rome: Bernabò, 1713) published by his son Domenico Bernini. But Baldinucci's biography was officially commissioned right after the great artist's demise by Christina of Sweden, who had always been a fervent admirer of the *cavaliere*. And the one edited by Domenico (despite the editorial chronology, Baldinucci's text was derived from it), as Tommaso Montanari argued, is based on his brother Pier Filippo's project and results from Gian Lorenzo's desire for self-assertion, "Bernini e Cristina di Svezia. Alle origini della storiografia berniniana", in A. Angelini, *Gian Lorenzo Bernini e i Chigi tra Roma e Siena* (Cinisello Balsamo [Milan]: Silvana Editoriale, 1998), pp. 331–447. Other important contemporary sources for Bernini's life and career are the writings by Paul Fréart de Chantelou (*Journal de voyage du Cavalier Bernin en France par M. de Chantelou. Manuscrit inédit publié et annoté par Ludovic de Lalanne*. Paris, 1885) and the abbé de la Chambre ("Eloge de M. le cavalier Bernin par M. l'abbé de la Chambre de l'Académie Française", in *Le Journal de sçavan pour l'année MLCXXXI*, v 9, Amsterdam (1682), pp. 56–62. Fréart de Chantelou was the gentleman in charge of accompanying Bernini during his stay in France (June–October 1665) and wrote an accurate account from that point of view, whereas De La Chambre was a member of the clergy who met Bernini in France and, fascinated by his personality, corresponded with the artist until his death. Chantelou's text, although in an abridged version, also appeared in Italian: *Viaggio del Cavalier Bernini in Francia* (Palermo: Sellerio, 1988), in the translation by Stefano Bottari

(1946). For the piece by De la Chambre, see T. Montanari, "Antologia di critici, Pierre Cureau de la Chambre e la prima biografia di Gian Lorenzo Bernini", *Paragone* 24–25 (1999), pp. 103–32.

Among the seventeenth century historians who wrote on sculpture in Rome, the principal source regarding the first half of the century, though laconic and lacking in literary ambitions but reliable and worthy of attention, is Giovanni Baglione, *Le Vite de' Pittori, Scultori et Architetti dal Pontificato di Gregorio XIII del 1572 fino a' tempi di Papa Urbano VIII nel 1642* (Rome: Andrea Fei, 1642). The other biographers writing in the seventeenth and eighteenth centuries who focused their attention on sculptors are: G.P. Bellori, *Le vite de' pittori, scultori e architetti moderni* (1672) ed. E. Borea, introduction by G. Previtali (Turin: Einaudi, 1976); L. Pascoli, *Vite de' pittori, scultori e architetti moderni* (1730), critical edition dedicated to V. Martinelli, introduction by A. Marabottini (Perugia: Electa-Editori Umbri Associati, 1992); G.B. Passeri, *Vite de' pittori, scultori e architetti che hanno lavorato in Roma morti dall'anno 1641 sino all'anno 1673* (Rome: Gregorio Settari, 1773); F. Baldinucci, *Notizie de' Professori del disegno da Cimabue in qua* [...], with new annotations and supplements ed. F. Ranalli, V. Batelli et al., Florence 1846–1847, vols. III, IV, V (Florence: anastatic reprint Eurografica, 1974), appendix with critical notice and supplements ed. P. Barocchi, index by A. Boschetto (Florence 1974–75); and N. Pio, *Le Vite di Pittori Scultori et Architetti [Cod. Ms. Capponi 257]*, ed. C. and R. Enggass (Vatican City: Biblioteca Apostolica Vaticana, 1977).

As regards artistic theory, sculpture was discussed in one of the famous *Discorsi sulle arti e sui mestieri* composed by Vincenzo Giustiniani, ed. A. Banti (Florence: Sansoni, 1981), and the object of a vast dissertation by Duquesnoy's pupil Orfeo Boselli, whose manuscript was published in the twentieth century: *Osservazioni della scoltura antica dai manoscritti Corsini e Doria e altri scritti* (ca. 1657), ed. Ph. Dent Weil, S.P.E.S. (Florence: 1978); and *Osservazioni sulla scultura antica. I manoscritti di Firenze e di Ferrara*, ed. A.P.

Torresi, preface by M. Fagiolo dell'Arco (Ferrara: Liberty House, 1994). The other seventeenth-century theoretician of antique and modern sculpture is the underestimated Giovanni Andrea Borboni, *Delle Statue* (Rome: Jacomo Fei, 1661). Regarding the seventeenth-century debate on sculpture: A. Angelini, *Gian Lorenzo Bernini e i Chigi* (Cinisello Balsamo [Milan]: Silvana Editoriale, 1998), pp. 302–5; M.C. Fortunati, "Il trattato Osservazioni della Scultura Antica di Orfeo Boselli. Per una rilettura", *Storia dell'Arte* 100 (1999), pp. 69–101; and M.G. Barberini, "Giovan Pietro Bellori e la scultura contemporanea", in *L'Idea del Bello. Viaggio per Roma nel Seicento con Giovan Pietro Bellori*, exhib. cat., Rome, Palazzo delle Esposizioni, vol. I (Rome: De Luca, 2000), pp. 121–29.

Poets, men of letters and polygraphs in general were also vividly interested in the sculpture of the time. As cultivated art lovers, they were often acute observers of iconographic and formal aspects professionals might well have overlooked. Mention should at least be made of Gian Battista Marino's interest in Cordier's work, Fulvio Testi's enthusiastic letters about Bernini's oeuvre, the essays devoted to Mochi's *Veronica* in St. Peter's, and Bernini's poetic success especially during the age of Urban VIII and Alexander VII. On the subject consult: C. D'Onofrio, *Roma vista da Roma* (Rome: Liber, 1967), *passim*; O. Ferrari, "Poeti e scultori nella Roma seicentesca: i difficili rapporti tra due culture", *Storia dell'Arte* 90 (1997), pp. 151–61; T. Montanari, "Sulla fortuna poetica di Bernini. Frammenti del tempo di Alessandro VII e di Sforza Pallavicino", *Studi secenteschi* XXXIX (1998), pp. 127–64; G. Perini, "'Un nuovo Guido ne' marmi': traccia per la fortuna critica di Algardi", in *Algardi. L'altra faccia del barocco*, exhib. cat., ed. J. Montagu, Rome, Palazzo delle Esposizioni, 31 January–30 April 1999 (Rome: De Luca, 1999), pp. 85–92. A special mention goes to Pietro Sforza Pallavicino, a great admirer of Bernini and modern statuary, the true theoretician of seventeenth-century aesthetics: M. Collareta, "La Chiesa cattolica e l'arte in età moderna", in *Storia dell'Italia religiosa II. L'età*

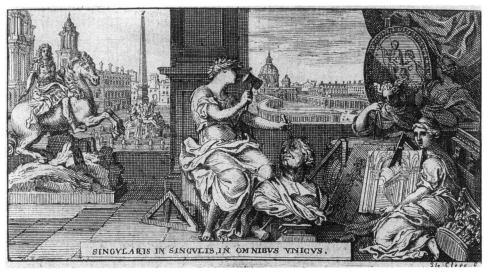

Fig. 13. Sébastien Le Clerc, frontispiece to P. Cureau de la Chambre,
Préface pour servir à l'histoire de la vie et des ouvrages du Cavalier Bernin. Paris, 1685.

moderna, ed. G. de Rosa and T. Gregory (Bari: Laterza, 1994), pp. 167–88, in particular pp. 185–87; T. Montanari, "Gian Lorenzo Bernini e Sforza Pallavicino", *Prospettiva* 87–88 (1997), pp. 42–68; and A. Angelini, *Gian Lorenzo Bernini e i Chigi* (Cinisello Balsamo [Milan]: Silvana Editoriale, 1998), pp. 284–305.

The masterpieces of modern statuary, some of which were illustrated with prints representing them in their urban context, appear in the guides of Rome and descriptions of the pontifical city: G. Baglione, *Le nove chiese di Roma, nelle quali si contengono le historie, pitture, sculture e architetture di esse* (1639), ed. L. Barroero, Rome: n.p., 1990); P. Totti, *Ritratto di Roma moderna* (Rome: Mascardi, 1638); F. Martinelli, *Roma ricercata nel suo sito e nella scuola di tutti gli antiquarij* (1644) (Rome: Biagio Deversini, 1658); Idem, *Roma ornata dall'Architettura, Pittura e Scultura*, ed. C. D'Onofrio, in *Roma nel Seicento*, Vallecchi, Florence 1969; G. Alveri, *Roma in ogni stato* (Rome: Mascardi, 1664); F. Titi, *Descrizione delle Pitture, Sculture e Architetture esposte al pubblico in Roma* (1763), ed. B. Contardi and S. Romano (Florence: Centro Di, 1978); *Le Fontane pubbliche delle piazze di Roma moderna* (Rome: De' Rossi

alla Pace, 1691); *Studio d'architettura civile sopra vari ornamenti di cappelle e diversi sepolcri tratti da più chiese di Roma* (Rome: De' Rossi alla Pace, 1711).

Among the modern texts that deal with the subject in general terms, special attention should be devoted to: R. Wittkower, *Arte e Architettura in Italia, 1600-1750* (1958), It. transl. by L. Monarca Nardini and M.V. Malvano (Turin: Einaudi, 1972): it is a lengthy treatise on seventeenth-century Italian art in which the great Vienna School scholar, who wrote the most complete and balanced monograph on Gian Lorenzo Bernini, concentrates on Roman statuary. Still useful, though today occasionally appearing rather dated due to his choices of priorities and historical hierarchies, J. Pope-Hennessy, *An Introduction to Italian Sculpture. Italian High Renaissance and Baroque Sculpture* (London: Phaidon Press, 1963), 3 vols. The finest overall historical-chronological study devoted to seventeenth-century Italian sculpture is still the one by A. Nava Cellini, *La scultura del Seicento. L'arte in Italia* (Turin: Utet, 1981). Pioneering in many aspects, it masterfully sums up issues investigated over a period of several decades by the scholar who focused

on the stylistic and philological method in her examination of works of art. In the various studies by Jennifer Montagu—*Roman Baroque Sculpture: the Industry of Art* (New Haven–London: Yale University Press, 1989), and *Gold, Silver and Bronze. Metal Sculpture of the Roman Baroque* (New Haven–London: Yale University Press 1996)—using an experimental method, sculpture is analysed in its productive processes: workshops and academies, master-pupil and designer-founder/carver relationships.

Contributions should not be overlooked on Roman sculpture in the catalogues of several major museums or collections, like I. Faldi, *Galleria Borghese. Le sculture dal secolo XVI al XIX* (Rome: Istituto Poligrafico dello Stato, 1954); or U. Schlegel, *Die italienischen Bildwerke des 17. und 18. Jahrhunderts in Stein, Holz, Ton, Wachs und Bronze, Staatliche Museen Preussischer Kulturbesitz*, vol. I (Berlin: Brüder Hartmann, 1978, 2nd ed. 1988); S. Androsov, *Alle origini di Canova, le terrecotte della collezione Farsetti*, exhib. cat., Rome, Fondazione Memmo, Palazzo Ruspoli, 12 December 1991–29 February 1992 (Venice: Marsilio, 1991); and M.G. Barberini, *Sculture in terracotta del Barocco romano. Bozzetti e modelli del Museo Nazionale del Palazzo Venezia* (Rome: Palombi, 1991). For the sculpture ensembles in St Peter's in the Vatican, consult the detailed catalogue of the books devoted to *La Basilica di San Pietro in Vaticano*, ed. A. Pinelli (Modena: Panini, 2000).

Two excellent bibliographies have been drawn up on the subject, one biographical and the other topographical, and both illustrated by wide-ranging and detailed set of photographs essential for any preliminary research in this field. The biographical list is *La scultura del Seicento a Roma*, ed. A. Bacchi (Milan: Longanesi, 1996); the topographical one is the book by O. Ferrari and S. Papaldo, *Le sculture del Seicento a Roma* (Rome: Bozzi, 1999).

Bibliographical indications relating to more specific issues are presented separately below under the titles of the various paragraphs into which this book is divided.

PRIMACY OF THE LOMBARDS IN ROME

On the presence of artists of Lombard birth in Rome in the early seventeenth century, consult the documentary repertory by A. Bertolotti, *Artisti lombardi in Roma nei secoli XV, XVI, XVII. Studi e ricerche negli archivi romani* (Milan: Hoepli, 1881), 2 vols.

On the cultural bonds between Milan and Rome at the time of Carlo and Federico Borromeo: G. Gabrieli, "Federico Borromeo a Roma", *Archivio della Società Romana di Storia Patria* LVI–LVII (1933–34), pp. 157–217; J. S. Ackerman, "Pellegrino Tibaldi, S. Carlo Borromeo e l'architettura ecclesiastica del loro tempo", in *San Carlo e il suo tempo*, proceedings of the international congress for the IV centennial of his death (Rome: Edizioni di storia e letteratura, 1986), pp. 573–86; B. Agosti, *Collezionismo e archeologia. Federico Borromeo e il Medioevo artistico tra Roma e Milano* (Milan: Jaca Book, 1996); S. Della Torre, "Le architetture monumentali: disciplina normativa e pluralismo delle opere", in *Carlo Borromeo e l'opera della "Grande Riforma". Cultura, religione e arti del governo nella Milano del pieno Cinquecento*, ed. F. Buzzi and D. Zardin (Cinisello Balsamo [Milan]: Silvana Editoriale, 1997), pp. 217–40.

For a well-illustrated picture of Lombard sculpture in the late-sixteenth century it is still worthwhile consulting A. Venturi, "La scultura del Cinquecento", in *Storia dell'Arte Italiana*, vol. X, pt. III (Milan: Hoepli, 1937), pp. 466–692. Also see the more updated contributions from the critical and bibliographical point of view by A.P. Valerio, "Annibale Fontana e il paliotto dell'altare della Vergine dei Miracoli in Santa Maria presso San Celso", *Paragone* 279 (1973), pp. 32–53; M. Tanzi, "La 'Madonna di San Celso' e una proposta per Cerano scultore", *Prospettiva* 78 (1995), pp. 75–83; and especially B. Agosti, "Contributo su Annibale Fontana", *Prospettiva* 78 (1995), pp. 70–74; Idem, "Colossi di Lombardia", *Prospettiva* 83–4 (1996), pp. 177–82; and *Scultura lombarda del Rinascimento. I monumenti Borromeo*, ed. M. Natale (Turin: Allemandi, 1996).

On Cosimo Fanzago's strictly Lombard training the most incisive contribution is still by Aurora Spinosa, "Cosimo Fanzago lombardo a Napoli", *Prospettiva* 7 (1975), pp. 10–26; on the artist's Roman activity R. Bösel, "Cosimo Fanzago a Roma", *Prospettiva* 15 (1978), pp. 29–39.

On Lombard architects directing Roman yards, refer to the highly efficient synthesis by Daniela del Pesco, *L'architettura del Seicento. Storia dell'arte italiana* (Turin: Utet, 1998), pp. 3–27. For architectural decoration also see A. di Castro, "Rivestimenti e tarsie marmoree a Roma tra Cinquecento e Seicento", in *Marmorari e argentieri a Roma e nel Lazio tra Cinquecento e Seicento. I committenti, i documenti, le opere*, presentation by V. Martinelli (Rome: Quasar, 1994), pp. 9–155. For the introduction of statues in niches in early seventeenth-century Roman architecture: O. Ferrari, the Introduction in *Le sculture del Seicento* (Rome: Bozzi, 1999), pp. LVII-LXI.

On Carlo Maderno: H. Hibbard, *Carlo Maderno and Roman Architecture, 1580–1630* (London: Zwemmer, 1971); on Borromini's Lombard origins: *Il giovane Borromini. Dagli esordi a San Carlo alle Quattro Fontane*, exhib. cat., ed. M. Kahn-Rossi and M. Franciolli, Lugano, Museo Cantonale d'Arte, 5 September–14 November 1999 (Milan: Skira, 1999).

Since there is no room here for an adequate bibliography on the theme of the rediscovery of early Christianity in the arts promoted by the Counter Reformation, mention shall be restricted to G. Previtali, *La fortuna dei primitivi. Dal Vasari ai Neoclassici* (Turin: Einaudi 1964, new revised and enlarged edition, introductory note by E. Castelnuovo, 1989), as well as the essay, already mentioned, by Barbara Agosti on Federico Borromeo, *Collezionismo e archeologia* (Milan: Jaca Book, 1996), *passim*.

In general on sculpture in Rome in the first years of the seventeenth century, aside from the general texts already mentioned: S. Pressouyre, "Sur la sculpture à Rome autour de 1600", *Revue de l'Art* 28 (1975), pp. 22–75; and C.E. Fruhan, *Trends in Roman Sculpture circa 1600* (Ann Arbor: Phil. diss., University of Michigan, 1986).

More particularly on Stefano Maderno and the altar of Santa Cecilia in Trastevere: A. Nava Cellini, "Stefano Maderno, Francesco Vanni e Guido Reni a Santa Cecilia in Trastevere", *Paragone* 227 (1969), pp. 18–41; T. Kämpf, "Framing Cecilia's Sacred Body: Paolo Camillo Sfondrato and the Language of Revelation", *The Sculpture Journal* VI (2001), pp. 10–20; for a synthetic profile of the sculptor the best is still the short essay by A. Nava Cellini, *Stefano Maderno* (Milan: Fabbri, "I Maestri della Scultura", 1966).

On Nicolas Cordier: S. Pressouyre, under "Cordier Nicolas", in *Dizionario Biografico degli Italiani*, vol. 29 (Rome: Istituto della Enciclopedia Italiana, 1983), pp. 1–3; Idem, *Nicolas Cordier. Recherches sur la sculpture à Rome autour de 1600*, vol. II (Rome: Boccard, 1984).

On Ippolito Buzio: A. Pampalone, under "Buzio Ippolito", in *Dizionario Biografico degli Italiani*, vol. 15 (Rome: Istituto della Enciclopedia Italiana, 1972), pp. 659–60; H.U. Kessler, "A Portrait of Lesa Deti by Ippolito Buzio", *Metropolitan Museum Journal* 32 (1997), pp. 77–84; and L. Sickel, "Appunti archivistici su Onorio Longhi e Ippolito Buzio", *Bollettino d'Arte* 117 (2001), pp. 125–35.

On Ambrogio Buonvicino: S. Papaldo, under "Buonvicino Ambrogio", in *Dizionario Biografico degli Italiani*, vol. 15 (Rome: Istituto della Enciclopedia Italiana 1972), pp. 288–89.

On the iconographic aspects of the low reliefs in the Pauline Chapel: A. Herz, "The Sixtine and Pauline Tombs. Documents of the Counter Reformation", *Storia dell'Arte* 43 (1981), pp. 241–62, and especially S. F. Ostrow, *L'arte dei papi. La politica delle immagini nella Roma della Controriforma* (1996) (Rome: Carocci, 2002).

On the restorations of antique sculpture executed by seventeenth-century sculptors in Rome, see the pages regarding the seventeenth century (pp. 221–29) by O. Rossi Pinelli, "Chirurgia della memoria: scultura antica e restauri storici", in *Memoria dell'antico nell'arte italiana. III. Dalla tradizione all'archeologia,* ed. S. Settis (Turin: Einaudi 1986), pp. 181–250; J. Montagu, "L'influsso del barocco sull'antichità

classica", in *La scultura barocca romana: l'industria dell'arte* (Turin: Allemandi 1991), pp. 151–72; *La collezione Boncompagni Ludovisi. Algardi, Bernini e la fortuna dell'antico*, exhib. cat., ed. A. Giuliano, Rome, Fondazione Memmo, Palazzo Ruspoli, 5 December 1992–30 April 1993 (Venice: Marsilio, 1992); and D. Sparti, "Tecnica e teoria nel restauro della Roma seicentesca. La collezione di sculture antiche del Cardinal Flavio Chigi", *Storia dell'Arte* 92 (1998), pp. 60–138.

TUSCAN PRESENCES

On Pietro Bernini and the early stages of his son Gian Lorenzo: A. Muñoz, "Il padre di Bernini. Pietro Bernini scultore (1562–1629)", *Vita d'arte* 2 (1909), pp. 425–70; R. Longhi, "I due Bernini. Precisioni nelle gallerie italiane: la Galleria Borghese" [1926], in *Saggi e ricerche. 1925–1928* (Florence: Sansoni, 1967), vol. II/1, pp. 267–71; A. Venturi, *La scultura del Cinquecento* (op cit.), pp. 886–92; V. Martinelli, "Contributi alla scultura del Seicento: Pietro Bernini e figli", *Commentari* IV (1953), pp. 133–54; Idem, "Novità berniniane: 4. 'Flora' e 'Priapo' i due termini già nella Villa Borghese a Roma", *Commentari* XIII (1962), pp. 268–88; C. D'Onofrio, *Roma vista da Roma* (Rome: Liber, 1967); I. Lavin, "Five New Youthful Sculptures by Gian Lorenzo Bernini and a Revised Chronology of his Early Works", *The Art Bulletin* L (1968), pp. 223–48; O. Raggio, "A New Bacchic Group by Bernini", *Apollo* CVIII 4 (1978), pp. 406–17; *Pietro Bernini, un preludio al Barocco*, exhib. cat., ed. Scramasax, Sesto Fiorentino, Teatro La Limonaia, Villa Corsi Salviati, 16 September–30 November 1989 (Florence: G. Capponi, 1989); H.U. Kessler, "Pietro Bernini (1562–1629) und seine Werke in der Certosa di San Martino in Neapel", *Mitteilungen des Kunsthistorischen Institutes in Florenz* XXXVIII (1994), pp. 310–35; A. Bacchi, "Del conciliare l'inconciliabile. Da Pietro a Gian Lorenzo Bernini: commissioni, maturazioni stilistiche e pratiche di bottega", in *Gian Lorenzo Bernini. Regista del Barocco*, exhib. cat., ed. M.G. Bernardini and M. Fagiolo dell'Arco, Rome,

Palazzo Venezia, 21 May–16 September 1999 (Milan: Skira 1999), pp. 65–76; H.U. Kessler, "Pietro Bernini's Statues for the Cappella Ruffo in the Church of the Girolamini in Naples", *The Sculpture Journal* VI (2001), pp. 21–29.

On Francesco Mochi: L. Dami, "Francesco Mochi", *Dedalo* V (1924–1925), pp. 99–132; A. Pettorelli, *Francesco Mochi e i gruppi equestri farnesiani* (Piacenza: Stabilimento Tipografico Piacentino, 1926); V. Martinelli, "Contributi alla scultura del Seicento: Francesco Mochi a Roma", *Commentari* II (1951), pp. 224–35; E. Borea, *Francesco Mochi* (Milan: Fabbri, "I Maestri della Scultura", 1966); I. Lavin and M. Aronberg Lavin, "Duquesnoy's 'Nano di Créqui' and Two Busts by Francesco Mochi", *The Art Bulletin* LII (1970), pp. 132–49; *Francesco Mochi 1580–1654*, on the occasion of the exhibitions for the fourth centennial of his birth (Florence: Centro Di, 1981); *I bronzi di Piacenza. Rilievi e figure di Francesco Mochi dai monumenti equestri farnesiani*, exhib. cat., Bologna, Museo Civico Archeologico, 21 March–18 May 1986 (Bologna: Grafis, 1986, the photographs are highly recommended); and M. Cambareri, "Francesco Mochi's Annunciation Group for Orvieto Cathedral", *The Sculpture Journal* VI (2001), pp. 1–9.

THE RISE OF GIAN LORENZO BERNINI

On Bernini the sculptor, Stanislao Fraschetti's monumental monograph is still fundamental, especially for the rich documentation contained in the notes that do not always appear in later studies: *Il Bernini. La sua vita, la sua opera e il suo tempo*, preface by A. Venturi (Milan: Hoepli, 1900); the richest and most complex overall study written in the late twentieth century is the one by R. Wittkower, *Gian Lorenzo Bernini, Sculptor of Roman Baroque* (London: Phaidon Press, 1955, 2nd ed. 1966; 3rd ed. with revisions by H. Hibbard, T. Martin and M. Wittkower 1981, It. translation by S. D'Amico, Milan: Electa 1990). The monumental study on the artist's drawings is also owed to Wittkower with Heinrich Brauer in *Die Zeichungen des*

Gian Lorenzo Bernini (Berlin: Heinrich Keller, 1931), 2 vols.

Other important monographic works: M. and M. Fagiolo dell'Arco, *Bernini. Una introduzione al gran teatro del barocco* (Rome: Bulzoni, 1967), with few though occasionally rare illustrations; C. Avery, *Bernini. Genius of the Baroque* (London: Thames and Hudson, 1997).

Several significant studies on the different stages of Bernini's career are: *Apollo e Dafne del Bernini nella Galleria Borghese*, ed. K. Hermann Fiore (Cinisello Balsamo [Milan]: Amilcare Pizzi, 1997); *Bernini scultore. La nascita del barocco in casa Borghese*, exhib. cat., ed. A. Coliva and S. Schütze, Rome, Galleria Borghese, 15 May–20 September 1998 (Rome: De Luca, 1998), with a detailed entries-essay mainly devoted to the works of the artist's youth; *Gian Lorenzo Bernini. Regista del Barocco. I restauri*, ed. C. Strinati and M.G. Bernardini (Milan: Skira, 1999); M. Fagiolo dell'Arco, *Berniniana. Novità sul regista del Barocco* (Milan: Skira, 2002).

The numerous, occasionally pioneering interventions by Valentino Martinelli are assembled in *Gian Lorenzo Bernini e la sua cerchia. Studi e contributi (1950–1990)* (Naples: Edizioni Scientifiche Italiane, 1994).

Several equally useful essays for the comprehension of the artist appeared in the following books: *Gian Lorenzo Bernini. New Aspects of His Art and Thought, a Commemorative Volume*, ed. I. Lavin (London: n.p., 1985); *Gian Lorenzo Bernini e le arti visive*, ed. M. Fagiolo dell'Arco (Rome: Istituto della Enciclopedia Italiana 1987); and *Bernini a Montecitorio, ciclo di conferenze nel quarto centenario della nascita di Gian Lorenzo Bernini*, ed. M.G. Bernardini, in collaboration with the Monuments and Fine Arts Office of Rome, Camera dei Deputati, Rome 2001.

On the artist's long years spent working for the Vatican and in St. Peter's: *Bernini in Vaticano*, exhib. cat., Vatican, Braccio di Carlo Magno, May–July 1981 (Rome: De Luca, 1981); A. Bacchi and S. Tumidei, *Bernini. La scultura in San Pietro* (Milan: Federico Motta, 1998).

On Bernini's preparatory drawings for the sculptures see, aside from the Brauer–Wittkower text, *Drawings by Gian Lorenzo Bernini from the Museum der Bildenden Kunste Leipzig. German Democratic Republic*, ed. I. Lavin (Princeton: Princeton University Press, 1981).

For two handier books you can consult: H. Hibbard, *Bernini* (London: Penguin, 1965); A. Angelini, *Bernini* (Milan: Jaca Book, 1998).

On Bolgi: V. Martinelli, "Andrea Bolgi a Roma e a Napoli", *Commentari* X (1959), pp. 137–58; A. Nava Cellini, "Ritratti di Andrea Bolgi", *Paragone* 147 (1962), pp. 24–40; and A. Pinna, under "Bolgi Andrea", in *Dizionario Biografico degli Italiani*, vol. 11 (Rome: Istituto della Enciclopedia Italiana 1969), pp. 277–78.

THE ALTERNATIVE STYLE OF ALESSANDRO ALGARDI

Algardi's overall artistic output benefits from the exemplary monographic study by Jennifer Montagu, *Alessandro Algardi* (New Haven–London: Yale University Press, 1985), 2 vols., as well as the specific studies the English scholar previously dedicated to him: "Alessandro Algardi's Altar of San Nicola da Tolentino and Some Related Models", *The Burlington Magazine* CXII (1970), pp. 282–91; "Le Baptême du Christ d'Alessandro Algardi", *Revue de l'Art* 15 (1972), pp. 64–78; "Alessandro Algardi and the 'Borghese Table'", *Antologia di Belle Arti* I (1977), pp. 311–28. Equally important, illuminating contributions were devoted to Algardi by Antonia Nava Cellini: "Aggiunte alla ritrattistica berniniana e dell'Algardi", *Paragone* 65 (1955), pp. 23–31; "Il Borromini, l'Algardi e il Grimaldi per Villa Doria Pamphili", *Paragone* 159 (1963), pp. 67–75; "L'Algardi restauratore a Villa Pamphili", *Paragone* 161 (1963), pp. 25–37; "Per l'integrazione e lo svolgimento della ritrattistica di Alessandro Algardi", *Paragone* 177 (1964), pp. 15–36. On the decoration of Villa Pamphili, refer to the study by Olga Raggio, "Alessandro Algardi e gli stucchi di Villa Pamphili", *Paragone* 251 (1971), pp. 3–38. On the sculptor's drawings, see V. Witzthum, "Disegni di Alessandro Algardi", *Bollettino d'Arte* XLVIII (1963), pp. 75–98.

Lastly, see the catalogue of the memorable exhibition mounted in Rome on the fifth centennial of the artist's birth, *Algardi. L'altra faccia del barocco*, ed. J. Montagu, Rome, Palazzo delle Esposizioni, 21 January–30 April 1999 (Rome: De Luca, 1999).

On Pietro da Cortona and sculpture: J. Montagu, "La scultura cortonesca", in *Pietro da Cortona 1597–1669*, exhib. cat., ed. A. Lo Bianco, Rome, Palazzo Venezia, 31 October 1997–10 February 1998 (Milan: Electa, 1997), pp. 127–32, 440–1; R. Spinelli, "'Modellato a regola d'arte'. Lo stucco nelle decorazioni fiorentine", in *La grande storia dell'artigianato*, vol. V, *Il Seicento e il Settecento* (Florence: Cassa di Risparmio di Firenze, Giunti, 2002), pp. 101–31.

On Pierre Puget: V. Witzthum, *Pierre Puget* (Milan: Fabbri, "I Maestri della Scultura", 1966); G. Walton, "Pierre Puget in Rome: 1662", *The Burlington Magazine* CXI 799 (1969), pp. 582–87; K. Herding, *Pierre Puget. Das Bildnerische Werk* (Berlin: Mann, 1970); *Pierre Puget (Marsiglia 1620–1694). Un artista francese e la cultura barocca a Genova* (Milan: Electa, 1995); Idem, "Pierre Puget: le Bernin de la France ou subtil antiberninien?", in *Le Bernin et l'Europe. Du baroque triomphant à l'âge romantique*, texts collected by C. Grell and M. Stanic (Paris: Presses de l'Université de Paris Sorbonne, 2002), pp. 303–23.

THE NEO-VENETIAN TREND

The neo-Venetian trend in Rome was critically identified for the first time by Roberto Longhi, "Gentileschi padre e figlia" [1916], in *Scritti giovanili. 1912–1922* (Florence: Sansoni 1961), vol. I, pp. 219–83, and since then has been considered one of the essential components of the seventeenth-century figurative scene, a training ground for painters like Pietro da Cortona, Andrea Sacchi, Pietro Testa, Pier Francesco Mola and Nicolas Poussin, just to mention the greatest. The fact that this trend also directly influenced sculptors like Algardi, in some aspects Bernini, and above all Duquesnoy, was not brought to light until later studies.

In particular, on Duquesnoy, see the one monograph still available: M. Fransolet, *Francois du Quesnoy, sculpteur d'Urbain VIII, 1597–1643* (Brussels: Palais des Académies, 1942), and the fundamental contribution by Italo Faldi, "Le 'virtuose operationi' di François Duquesnoy scultore incomparabile", *Arte antica e moderna* 5 (1959), pp. 52–62; A. Mezzetti, *L'ideale classico del Seicento in Italia e la pittura di paesaggio*, exhib. cat., Bologna, Palazzo dell'Archiginnasio, 8 September–11 November 1962 (Bologna: Edizioni Alfa, 1962), pp. 361–71; K. Noehles, "Francesco Duquesnoy: un busto ignoto e la cronologia delle sue opere", *Arte antica e moderna* 25 (1964), pp. 86–96; A. Nava Cellini, "Duquesnoy e Poussin: nuovi contributi", *Paragone* 195 (1966), pp. 30–59; M. Boudon, "La Saint Suzanne de François de Quesnoy et le programme sculpté de Sainte Marie de Lorette à Rome", *Storia dell'Arte* 96 (1999), pp. 122–55; M.G. Barberini, in *L'idea del bello* (Rome: De Luca, 2000), pp. 394–98.

ASPECTS OF ROME UNDER THE BARBERINI

On Bernini's portraits around 1620, aside from the many studies in works of a general character, see the valuable, more specific contributions by Valentino Martinelli, "Capolavori noti e ignoti del Bernini: i ritratti dei Barberini, di Innocenzo X e di Alessandro VII", *Studi romani* III (1955), pp. 32–52; Idem, "I busti berniniani di Paolo V, di Gregorio XV e di Clemente X", *Studi romani* III (1955), pp. 647–66; I. Lavin, "Five New Youthful Sculptures", *The Art Bulletin* L (1968), pp. 223–48; Idem, "Bernini's Bust of Cardinal Montalto", *The Burlington Magazine* CXXVII (1985), pp. 32–38; A. Sutherland Harris, "Bernini and Virginio Cesarini", *The Burlington Magazine* CXXXI (1989), pp. 17–23; *Effigies and Ecstasies. Roman Baroque Sculpture and Design in the Age of Bernini*, exhib. cat., ed. T. Clifford and A. Weston Lewis, Edinburgh, 25 June–20 September 1998 (Edinburgh: National Gallery of Scotland, 1998); O. Ferrari, "Bernini ritrattista", in *Gian Lorenzo Bernini. Regista*, exhib. cat., ed. M.G. Bernardini and M. Fagiolo dell'Arco, Rome,

Palazzo Venezia, 21 May–16 September 1999 (Milan: Skira 1999), pp. 93–117.

On Finelli's portraits: A. Nava Cellini, "Un tracciato per l'attività ritrattistica di Giuliano Finelli", *Paragone* 131 (1960), pp. 9–30; C. Pizzorusso, *A Boboli e altrove. Scultura fiorentina del Seicento* (Florence: Olschki, 1989), pp. 113–16; on Finelli in general, see P. Santa Maria, under "Finelli Giuliano", in *Dizionario Biografico degli Italiani*, vol. 48 (Rome: Istituto della Enciclopedia Italiana 1997), pp. 32–34; the ample monograph by Damian Dombrowski, *Giuliano Finelli. Bildhauer zwischen Neapel und Rom* (Frankfurt am Main: Peter Lang, 1997) in which, however, the catalogue of the artist's works is too extensive.

On the portraits of Bernini's maturity: R. Wittkower, *Bernini's Bust of Louis XIV* (London–New York–Toronto: Oxford University Press, 1951); Idem, "Bernini's Studies. II, The Bust of Mr. Baker", *The Burlington Magazine* XCV (1963), pp. 19–22; I. Lavin, "L'immagine berniniana del Re Sole", in R. Wittkower, *Passato e presente nella storia dell'arte* (1993) (Turin: Einaudi 1994), pp. 233–324; Idem, *Bernini e l'immagine del principe cristiano ideale* (Modena: Panini 1998); A. Angelini, "Il busto marmoreo di Alessandro VII scolpito da Gian Lorenzo Bernini nel 1657", *Prospettiva* 89–90 (1998), pp. 184–92.

THE "MARAVIGLIOSO COMPOSTO" OF THE ARTS

On this theme see in particular the interpretative essays by Irving Lavin: *Bernini and the Crossing of Saint Peter's* (New York: New York University Press, 1968); *Bernini e l'unità delle arti visive* (Rome: L'Elefante, 1980).

On Bernini's mature activity in general: R. Battaglia, *La Cattedra berniniana di San Pietro* (Rome: Reale Istituto di studi romani, 1943); I. Lavin, "Bernini's Death", *The Art Bulletin* (1972), pp. 159–86; R. Preimesberger, "'Obeliscus Pamphilius'. Beiträge zu Vorgeschichte und Ikonographie des Vierströmebrunnens auf Piazza Navona", *Müchner Jahrbuch für Kunstgeschichte* XXV (1974), pp. 77–162; C. D'Onofrio, *Gian Lorenzo Bernini e gli angeli di ponte S. Angelo.*

Storia di un ponte (Rome: Società Editrice Romana, 1981); V. Martinelli (ed.), *Le statue berniniane del Colonnato di San Pietro* (Rome: De Luca, 1987); V. Martinelli (ed.), *L'ultimo Bernini, 1665–1680. Nuovi argomenti, documenti e immagini* (Rome: Quasar, 1996).

For Alexander VII's commissions to Bernini: *L'Ariccia del Bernini*, exhib. cat., ed. F. Petrucci, Ariccia, Palazzo Chigi, 10 October–31 December 1998 (Rome: De Luca, 1998); A. Angelini, *Gian Lorenzo Bernini e i Chigi* (Cinisello Balsamo [Milan]: Silvana Editoriale, 1998), *passim*; *Alessandro VII il papa senese di Roma moderna*, exhib. cat., ed. A. Angelini, M. Butzek and B. Sani, Siena, Palazzo Pubblico and Palazzo Chigi Zondadari, 23 September 2000–10 January 2001 (Siena: Maschietto e Musolino, 2000), *passim*.

On Francesco Baratta: H. Honour, under "Baratta Francesco", in *Dizionario Biografico degli Italiani*, vol. 5 (Rome: Istituto della Enciclopedia Italiana 1963), pp. 788–89.

THE METEOR OF MELCHIORRE CAFFÀ

A. Nava Cellini, "Contributi a Melchiorre Caffà", *Paragone* 83 (1956), pp. 17–31; R. Wittkower, "Melchiorre Caffà's Bust of Alexander VII", *The Metropolitan Museum of Art Bulletin* XVII (1959), pp. 197–204; R. Preimesberger, under "Caffà Melchiorre", in *Dizionario Biografico degli Italiani*, vol. 16 (Rome: Istituto della Enciclopedia Italiana 1973), pp. 230–35; D. Jemma, "Inediti documenti di Melchiorre Caffà", *Paragone* 379 (1981), pp. 53–58; E. B. Di Gioia, "Un bozzetto di Melchiorre Caffà per il bassorilievo di S. Eustachio in Santa Agnese in Agone", *Bollettino dei musei comunali di Roma* XXVIII–XXIX (1981–83), pp. 48–67; J. Montagu, "The graphic work of Melchiorre Caffà", *Paragone* 413 (1984), pp. 50–61.

MASTERS AND PUPILS

On this theme, from the general methodological angle see especially Jennifer Montagu's important

contribution in *La scultura barocca romana* (Turin: Allemandi 1991), pp. 126–50.

On Antonio Raggi, aside from Nava's first article (*La scultura barocca a Roma. Ercole Antonio Raggi, L'Arte* XL [1937], pp. 284–305), the only monographic study is still the one by Robert Henry Westin, *Antonio Raggi: a Documentary and Stylistic Investigation of His Life, Work and Significance in Seventeenth Century Roman Baroque Sculpture* (Ann Arbor: Phil. diss., Pennsylvania State University, 1978); and, idem, "Antonio Raggi's Death of St. Cecilia", *The Art Bulletin* LVI (1974), pp. 422–29. On the role played by the artist and his influence on sculptors of the next generation, see R. Enggass, *Early Eighteenth-Century Sculpture in Rome, an illustrated catalogue raisonné*, vol. I (University Park-London: Pennsylvania State University Press, 1976), pp. 29–33. On the relationship between Raggi and Baciccio at the time of the decoration of Il Gesù church, again see R. Enggass, "La Chiesa trionfante e l'affresco della volta del Gesù", in *Giovan Battista Gaulli. Il Baciccio 1639–1709*, exhib. cat., ed. M. Fagiolo dell'Arco, D. Graf and F. Petrucci, Ariccia, Palazzo Chigi, 11 December 1999–12 March 2000 (Milan: Skira, 1999), pp. 27–45 and *passim* in the entire book.

On Ercole Ferrata we should recall Vincenzo Golzio, "Lo 'studio' di Ercole Ferrata", *Archivi d'Italia e Rassegna Internazionale degli Archivi* II (1935), pp. 64–74; A. Nava Cellini, "Contributo al periodo napoletano di Ercole Ferrata", *Paragone* 137 (1961), pp. 37–44; K. Lankheit, *Florentinische Barock-Plastik die Kunst am Hofe der Letzen Medici* (Munich: Bruckmann, 1962), pp. 30–37; G. Borghini, "Nota sul modello in grande per la Santa Caterina di Ercole Ferrata nel Duomo di Siena", *Antologia di Belle Arti* 21–22 (1984), pp. 77–79; M. Fiaschi, "Ercole Ferrata: nuovi documenti e nuove attribuzioni", *Studi romani* XVII (1999), pp. 43–53; A. Spiriti, "Ercole Ferrata tra Milano e Roma", *Storia dell'Arte* 100 (1999), 102–16.

On Ferrata's influence on Florentine sculpture in the age of Cosimo III (1670–1723) see J. Montagu and K. Lankheit, "Scultura.

Introduzione", in *Gli ultimi Medici. Il tardo barocco a Firenze 1670–1743*, exhib. cat., Florence, Palazzo Pitti, 28 June–30 September 1974 (Florence: Centro Di, 1974), pp. 26–153.

On Francesco Aprile: A. Nava Cellini, under "Aprile Francesco", in *Dizionario Biografico degli Italiani*, vol. 3 (Rome: Istituto della Enciclopedia Italiana 1961), p. 642; A. M. Gunter, "Scultori a Roma tra Seicento e Settecento: Francesco Cavallini, Francesco Aprile e Andrea Fucigna", *Storia dell'Arte* 97 (1997), pp. 315–66.

On Maglia and Ottoni: T. Pickrel, "Maglia, Théodon and Ottoni at S. Carlo ai Catinari: a Note on the Sculptures in the Chapel of S. Cecilia", *Antologia di Belle Arti* 23–24 (1984), pp. 27–37.

On Giuseppe Mazzuoli: F. Pansecchi, "Contributi a Giuseppe Mazzuoli", *Commentari* X (1959), pp. 33–43; M. Butzek, "Die Modellsammlungen der Mazzuoli in Siena", *Pantheon* XLVI (1988), pp. 75–102; Idem, "Giuseppe Mazzuoli e le statue degli apostoli del Duomo di Siena", *Prospettiva* 61 (1991), pp. 75–89; A. Angelini, "Giuseppe Mazzuoli, la bottega dei fratelli e la committenza della famiglia de' Vecchi", *Prospettiva* 79 (1995), pp. 78–100.

On Pietro Balestra: T. Montanari, *Bernini e Cristina di Svezia*, in A. Angelini, *Gian Lorenzo Bernini e i Chigi tra Roma e Siena* (Cinisello Balsamo [Milan]: Silvana Editoriale, 1998), pp. 455–77.

On Giulio Cartari: F. Negri Arnoldi, under "Cartari Giulio", in *Dizionario Biografico degli Italiani*, vol. 21 (Rome: Istituto della Enciclopedia Italiana 1976), pp. 791–92.

On Domenico Guidi: D. L. Bershad, *Domenico Guidi. A 17th century Roman sculptor* (Los Angeles: doctoral diss., University of California, 1970).

On the Giorgetti brothers: J. Montagu, "Antonio e Giuseppe Giorgetti: Sculptors to Cardinal Francesco Barberini", *The Burlington Magazine* LII (1970), pp. 278–98.

On Ciro Ferri and sculpture: H.-W. Kruft, "A Reliquary by Ciro Ferri", *The Burlington*

Magazine CXII (1970), pp. 692–95; Idem, "Another Sculpture by Ciro Ferri in Malta", *The Burlington Magazine* CXXIII (1981), pp. 26–29.

On Camillo Rusconi's training and his contacts with Raggi: R. Enggass, "Rusconi and Raggi in Sant'Ignazio", *The Burlington Magazine* CXVI (1974), pp. 258–62.

THE FRENCH IN ROME

On the crisis of art commissions in Rome after 1670 the text by Francis Haskell is still worthwhile, *Patrons and Painters. A Study in the Relations between Italian Art and Society in the Age of the Baroque* (New York: Alfred N. Knopf, 1963); on developments in sculpture in Rome at the end of the seventeenth century and the important presence of the French: R. Enggass, *Early Eighteenth Century Sculpture in Rome* (University Park–London: Pennsylvania State University Press, 1976), pp. 24–27 and *passim*. On the French sculptors in particular: F. Souchal, *French Sculptors of the 17th and 18th Centuries. The Reign of Louis XIV, Illustrated Catalogue* (Oxford: Bruno Cassirer, 1977).

On Pierre Legros: G. Bissel, *Pierre Le Gros, 1666–1719* (Reading: n.p., 1997); A. Magnien, "Le sculpteur A. Fr. D'Hez biographe de Pierre Puget et Pierre II Legros", *Revue de l'Art* 127 (2000–2001), pp. 32–42.

On Monnot: D. L. Bershad, "Pierre-Étienne Monnot: Newly Discovered Sculptures and Documents", *Antologia di Belle Arti* 23–24 (1984), pp. 72–75; A. Bacchi, "'L'Andromeda' di Lord Exeter", *Antologia di Belle Arti* 48–51 (1994), pp. 64–70; Idem, "'L'operazione con li modelli': Pierre Étienne Monnot e Carlo Maratta a confronto", *Ricerche di Storia dell'Arte* 55 (1995), pp. 39–52.

On the role and importance of the Académie in Rome: N. Pevsner, *Le accademie d'arte* (1940), It. trans. L. Lovisetti Fuà, introduction by A. Pinelli (Turin: Einaudi 1982), pp. 77–156.

On Andrea Pozzo and the sculptors who worked on the altar of St. Ignatius: B. Kerber, "Designs for Sculpture by Andrea Pozzo", *The Art Bulletin* XLVII (1965), pp. 499–502; Idem, *Andrea Pozzo* (Berlin–New York: Walter de Gruyter, 1971), pp. 140–80.

[5] Alessandro Angelini (Siena, 1958) teaches History of Modern Art at the University of Siena. He published, among others, *Disegni italiani del tempo di Donatello* (Florence 1986) and *Gian Lorenzo Bernini e i Chigi tra Roma e Siena* (Milan 1998) and organised the exhibition 'Alessandro VII Chigi il papa senese di Roma moderna' (Siena 2000), editing the catalogue together with M. Butzek and B. Sani. Since 1982 writes on the journal *Prospettiva* and he is presently a member of its editorial staff.